CHIBI MANGA

Irresistible!

First published in 2016 by
Harper Design
An Imprint of HarperCollins Publishers
195 Broadway
New York, NY 10007
Tel: (212) 207-7000
Fax: (855) 746-6023
harperdesign@harpercollins.com
www.hc.com

Distributed throughout the world by
HarperCollins Publishers
195 Broadway
New York, NY 10007

Editor and project director:
Josep M. Minguet

Designer and art director:
Eva Minguet for Monsa Publications
www.monsa.com

Cover illustration courtesy of Emperpep
Back cover illustrations courtesy of Ame, Emperpep, Ame, Sandra G.H.,
Dat Le, Meago, Harol, M, and Hetiru.

ISBN 978-0-06-242568-3

Library of Congress Control Number: 2015946551

Printed in Spain

First Printing, 2016

CHIBI MANGA

Irresistible!

Eva Minguet

HARPER DESIGN

An Imprint of HarperCollinsPublishers

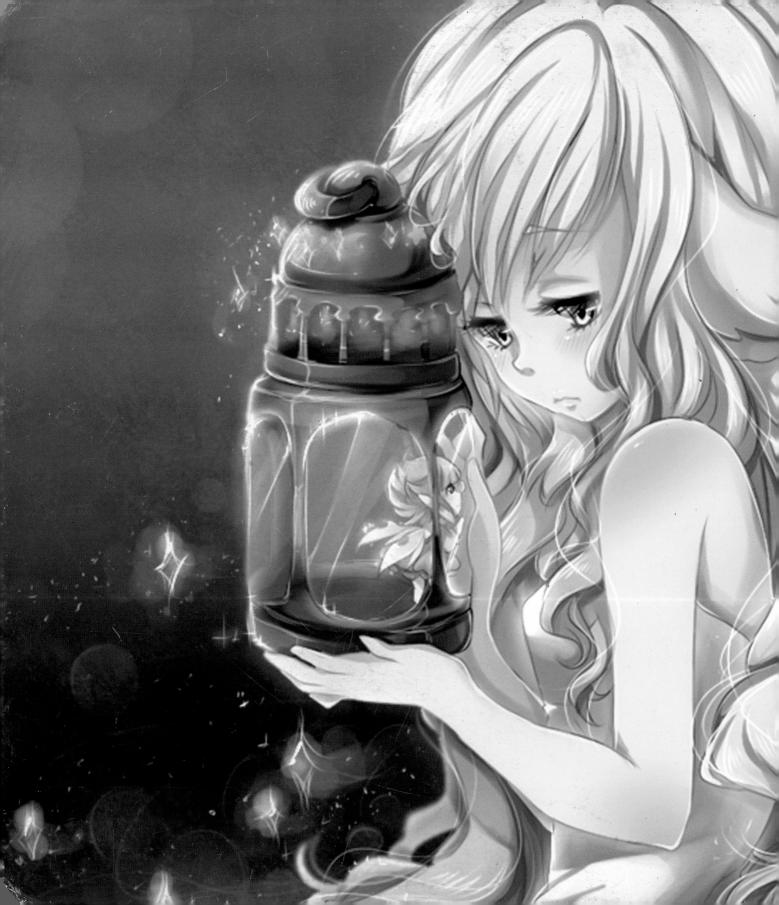

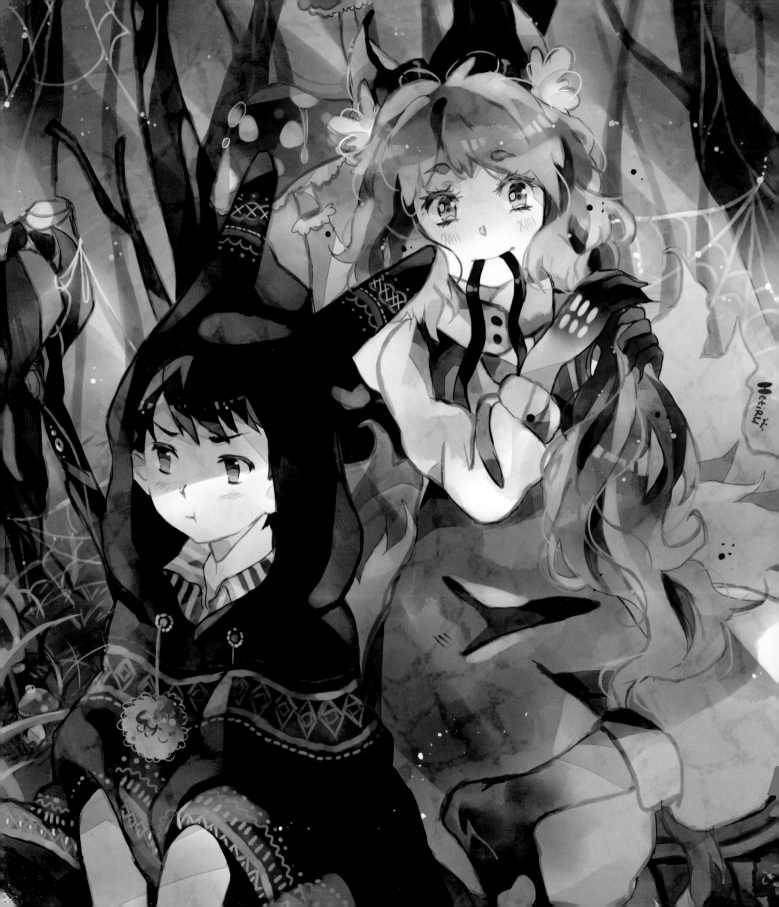

CONTENTS

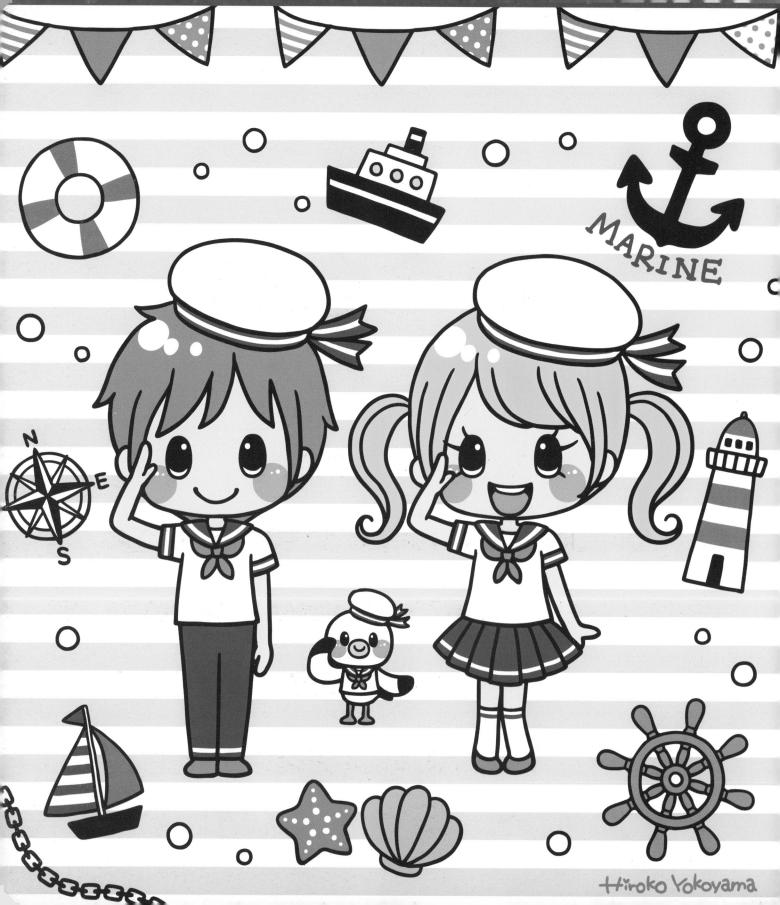

MARINE

Hiroko Yokoyama

INTRODUCTION

- **WHAT IS A CHIBI?**

- **CREATING A CHIBI STEP BY STEP**

- **SOFTWARE THAT YOU CAN USE TO EDIT YOUR WORK**

- **DIGITAL WORKSHOP**

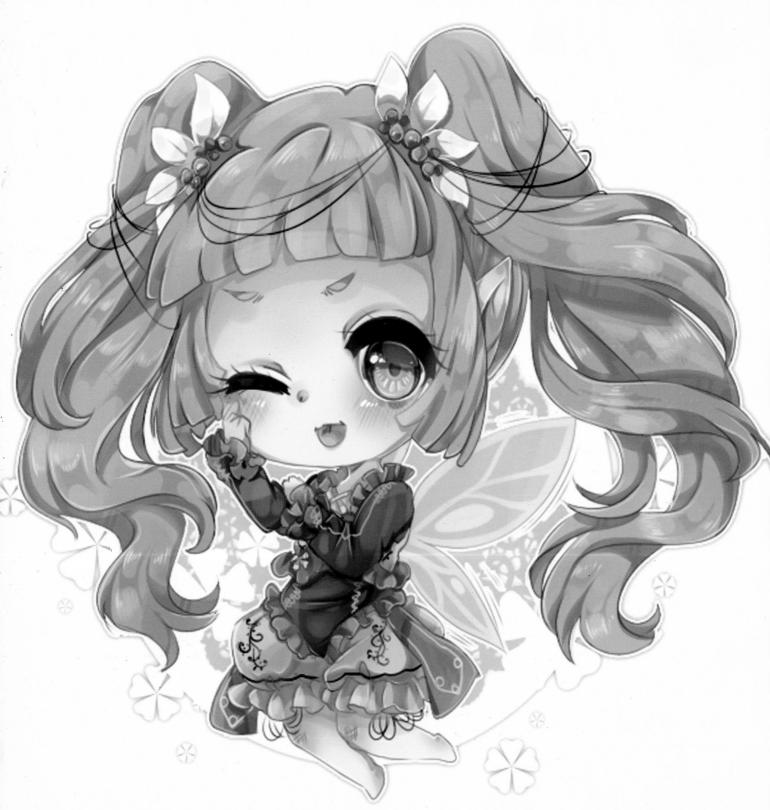

WHAT IS A CHIBI?

From their big bright eyes and chubby cheeks to their childlike cuteness and adorable expressions, it's hard not to fall in love with Chibi Mangas.

The origin of many of popular chibis are the result of creating a child version of adult characters from well-known anime series such as *Sailor Moon*, *Naruto*, *Dragon Ball*, and *One Piece*.

Chibi is a Japanese word from the otaku culture and means "small child." It has since become a popular term used to refer to childlike characters that, in the world of manga illustrations, have very distinctive features: large heads, small bodies, and large, expressive eyes. They're also usually dressed in cute outfits that emphasize their sweet, childlike nature.

In this latest addition to the manga series, you'll discover a practical step-by-step handbook for learning how to draw, illustrate, and digitally enhance these adorable characters. Tutorials range from creating your own chibi fairy princess to chibi mermaids, ghosts, and even a chibi robot. The last chapter is meant as an inspiration and features a gallery of other chibi characters.

Filled with super cute characters created by artists from around the world, this is the perfect guidebook to creating your own collection of sweet chibi manga.

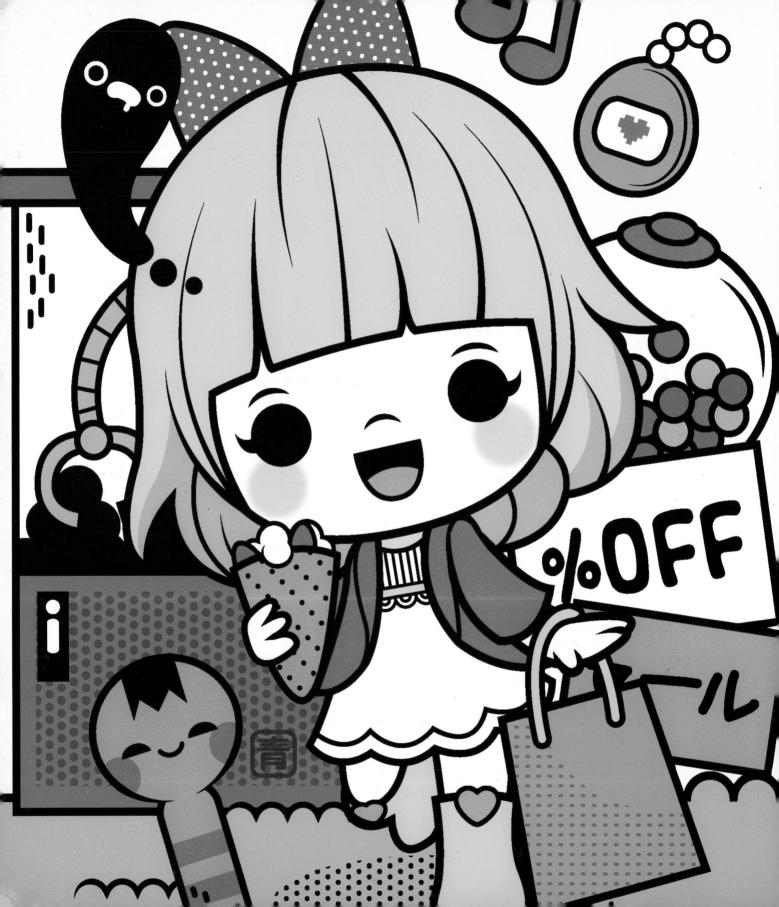

CREATING A CHIBI STEP BY STEP

In this book, you'll find 18 chibi mangas created by artists from around the world. Each artist presents their initial sketches for their character. After picking the one they like best, they'll take it through the following steps as listed below to the finished illustration.

STRUCTURE: preliminary sketch to set up the chibi's stance and proportions.

VOLUME: Using the structure to create the body of the chibi, being sure to make the head larger than the body.

Anatomy: Adding features such as the eyes, nose, mouth, and ears, as well as hair and eyebrows.

Detail: One of the most important steps, this is where you incorporate details such as clothes, accessories, animals, objects, and scenery to help define the personality of your chibi.

COLOR: This step is usually divided into two parts. In the first part, use flat colors to define and differentiate. In the second part, add shadows and highlights to give volume and realism to your characters.

BACKGROUND: This step is also divided into two parts. In the first part, add various decorative elements to the preliminary background drawing to give it a more realistic scene. In the second part focus on applying different textures, in addition to playing with shadows, to give depth and volume to the work.

And finally, **FINISHING TOUCHES** and **TIPS & TRICKS**, where each illustrator indicates some tricks to facilitate and improve the working proccess, and shares the programs used to edit their work.

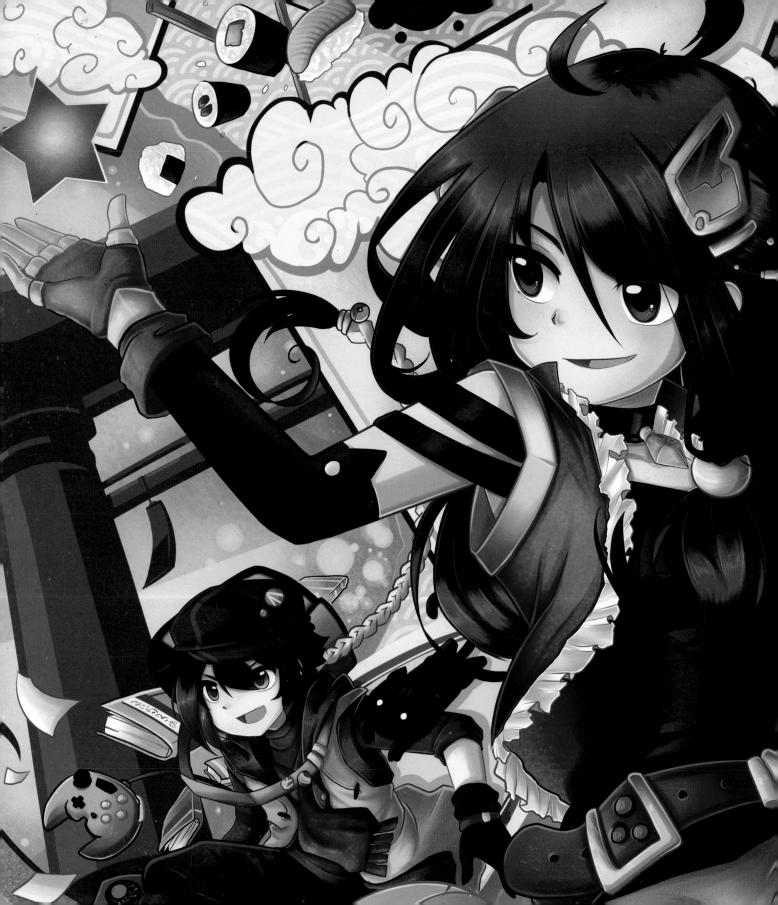

SOFTWARE THAT YOU CAN USE TO EDIT YOUR WORK

Paint Tool SAI: A painting software that is ideal for digital drawings. It is very fast and easy to use. Many of its features have been designed on a tablet.

Adobe Illustrator: This is a more suitable program for technical works and vector drawings. Given its wealth of options, it is presented as a more complex software, but with many more possibilities to edit work through its filters, effects, gradients, brushes, and more.

Adobe Photoshop: The most advanced program that exists today, it has many functions and possibilities to edit your work, including level settings and color, artistic filters, textures, and better management of layers.

Manga Studio 5: Its tools are designed and optimized for the creation of comics. It has items for creating cartoon designs, drawings, inking, application of tones, textures, and creating text boxes and titles.

Clip Studio Paint: This is the standard painting tool used to draw manga. Of the many options it offers, it has evolved to develop not only illustration but color production as well. The paint bucket tool and the automatic selection option are excellent. The transformation of the selected area (free transformation and mesh transformation) is very useful to include multiple layers, even while working with Photoshop.

DIGITAL WORKSHOP

Modern illustrators use a range of digital software, such as PaintTool SAI, Adobe Illustrator, Adobe Photoshop, Manga Studio 5, and Clip Studio Paint. These programs aid the creative process and can be used to achieve flawless results.

SCANNING

Most scanning software have controls to adjust an image's curves and color balance.

Always scan the highest-quality original. You should not choose a higher interpolated resolution, but you can use a high standard resolution and higher bit depth. Most scanners use twenty-four or forty-eight bits to capture color information. This setting determines how the scanner will set the color of a particular pixel. Old scanners with fewer bits could interpret a pixel with a red hue from a total of two hundred tones; newer scanners with more bits can interpret a pixel among four thousand tones of red. Therefore, the higher the bit depth, the more accurate the colors.

Adjust lighting levels so the picture looks good. Increasing the contrast can improve the image.

Once you have scanned the image, import the .PSD or .TIFF file into a digital editing program to start the coloring process.

APPLYING COLORS AND FINISHES

Before you start coloring, decide what colors you want to use and where to place the light source for shadows.

Based on the background layer, which is the scanned image, transform the colors to RGB, eight bits per channel.

To begin the coloring process, I first use Multiply mode to create different layers. In each layer, color part of the work—face, clothes, hair, and details. In the Color Picker, create all the colors needed for the work, and with the help of a brush, color your drawing—trying to stay in the lines—by layers, according to the selected color.

To create a new layer in Illustration mode, draw over all the lines of the original drawing with a brush, using the black color at 40 percent opacity. Then use Multiply mode to select the layers created, excluding the background layer, and combine them.

To get a more natural color finish, use different tools, such as textures with different intensities, to create depth. You can also use different opacity values.

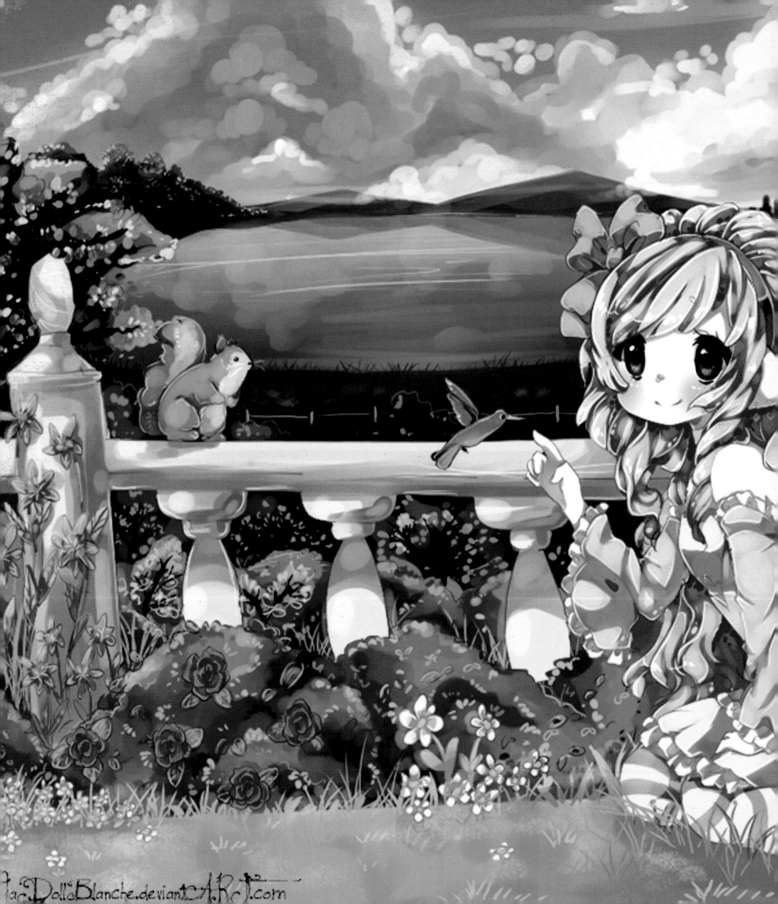

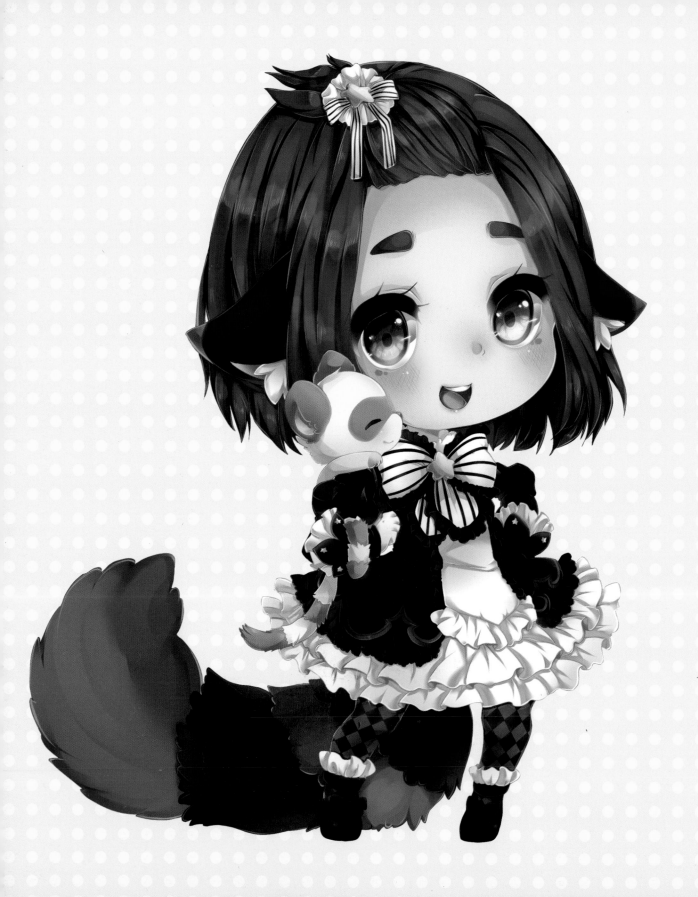

SUPER CUTE

RACCOON GIRL

MINA

TORII GIRL

PLAYROOM

BLUE MOON

RACCOON GIRL

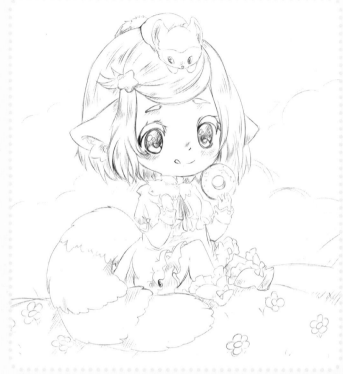

Esther is a little raccoon girl. She is friendly and polite. She loves to gaze at the stars with her friends and eat delicious sweets. She also has a little pet lemur that follows her everywhere.

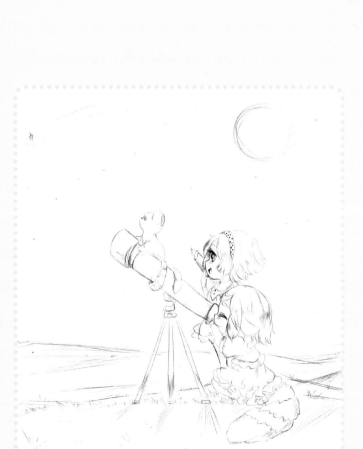

1. SKETCH

After placing Esther in a few different scenes, the artist chose to sue the drawing of her on a stage holding her lemur pet.

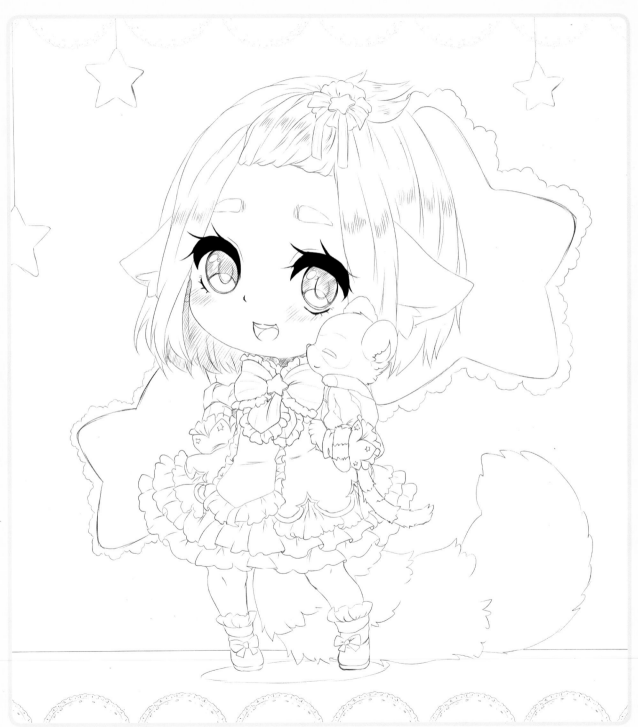

2. STRUCTURE

Draw Esther in a cute dynamic pose to make her look more lively.

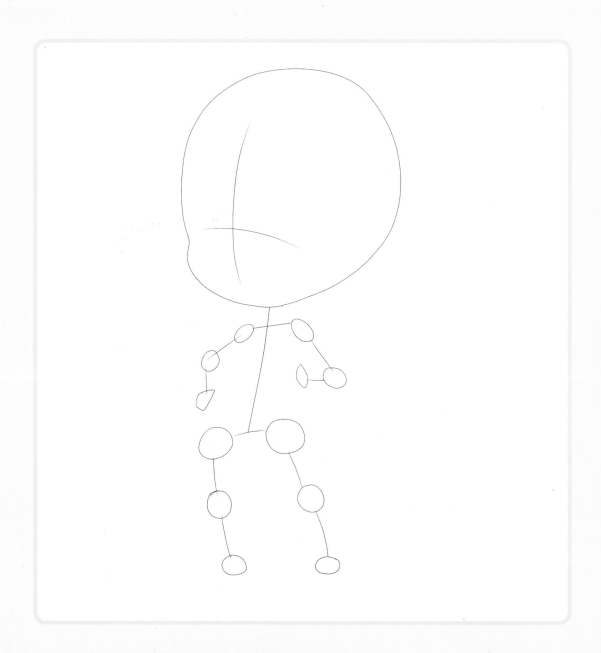

3. VOLUME

Add her eyes, her mouth, and a small spot for her nose. Use thin lines to outline her body and thick lines for her eyes. This draws the focus to her large, beautiful eyes.

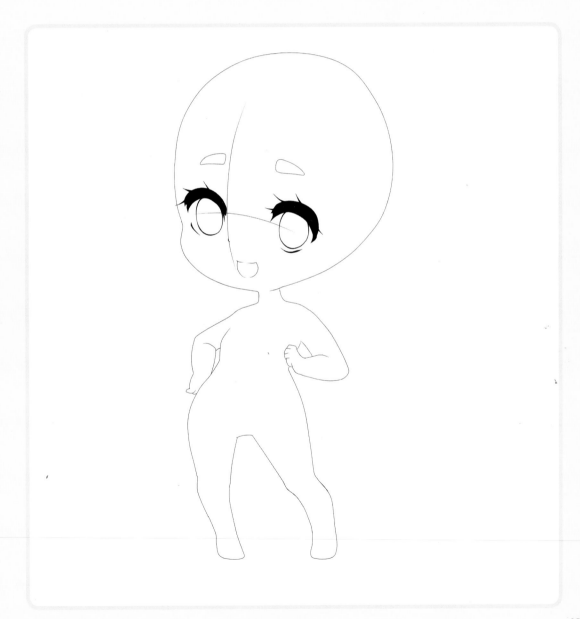

4. ANATOMY

Add her ears, a cute hairdo, her pet lemur, and her raccoon tail. The artist placed the lemur snuggling under her chin to show how much she loves her pet.

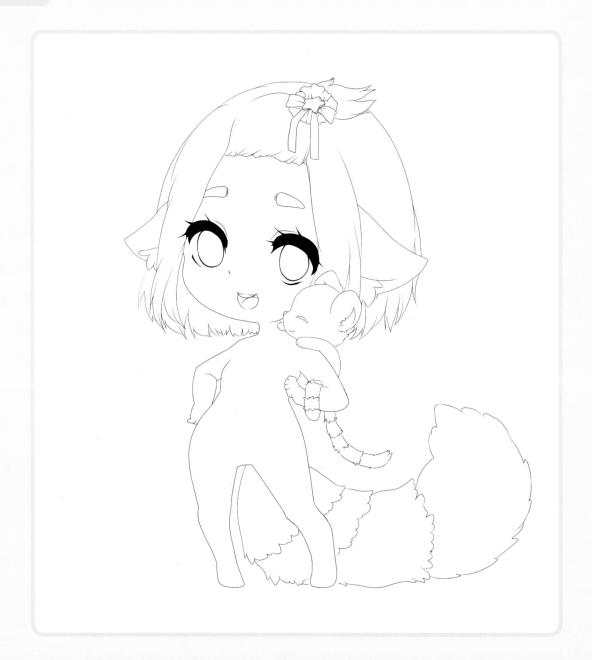

5. DETAILS

To give her more dimension, add details to her hair and give her a cute outfit, like a frilly Lolita dress, to match her personality.

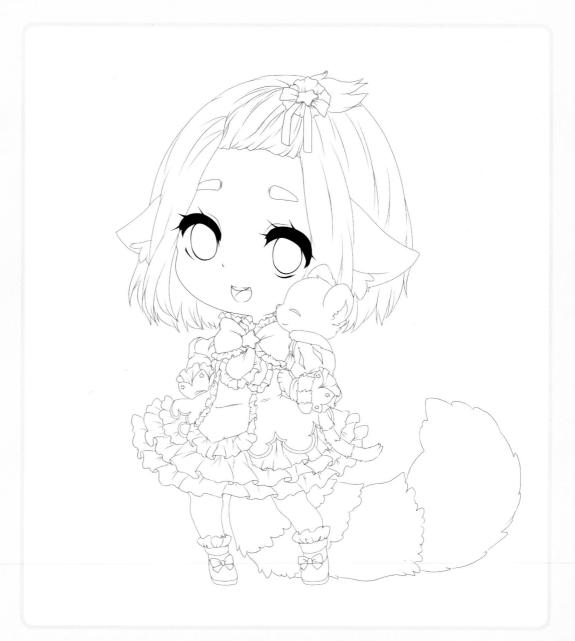

6.1. COLOR

Color in Esther and her pet lemur. Be sure to pick a color for her eyes that stands out.

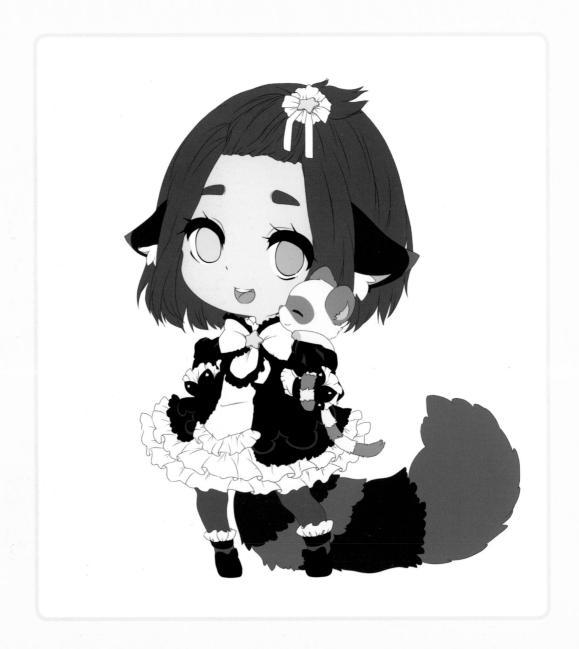

6.2. COLOR

To add depth to the character, use patterns on her tights and ribbons. Use a solid brush tool to create shadows and highlights.

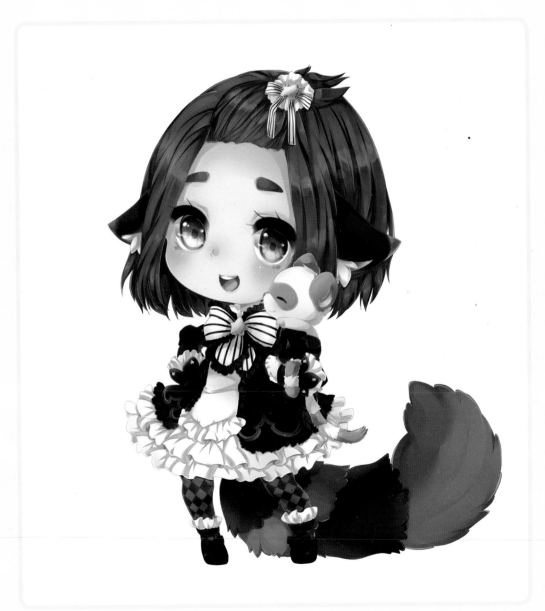

7.1. BACKGROUND

The background is a diamond pattern with gold stars to match the diamond pattern on her sock and the star in her ribbon.

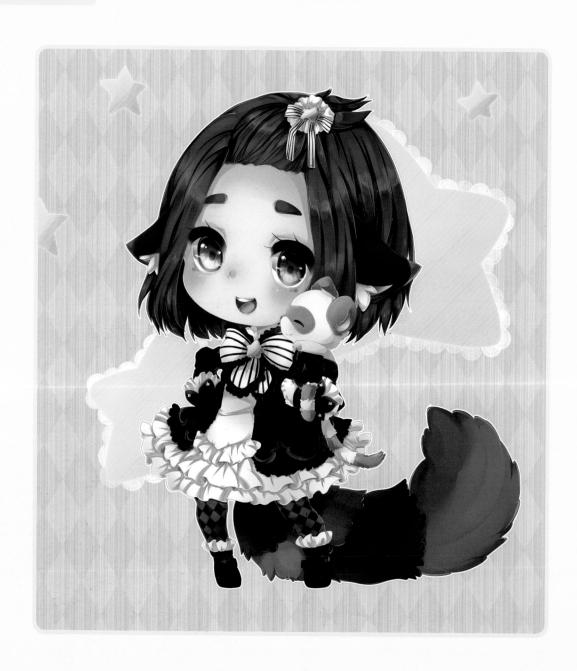

7.2. BACKGROUND

Create some half transperent white and violet stars, and complete the outlines of some of them.

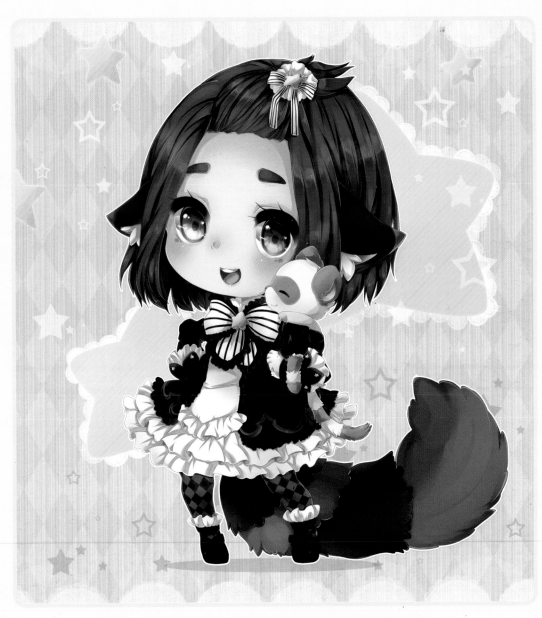

8. FINISHING TOUCHES

Lastly, combine all the individual layers into one layer and use Photoshop to explore different effects you might want to add.

TIPS & TRICKS

- Draw a white outline around the character to make her stand out from the background.

- Photoshop color effects, such as brightness and contrast, make the picture look more saturated.

- Software used: Adobe Photoshop.

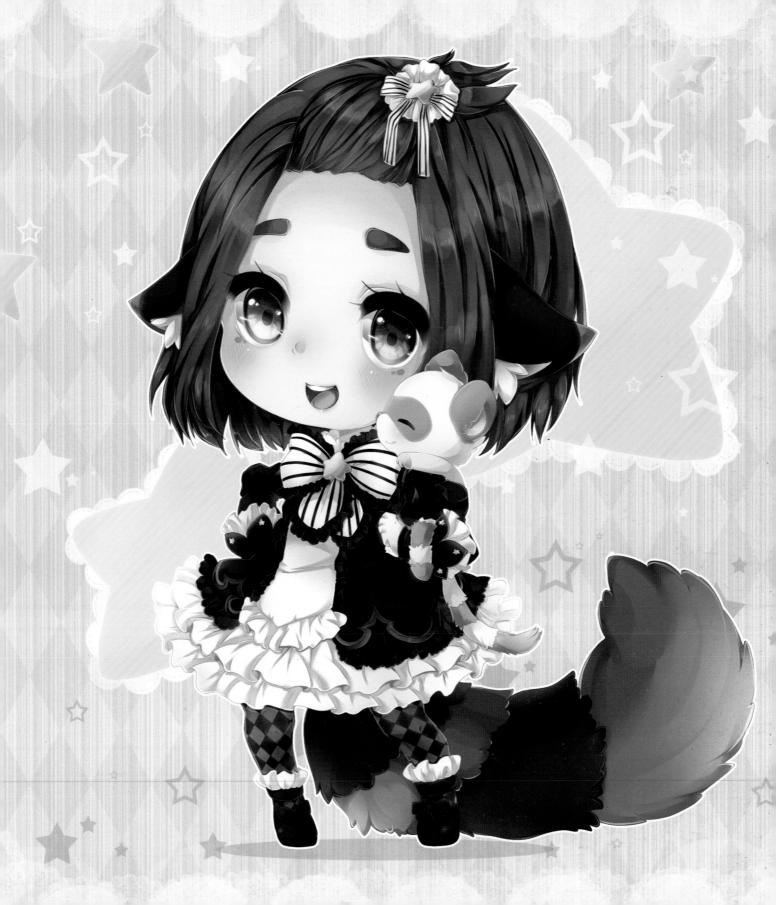

MINA

Mina is a typical teenage girl who enjoys spending a lot of time on the internet, playing games while eating sweets.

In spite of that, she has pretty good grades at school, since her father is a professor. He would do anything for Mina. She is a daddy's girl.

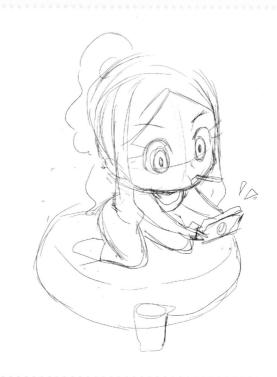

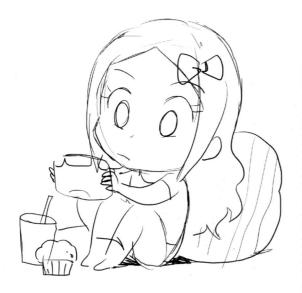

1. SKETCH

Let's draw Mina doing what she likes most, playing games on the internet.

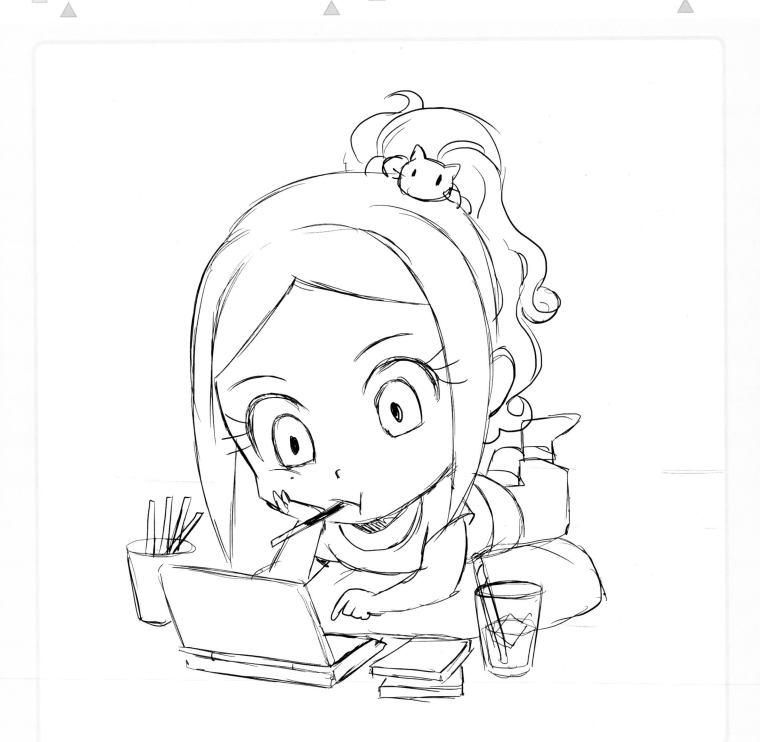

2. STRUCTURE

Draw the shape of the body and leave some space for various items like food, laptop, and other tools like pencils and pens. Draw her in lounging in front of the laptop.

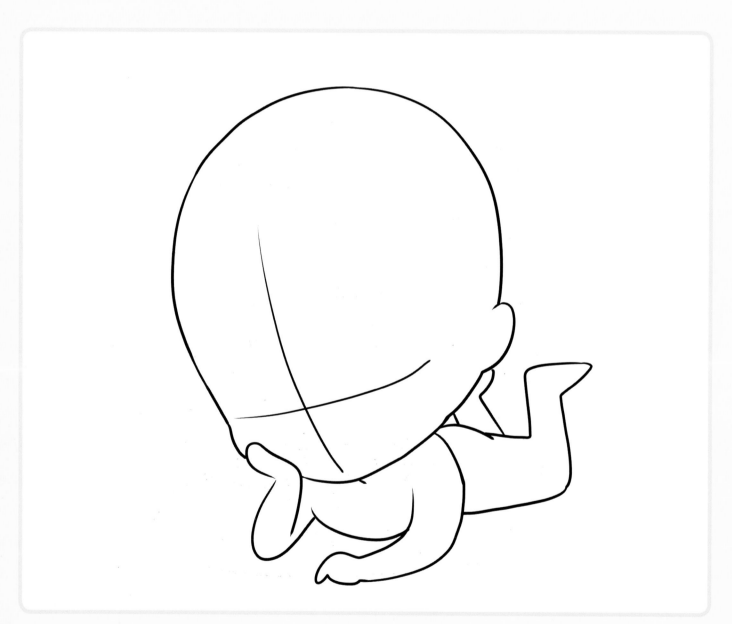

3. VOLUME

Add a big pillow underneath her and give her hair and facial features such as eyes, eyebrows, and a nose.

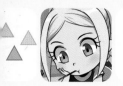

4. ANATOMY

We have to create some foreshortening here, by using round-shaped structures to draw bust and hips more or less in the right place.

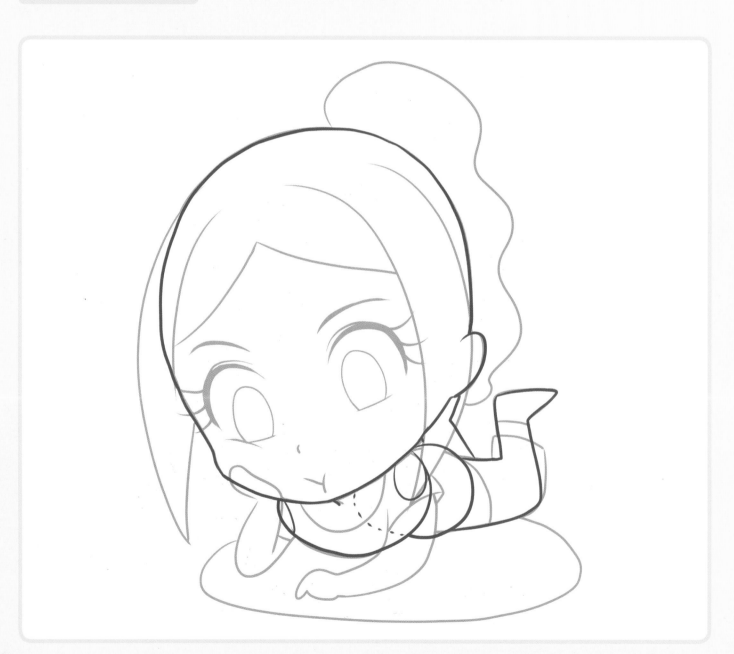

5. DETAILS

Now it's time to add details to her, such as a laptop, food, and some games. Also add more details to her face, hair, and accessories. Note the water glass is transparent, so leave some thin lines on the pillow, but erase slightly to indicate transparency.

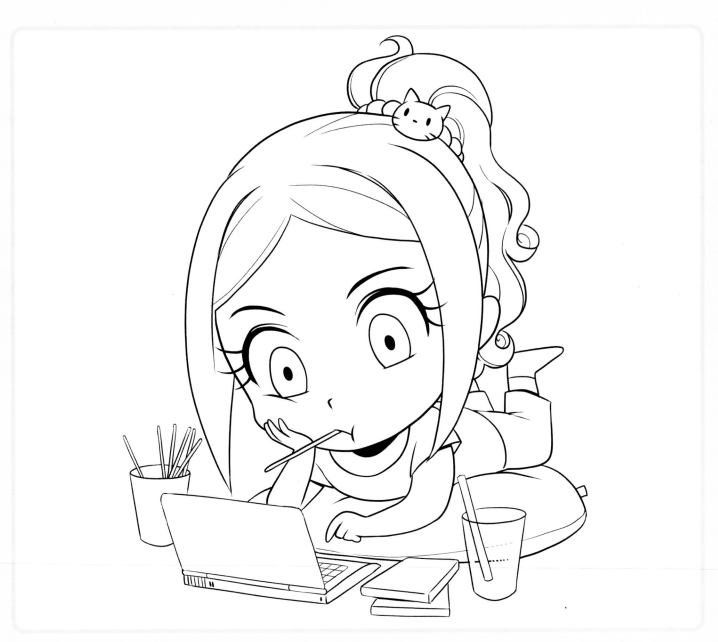

6.1. COLOR

Feel free to use basic colors: we will complete the decoration later.

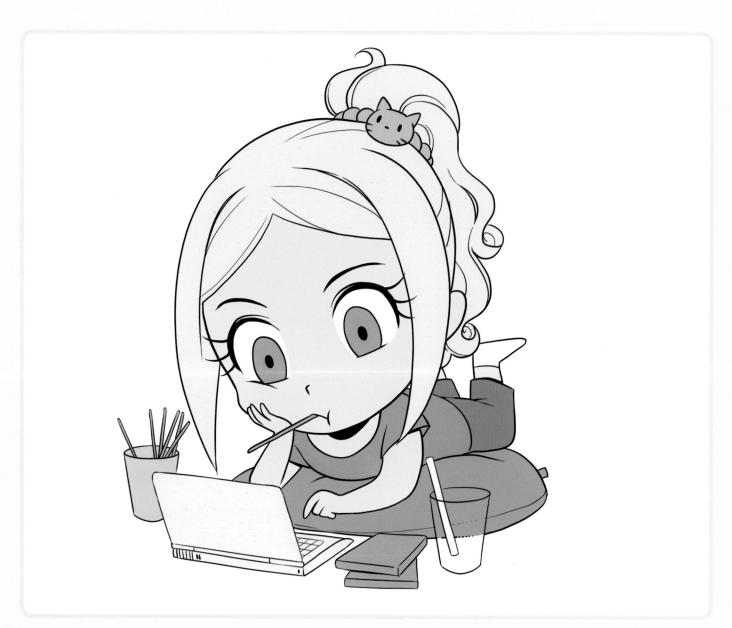

6.2. COLOR

Explore with highlights, shadows, and some more color details like blushes, game box covers, ice cubes, etc.

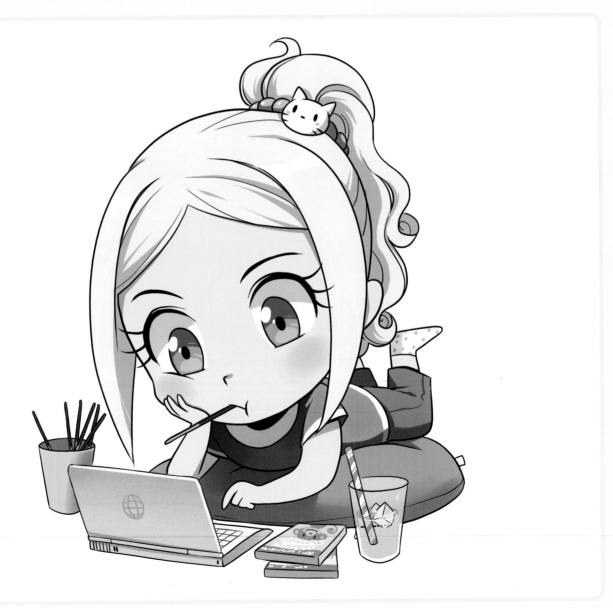

7.1. BACKGROUND

The background the artist chose to put the character in is her room. Draw the room corner so the picture appears less flat.

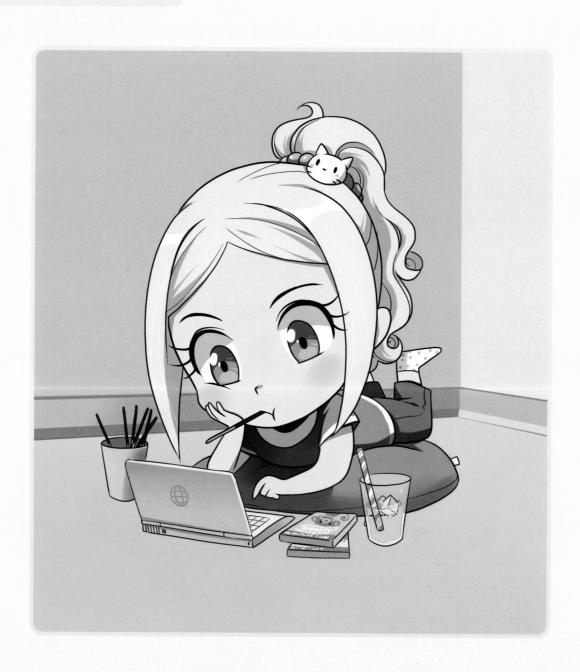

7.2. BACKGROUND

Then add texture to the carpet (use the "soft light" layer mode in Photoshop), and some stripes on the walls, so that they are not too empty.

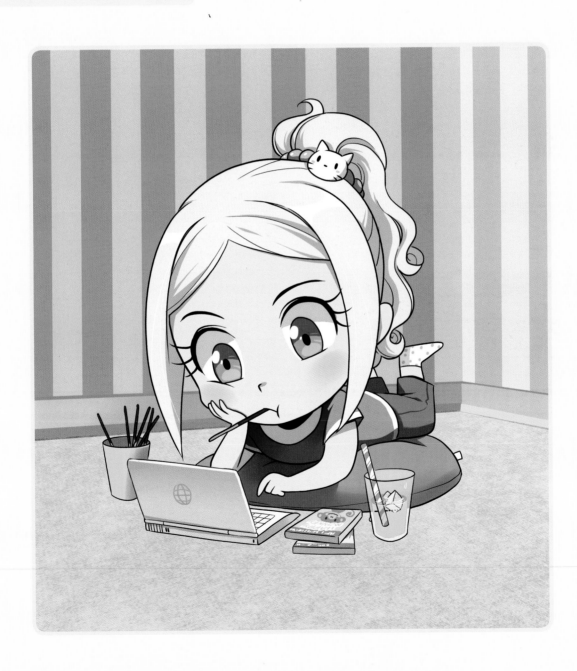

8. FINISHING TOUCHES

In the end, you can explore with shadows on the floor, add details like crumbs on the pillow, or music notes . . . and it's done!

TIPS & TRICKS

- For the drink, in order to make it look transparent use a small opacity when coloring it in.

- Add a bubble with a music note to suggest the laptop is making noises.

- Software used: Paint Tool SAI & Adobe Photoshop.

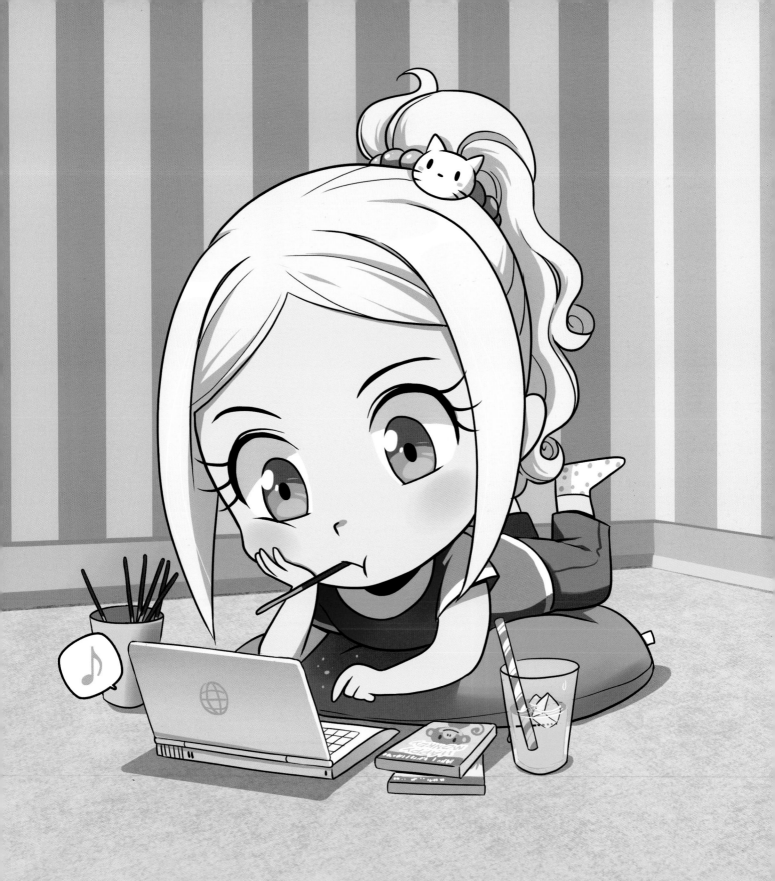

 # TORII GIRL

Torii Girl is a tourist visiting Japan. She enjoys exploring Japanese temples and has many spiritual friends.

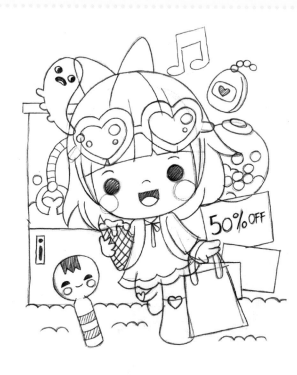

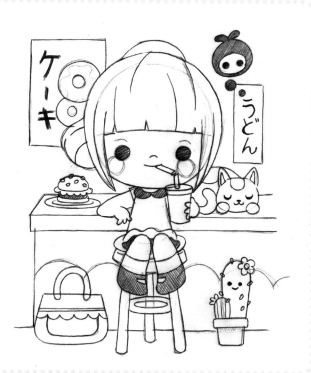

1. SKETCH

After initial sketches, the artist chose to place Torii Girl standing outside a Japanese temple with friendly spirits flying around her.

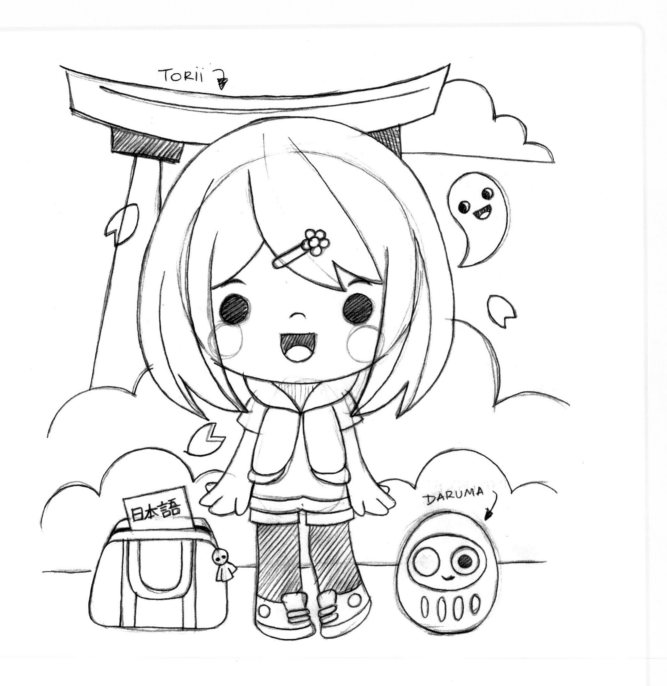

2. STRUCTURE

Draw the basic form of the girl and place her in the middle of the canvas.

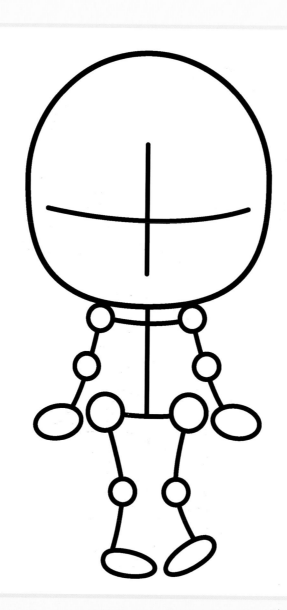

3. VOLUME

Next, add her eyes and smiling mouth, and fill out her body, being sure to keep the proportions of her body smaller than her head.

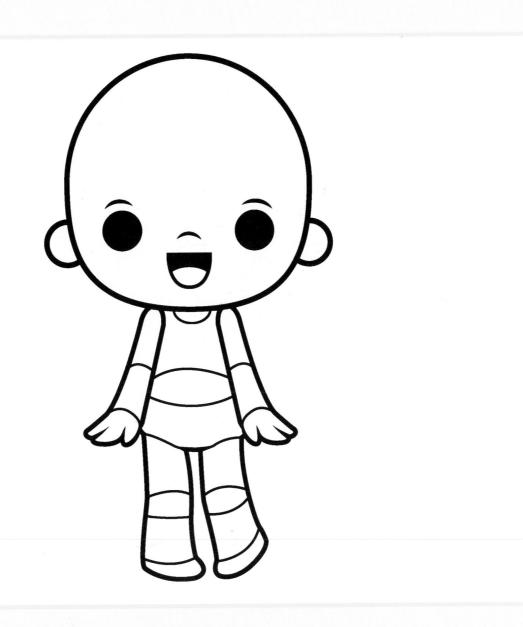

4. ANATOMY

Give her a cute hairdo and add other elements to the scene, including a few spirits and her bag.

5. DETAILS

How old is the character? What kind of clothes is she wearing? These details help to finalize the drawing conception. The artist chose to dress her in a comfortable outdoorsy outfit. Add a detail in her hair, giving it a sweet and youthful touch.

6.1. COLOR

In this case, a limited color palette was chosen even before starting the sketches. Having only a few preset colors, you have to explore the tone and contrast between them, and as a result you get a much cleaner and unified image.

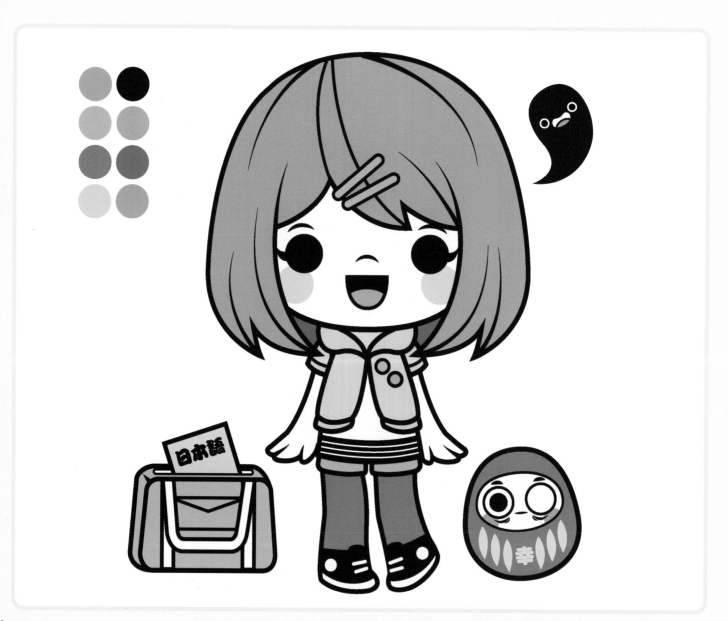

6.2. COLOR

Apply a soft shadow to the hair to give it depth and volume to the shape of the head, and give her pink cheeks to make her look younger and sweeter.

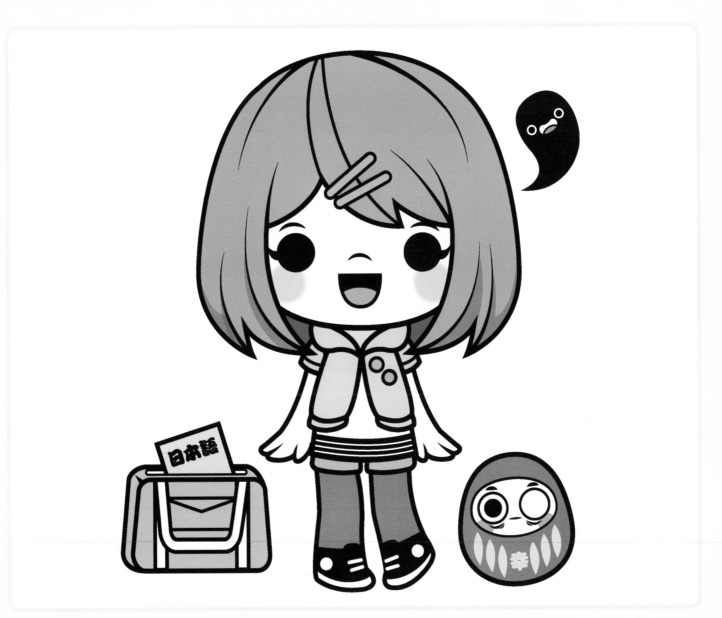

7.1. BACKGROUND

The background is essential in order to know where the character is. Although usually left for last, designing the background is no less important. Use darker colors on the background so that the lighter colors used for the girl will pop and stand apart.

7.2. BACKGROUND

By applying patterns and textures, our image gets extra value. Use different color little circles to separate the objects in the back from the objects in the front.

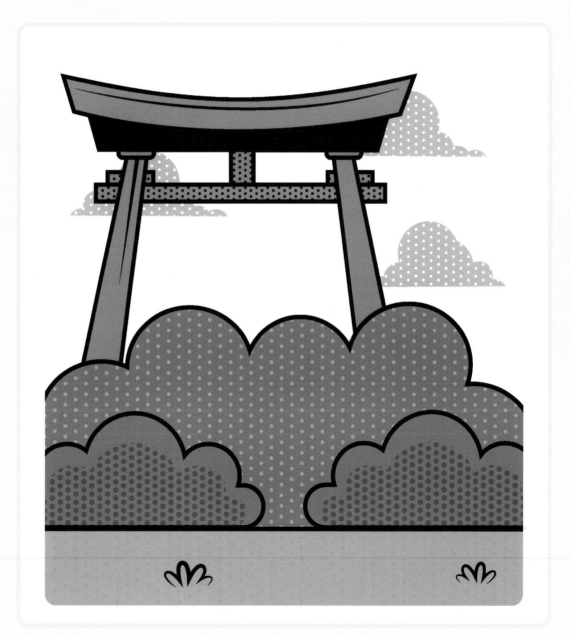

8. FINISHING TOUCHES

By using flat colors without shadows or highlights, the dot pattern works to give depth and texture to the different elements in the image.

TIPS & TRICKS

- Enlarging or shrinking the dots gives more diversity to the image. You can always use the same dots, but by changing the colors of the dots and their size they then serve to add contrast.

- Use a thicker line around the character to make her stand out.

- Apply a slight blur effect to soften the hard vectors.

- Software used: Adobe Illustrator & Adobe Photoshop.

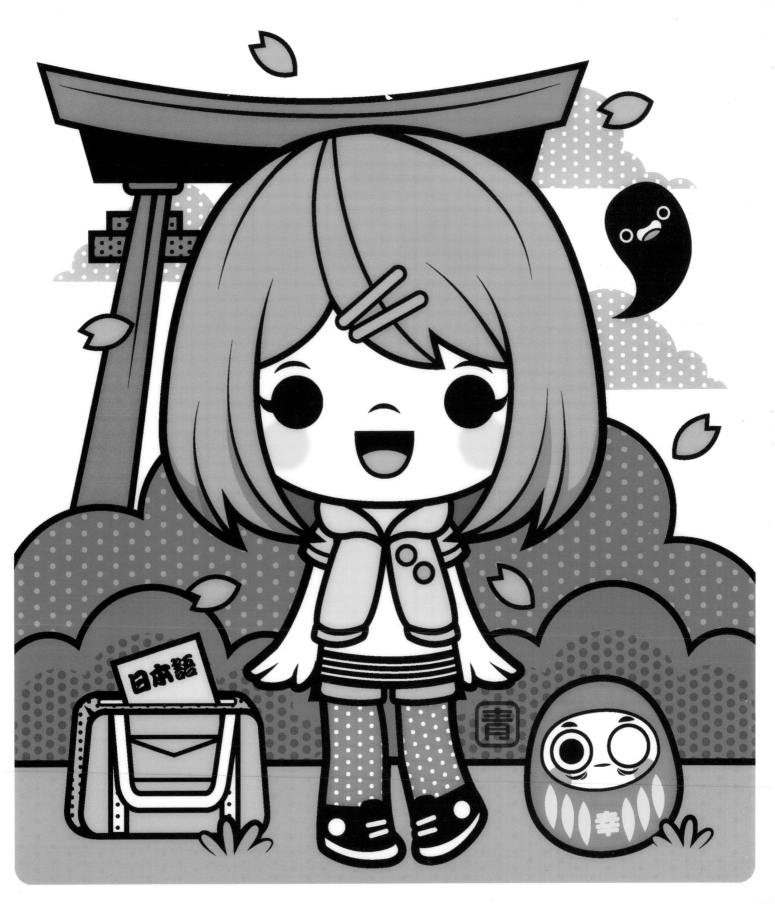

PLAYROOM

Little Lisa is having fun in their playroom. She is a cheerful and very imaginative girl, with her rocking horse and toy playmates she has great adventures without leaving her room.

1. SKETCH

Let's select the sketch on the rocking horse, because it allows us a wider perspective of the character and its environment.

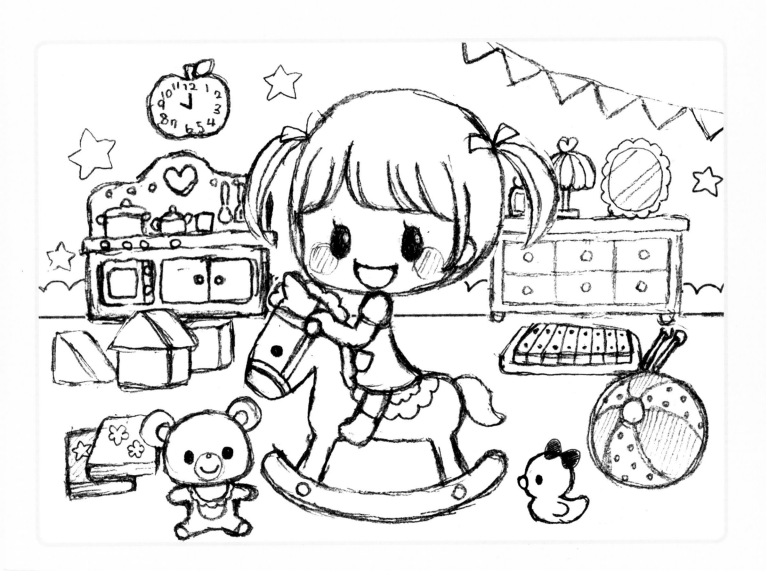

2. STRUCTURE

Place the character on top of the rocking horse with her toy friends in the center of the illustration. Make sure to curve her leg slightly and bend her arm to show she is riding the horse.

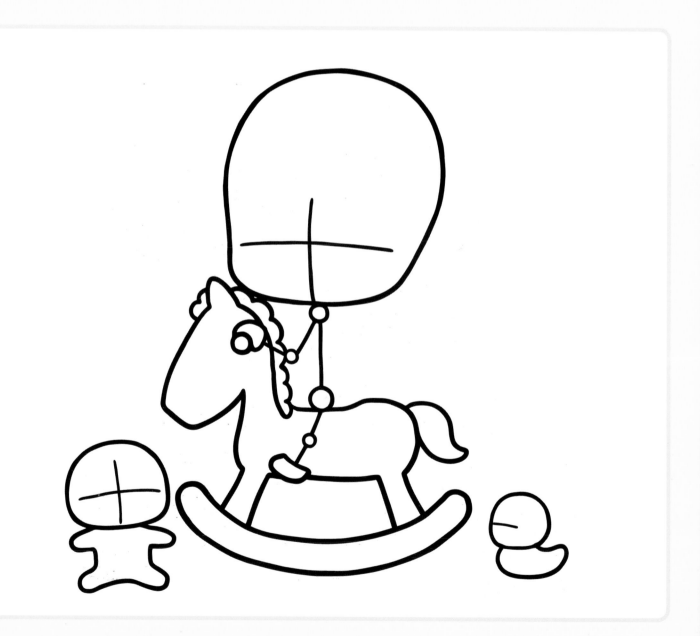

3. VOLUME

Draw the girls body and her hair. Next create the bodies of her friends.

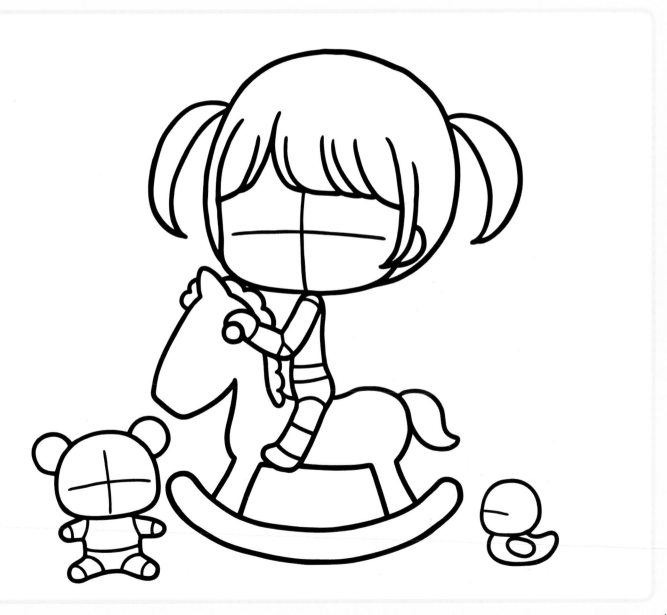

4. ANATOMY

Add eyes and mouths to the character and to her little friends. Make the eyes and mouth occupy most of her face.

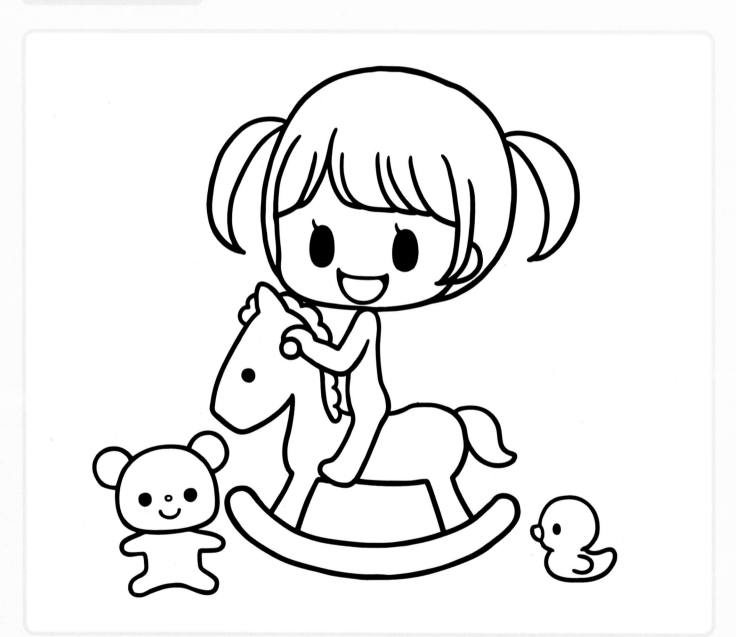

5. DETAILS

Next, add her dress, bows to her hair, and a harness to the rocking horse. To give the scene the look of a child's playroom, include more toys like a ball, cubes, and books.

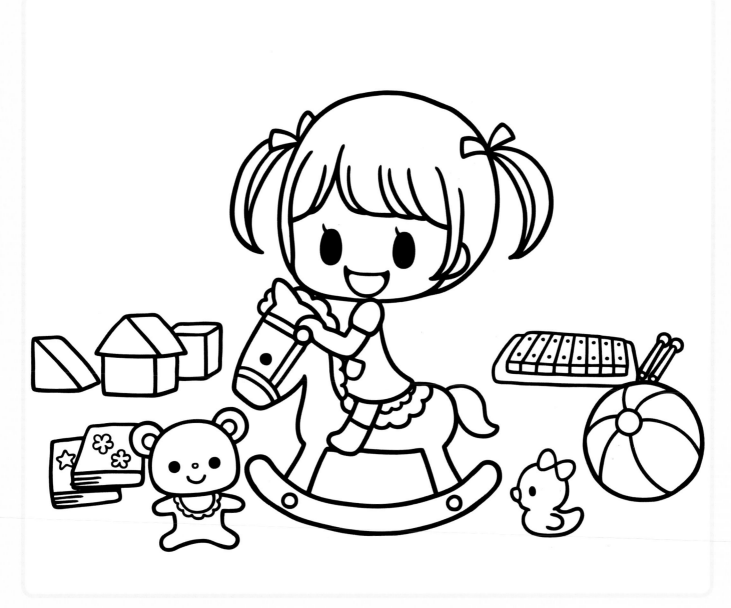

6.1. COLOR

The colors chosen are predominantly pink, and all have a warm hue.

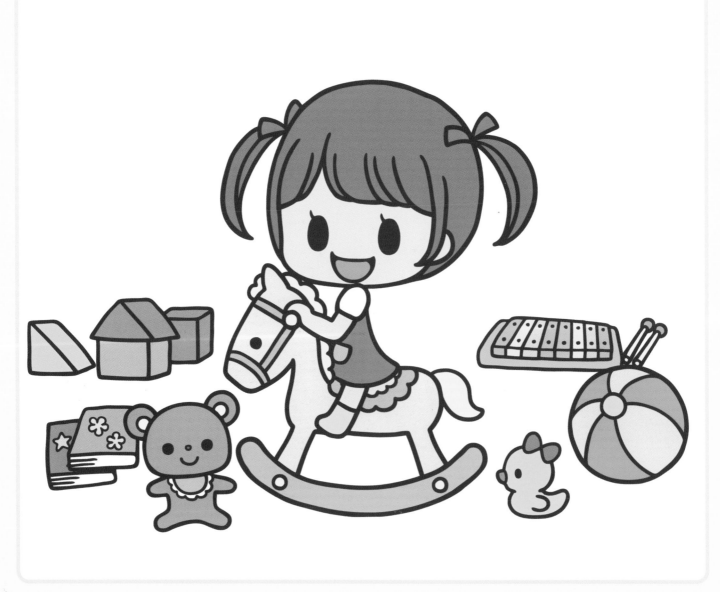

6.2. COLOR

Apply white spots to the eyes and the hair to give more depth. Use other colors to give texture and more detail, such as pink to her cheeks, yellow to the bear, and polka dots to the ball.

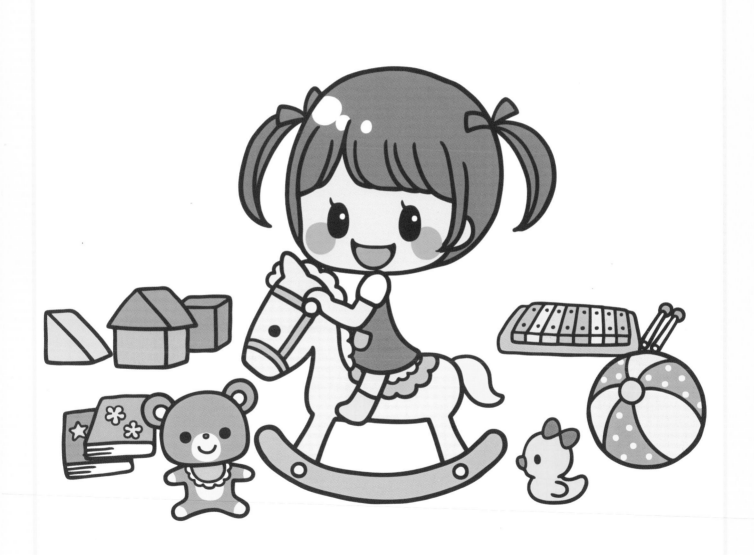

7.1. BACKGROUND

To complete the playroom, create a fun background with toy furniture and soft pastel colors.

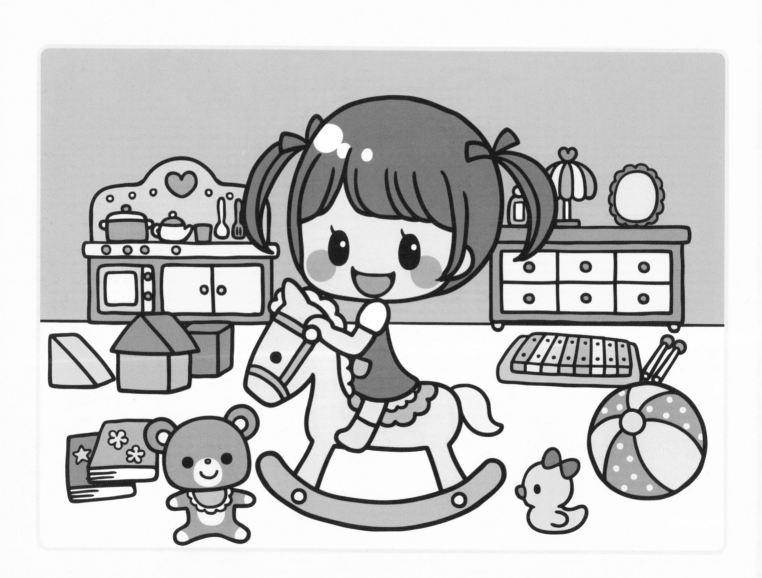

7.2. BACKGROUND

Decorate the wall with different stars, flags, and an apple, which later will be transformed into a wall clock. The idea is to create a fun environment for the character.

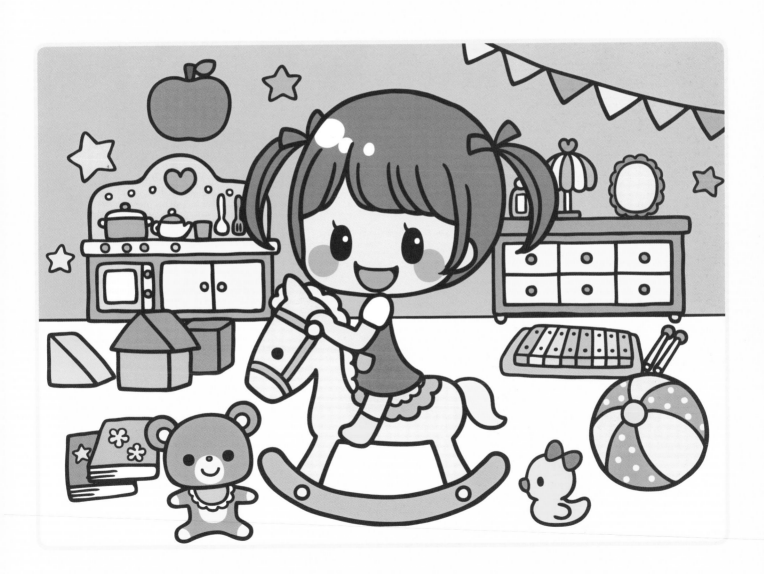

8. FINISHING TOUCHES

Fill in the flags with details such as stripes and polka dots. You may also want to add an embellishment to the wall such as thick stripes and clouds along the bottom edge.

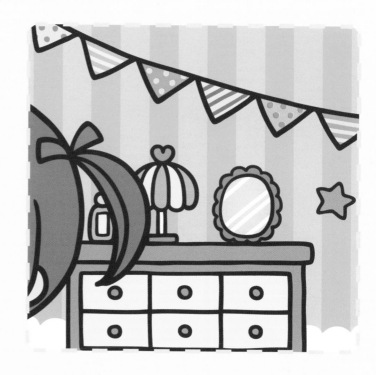

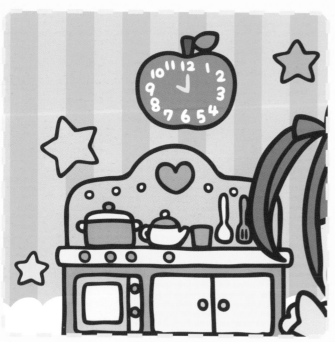

TIPS & TRICKS

- Don't forget about the apple clock. Add numbers and hands to the inside.

- Softer pastel tones give the whole of the illustration a warmer, more childlike appearance.

- To delineate the character and objects in the room, a thick brown outline is applied. This also helps when it's time to start coloring.

- Software used: Adobe Illustrator & Adobe Photoshop.

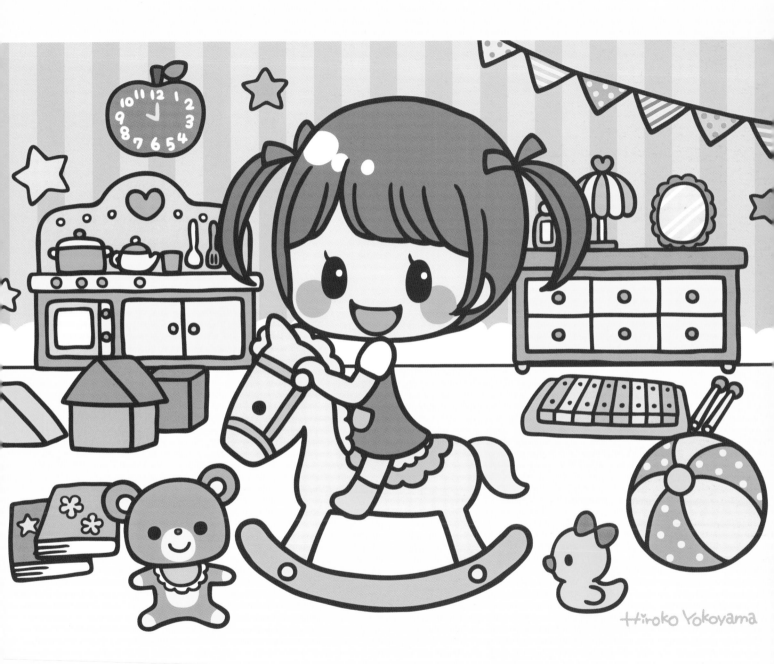

Hiroko Yokoyama

BLUE MOON

Luna loves to look up at the stars at night and study the constellations. She dreams of one day becoming a great astronaut so she can get a closer look at them.

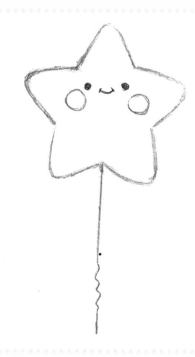

1. SKETCH

Once you create a sketch you like, you need to scan it and make whatever adjustments are needed in order to begin illustrating it digitally. For this exercise, the artist chose a sketch of Luna sitting in the moon and surrounded by stars.

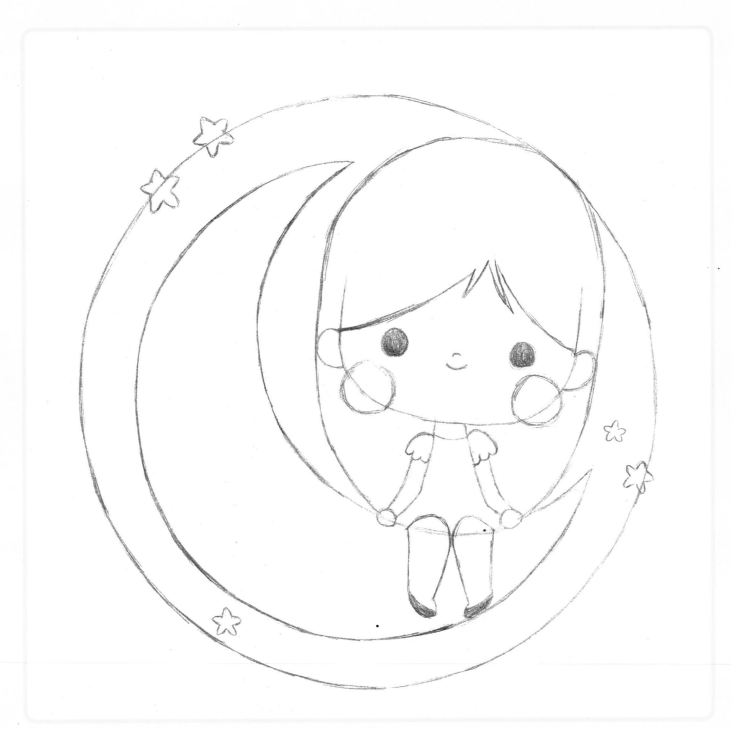

2. STRUCTURE

Use the sketch as a guide to mark some structural points on the main character, and also to finish building it and analyzing its relationship with the rest of the elements of the illustration.

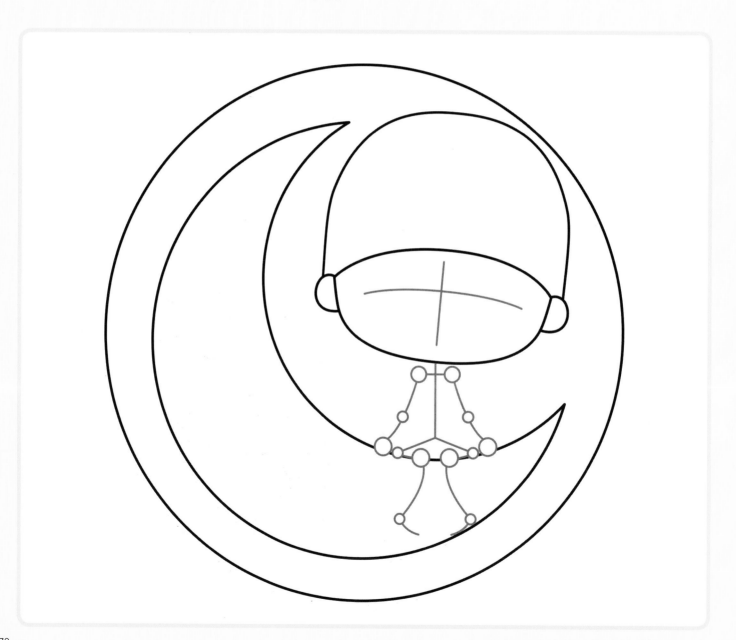

3. VOLUME

Next, use the guide marks to create Luna's body.

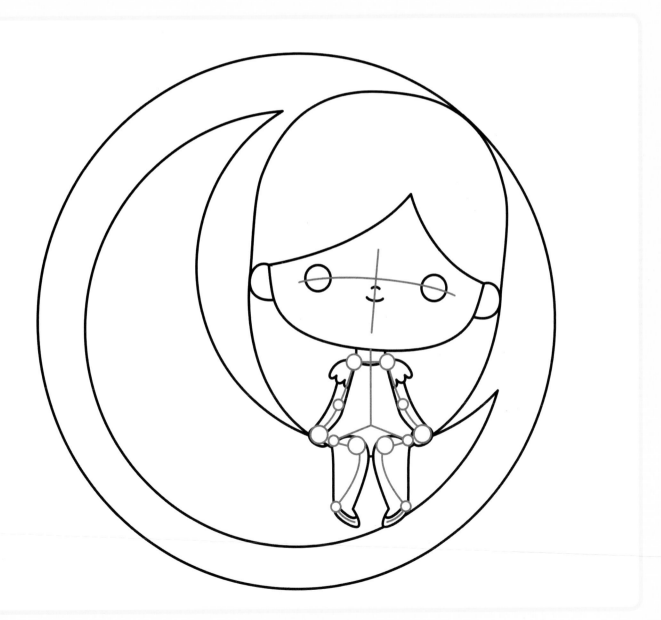

4. ANATOMY

Once the illustration is digitized, some modifications are made to the main character in order to convey through her expressions and proportion specific characteristics. In this case, a happy little girl surrounded by the stars she loves.

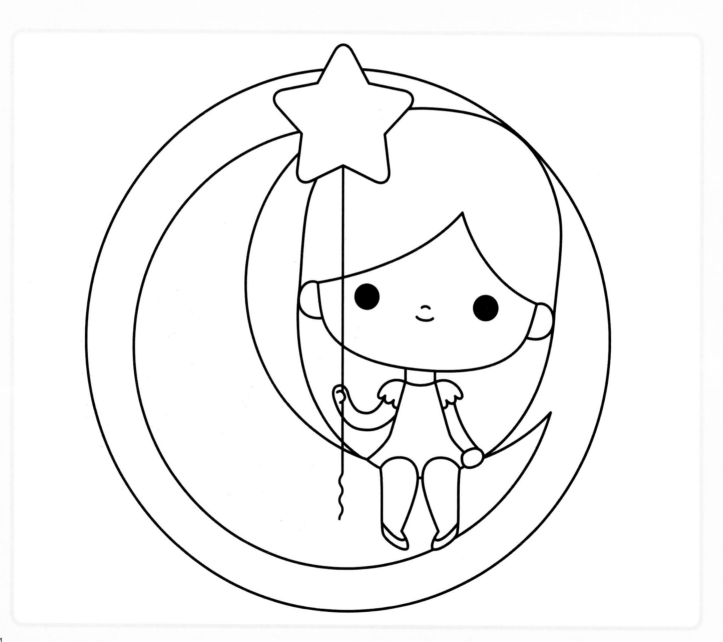

5. DETAILS

Add a number of different size stars to the background and a face to Luna's star balloon. Two circles are added to her cheeks to make her cuter.

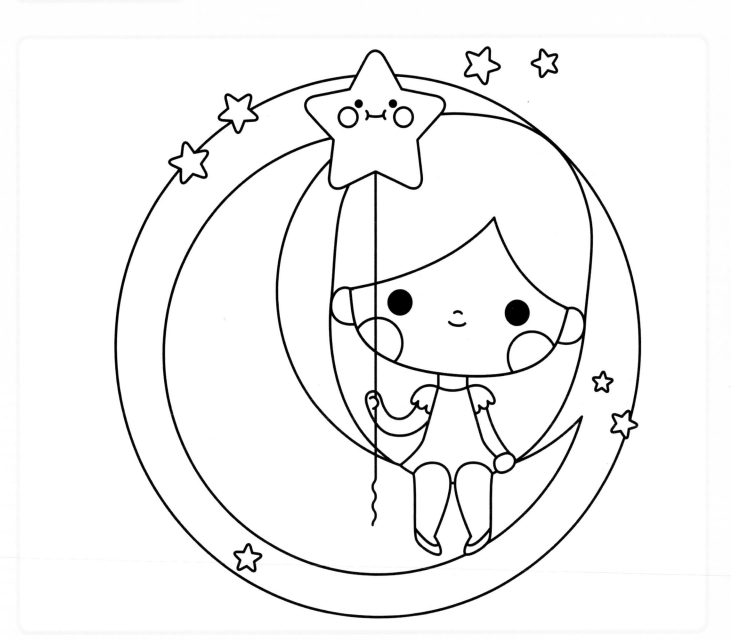

6.1. COLOR

Combine different tones of violet and pink to give the illustration a more delicate and feminine look. Don't forget to color in the cheeks of both Luna and her star balloon.

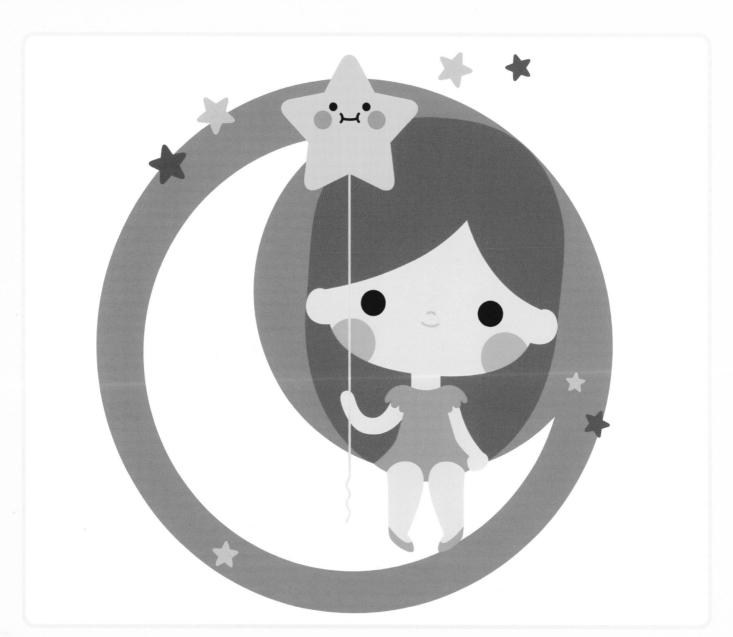

6.2. COLOR

Apply some very soft spots of purple to the moon to give a more lunar look. Then, blur the pink cheeks of the star and the girl to make their cheeks appear rosy.

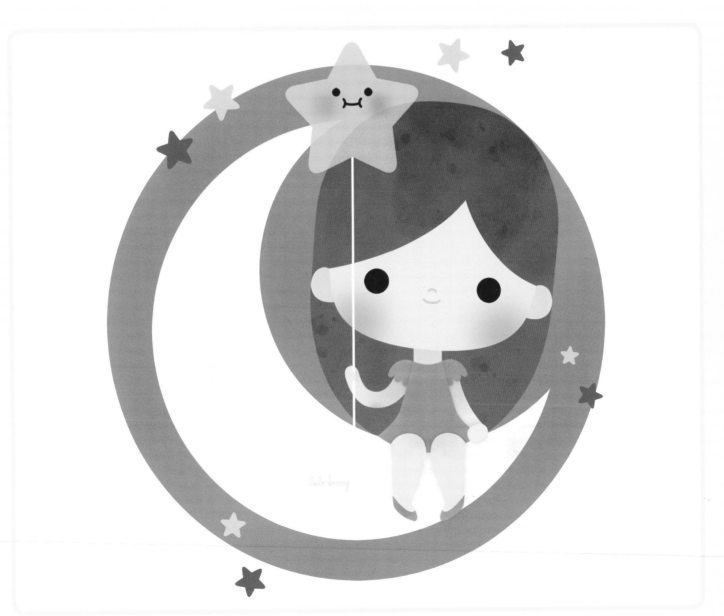

7.1. BACKGROUND

The artist chose a crescent-shaped moon for Luna to sit on and a circular element behind it to frame the image.

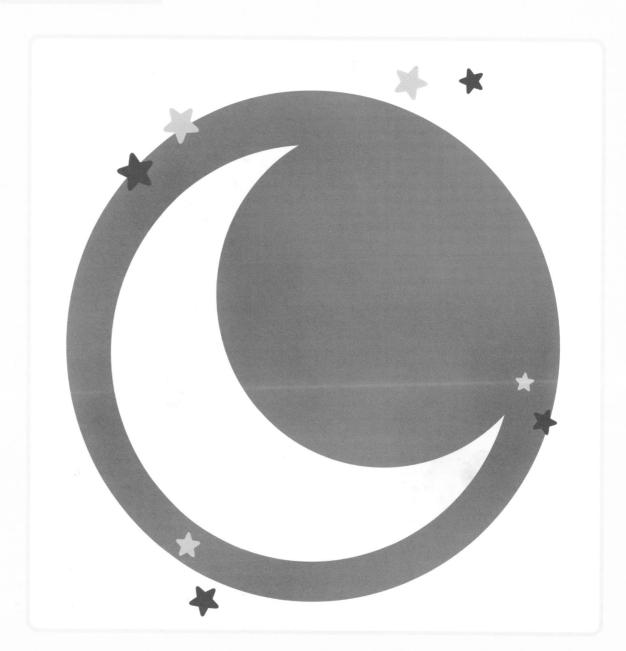

7.2. BACKGROUND

Place the girl beside her balloon, sitting on the crescent as if it were a swing.

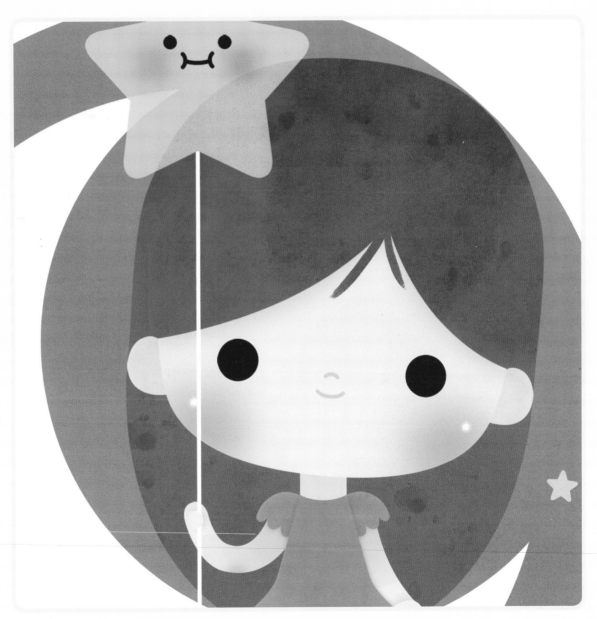

8. FINISHING TOUCHES

Focus on the hair area, draw a couple pieces of hair on her forehead to give some movement to the hair, and apply tiny transparent white dots to her cheeks as highlights to give her more depth.

TIPS & TRICKS

• Do not forget to do a few color proofs in the color step until you find the colors that best suit the image.

• If you are looking for a less vectorial result, it is important to sprinkle some specific areas to soften details.

• Software used: Adobe Illustrator & Adobe Photoshop.

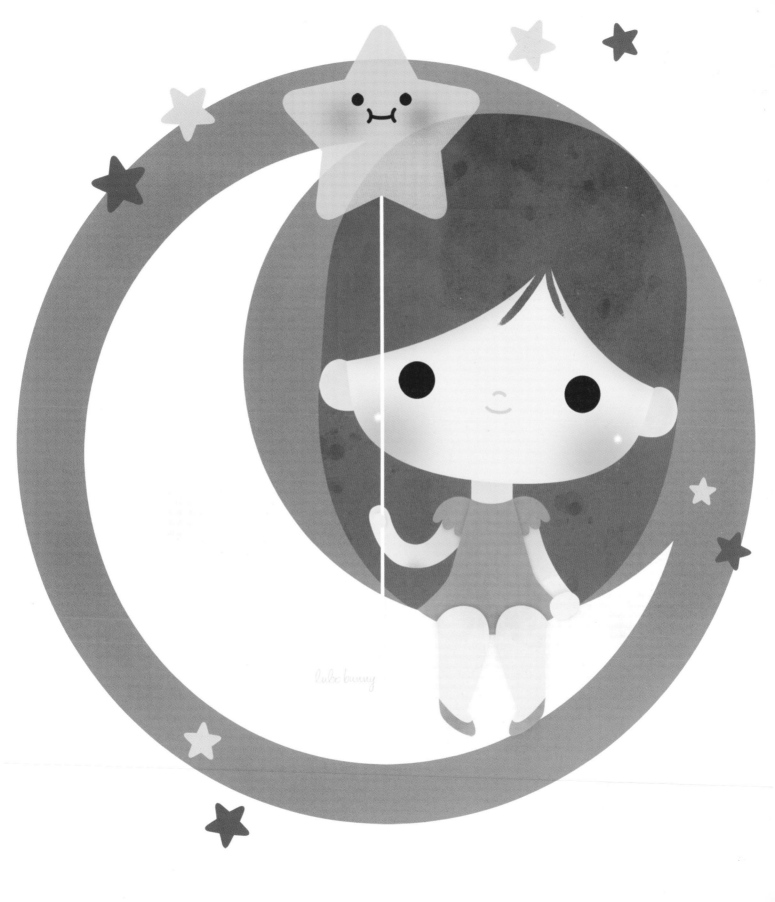

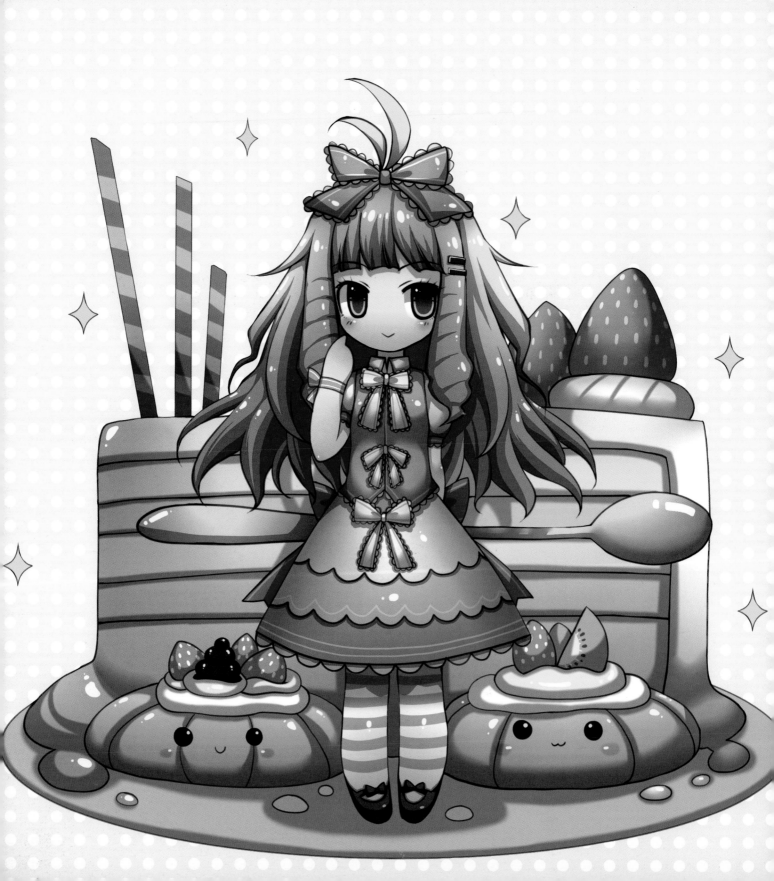

SWEET FLAVOR

KAWAII PASTRY LOLITA

RAMEN CHIBI

MEET BELLE

BUNNY BABY

KAWAII PASTRY LOLITA

Rachel is a cute little girl who loves sweets. She dreams of living in a magical world full of giant desserts and kawaii pastries that she can play with.

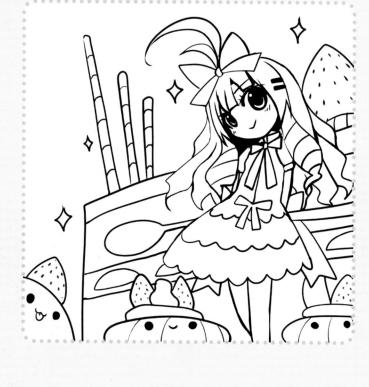

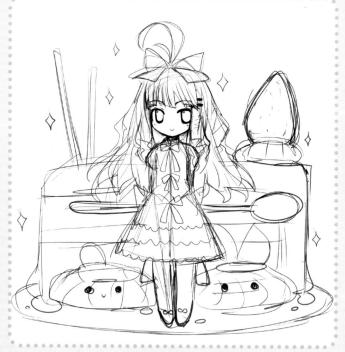

1. SKETCH

Place Rachel in the center of the image, surrounded by giant desserts.

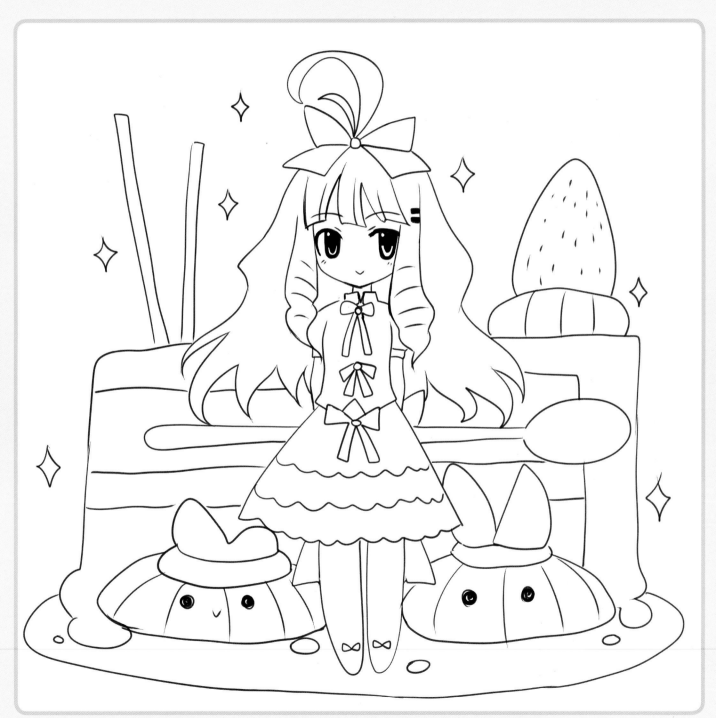

2. STRUCTURE

Sketch out the figure in relation to the other elements in the image. Pay attention to the proportions.

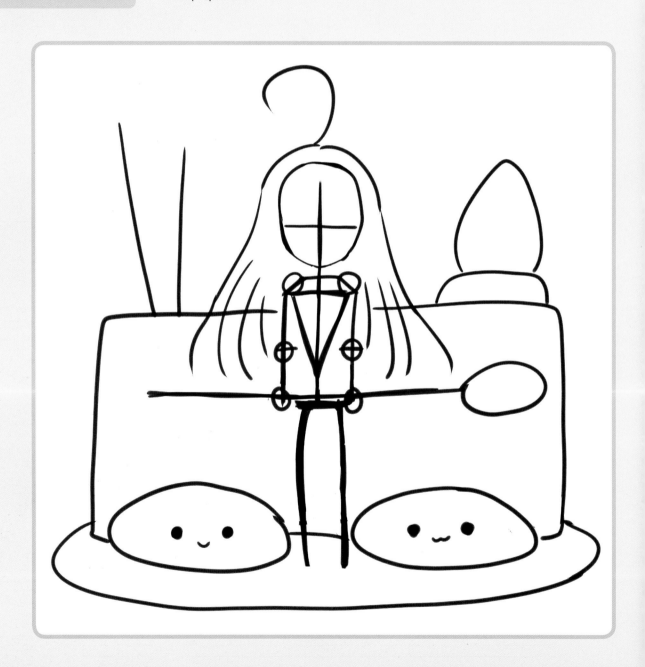

86

3. VOLUME

Draw the basic outline of the character, her hair, and some of the pastries. To give her a more dynamic pose, bend one of her arms up.

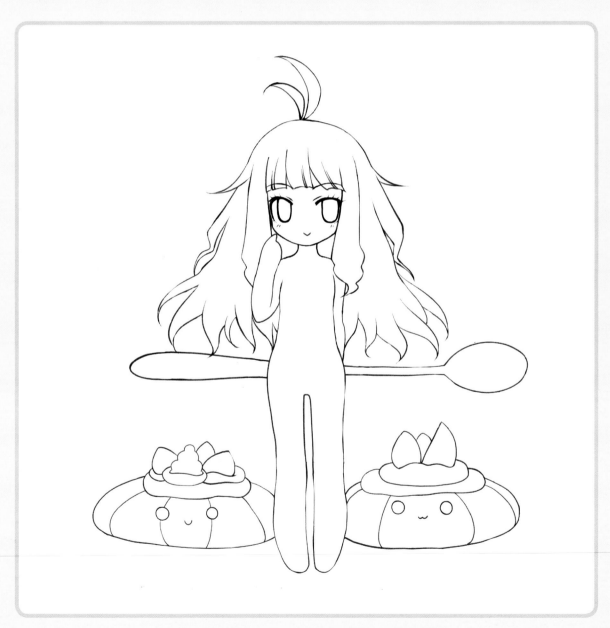

4. ANATOMY

Next draw on a Lolita dress and add a bow to Rachel's hair. You want to start thinking about the background so draw a large circle at the bottom of the image to represent a dish.

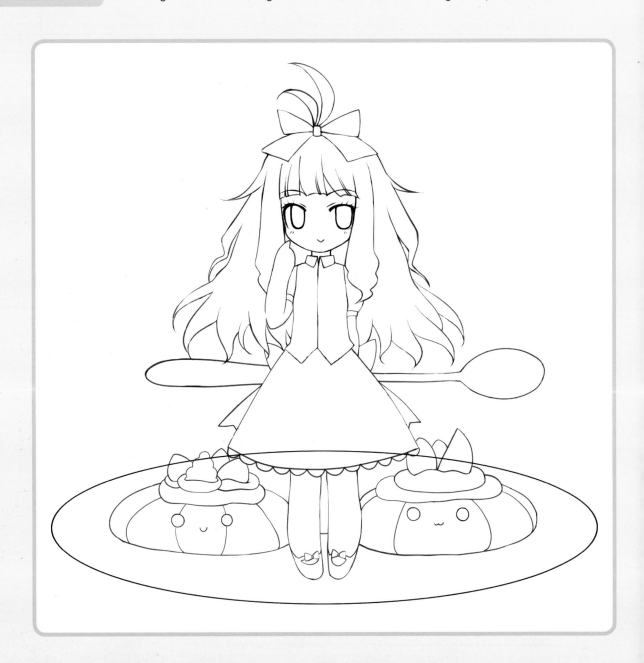

5. DETAILS

Decorate all the small details on her dress, and after the strawberry cake is added, incorporate some sparkles on the background.

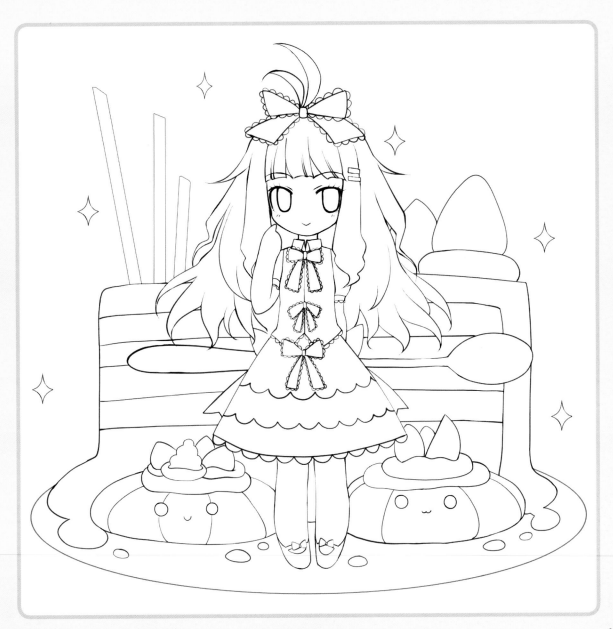

6.1. COLOR

Apply base colors to the girl and objects around her. Choose colors that make the picture look cheerful.

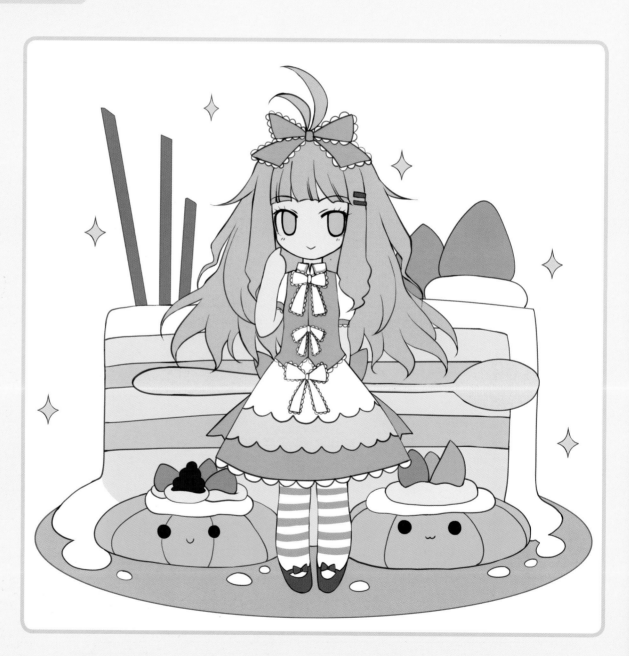

6.2. COLOR

Use multiple layers for shadowing, and add a reddish-gray light. Try to avoid using pure neutral gray; it will otherwise make the picture look too drab.

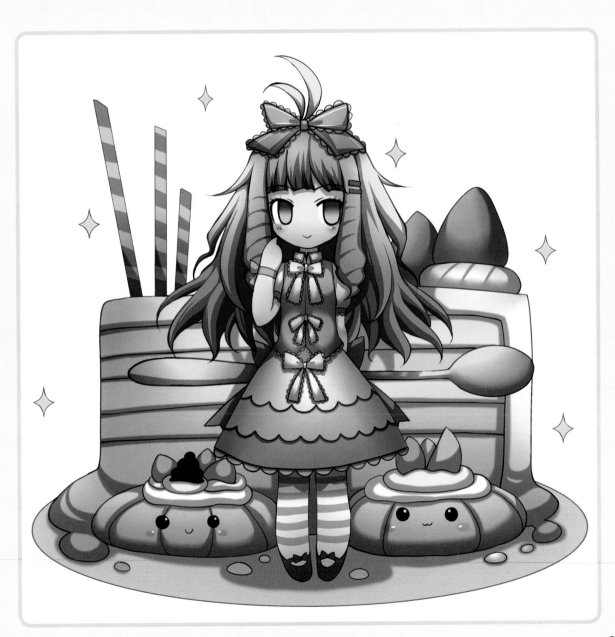

6.3. COLOR

Add highlights to her hair, dress, and the desserts. Use screen type layer for highlighting, and blend some shadow areas with a smudge tool to soften the picture.

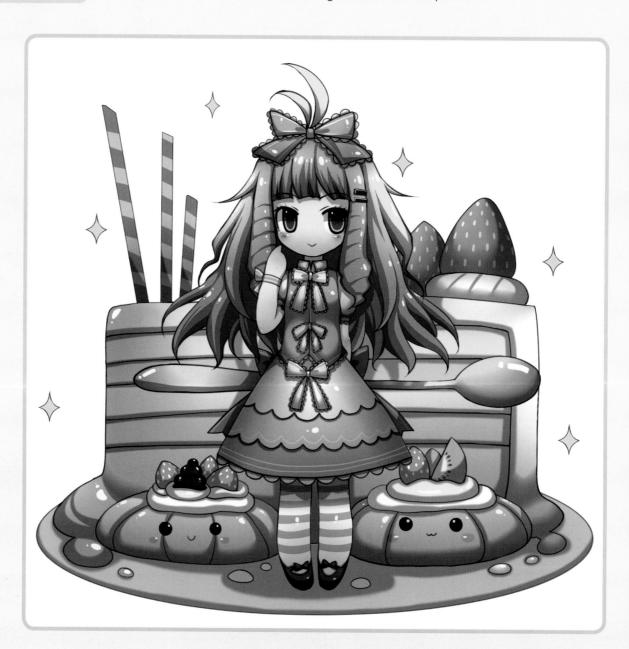

7. BACKGROUND

For the background, create a pink diamond pattern, similar to a tablecloth. Adjust the size and opacity to match the whole image. In addition, a second deeper shadow is added at this step, with multiply layer mode.

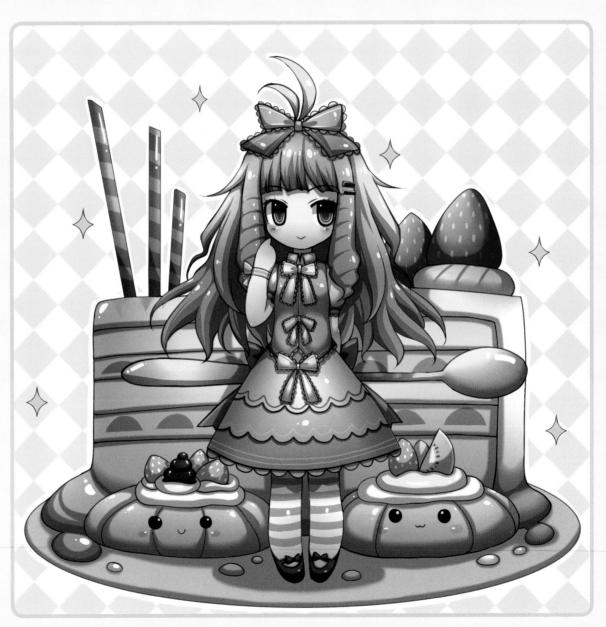

8. FINISHING TOUCHES

A cute worm is added to the strawberry on the cake, and more texture is added to the girl and other elements in the image.

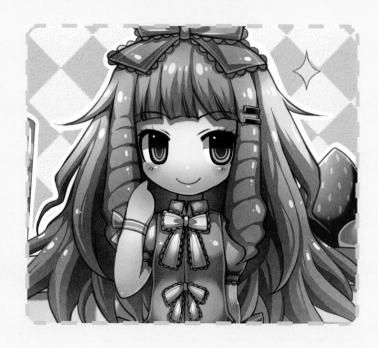

TIPS & TRICKS

• You can easily add texture by using the texture panel in any software; enjoy experimenting with this.

• You can also explore different textures on the internet.

• Adjust the size and opacity of the texture until you reach a nice balance.

• Software used: Paint Tool SAI & Adobe Photoshop.

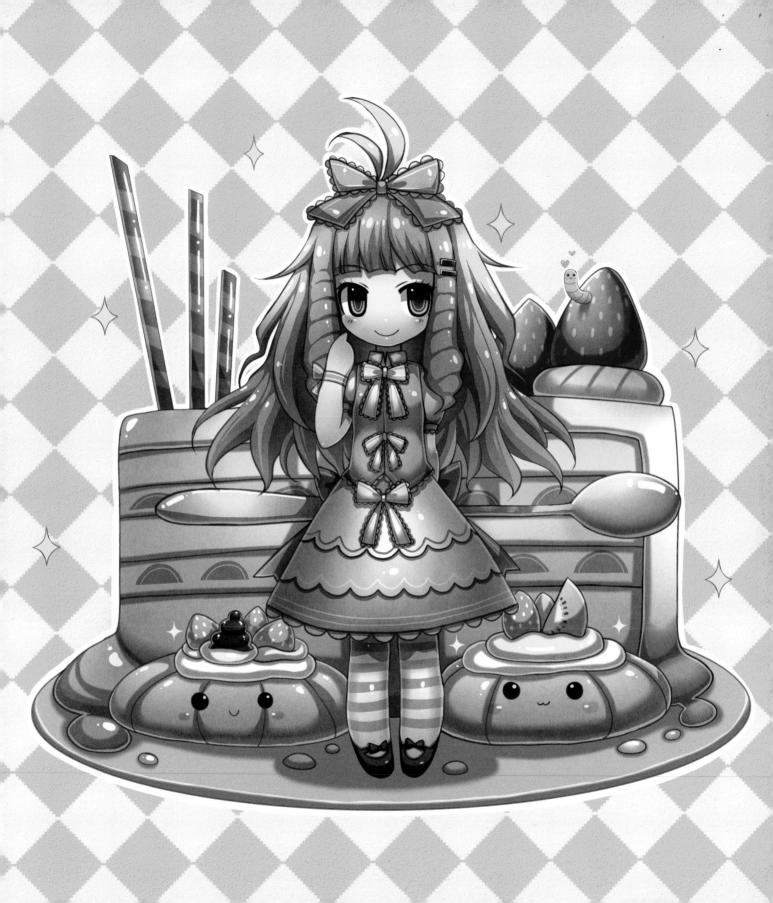

RAMEN CHIBI

Ramen is a cute girl with pasta hair. She loves to rest and take a bath in a ramen bowl, and wash her pasta hair with a flavored pork shampoo. She has a sister with spaghetti hair.

Ramen's dress illustrates soup ingredients: nori on the top, and egg and pork layers on the bottom. She also puts chopsticks in her hair.

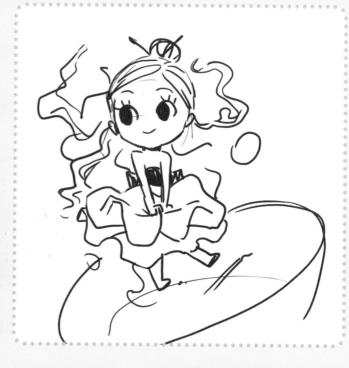

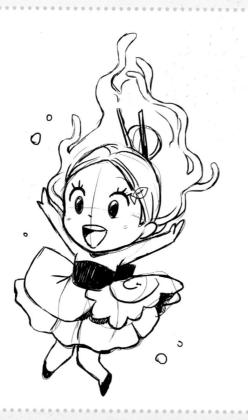

1. SKETCH

The idea is to pick a sketch that is both cheerful and dynamic. The sketch used for this exercise is an image of Ramen jumping into a bowl with her curly hair flying up and other ramen ingredients falling in around her.

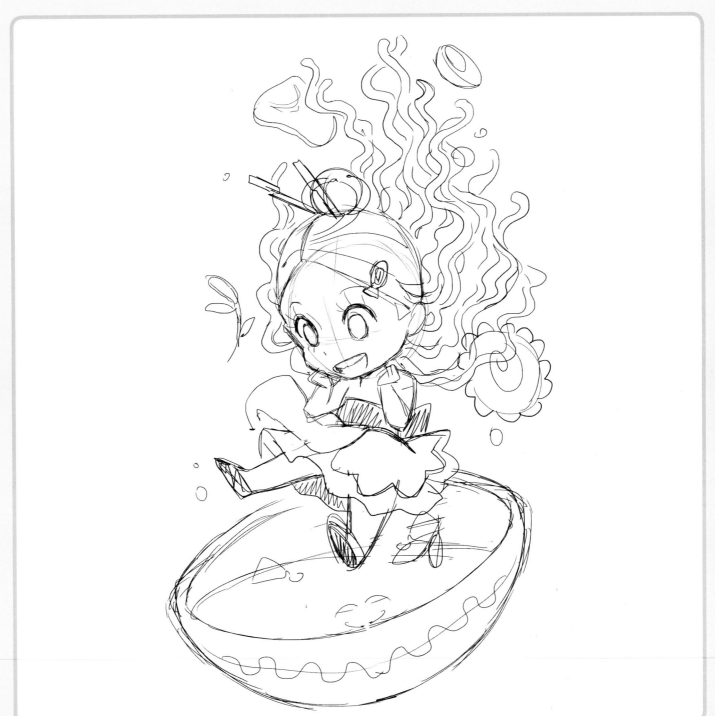

2. STRUCTURE

Sketch Ramen's position, being sure to show she is falling down. Add lines to her face to position her eyes, mouth, and nose.

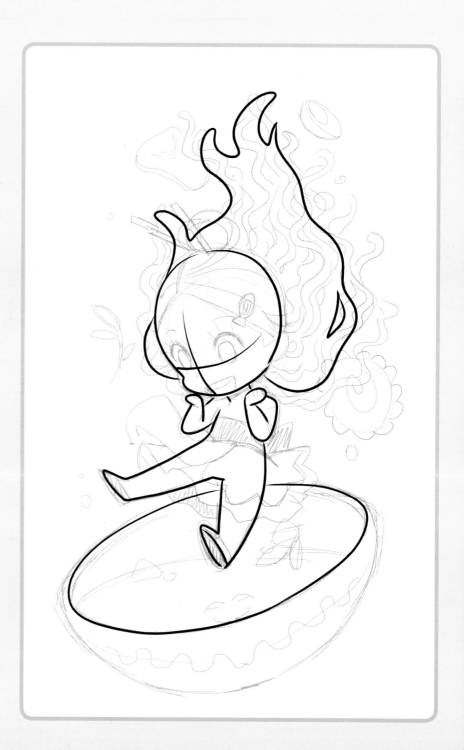

3. VOLUME

Clean up the lines and try to make them of the same thickness.

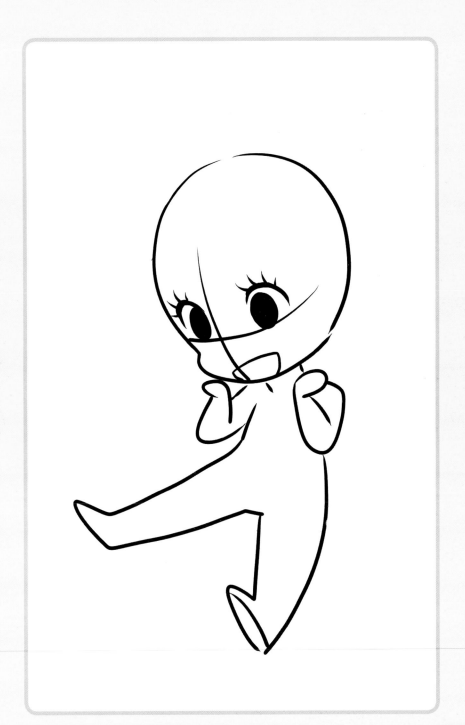

4. ANATOMY

Drawing each individual noodle hair may be time consuming, but it is essential to creating the right look. When drawing the dress, be sure to remember to add the right folds of the pork and egg on her skirt.

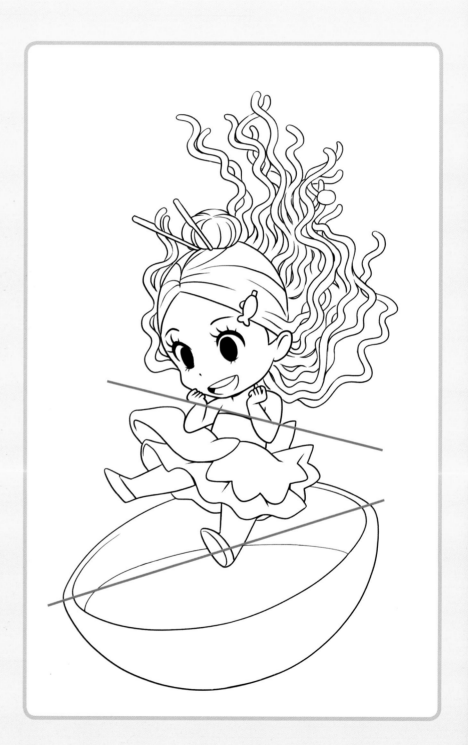

5. DETAILS

Add the other falling ramen ingredients.

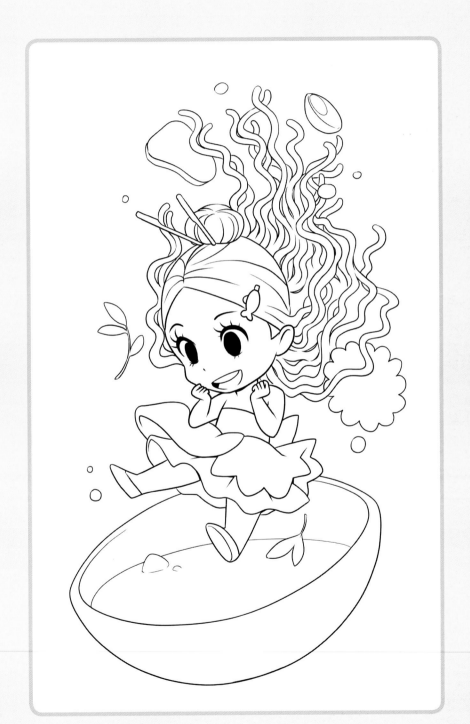

6.1. COLOR

Next, begin coloring using flat colors.

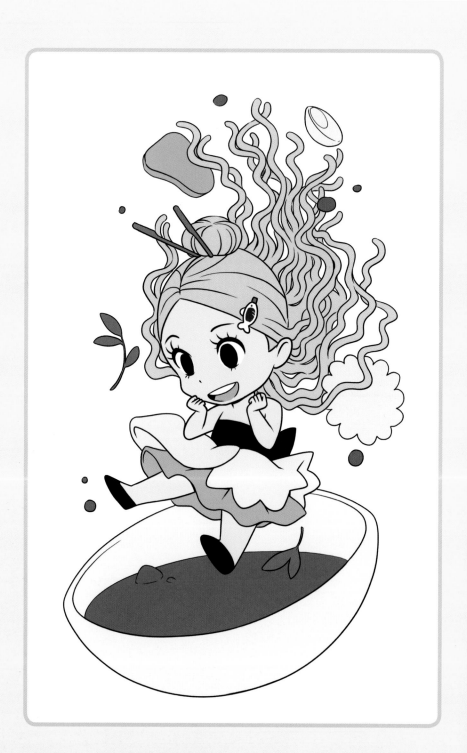

6.2. COLOR

Add shadows, highlights, and other color details such as the yolk on the egg and the pink swirl of the pork. Add bubbles and spices to the soup.

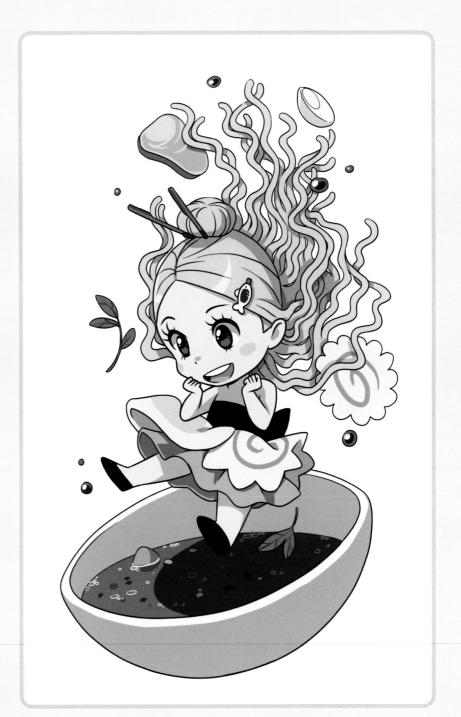

7.1. BACKGROUND

Create a simple but colorful background. Ramen is detailed enough, so it's good not to create a background that is too complex.

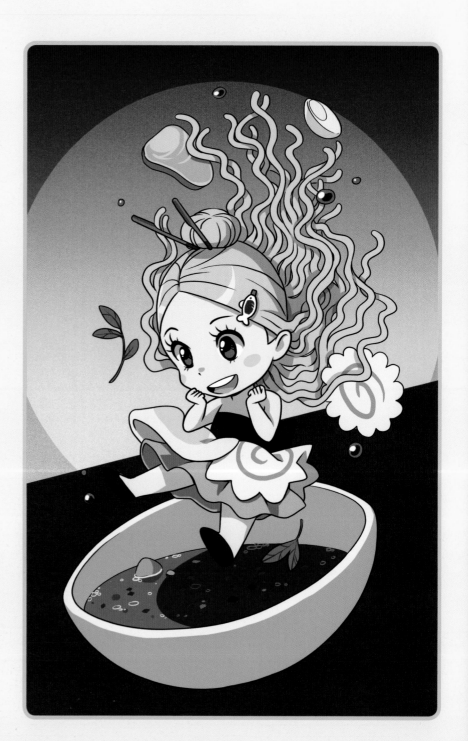

7.2. BACKGROUND

Try to use different shapes and gradients, and also add some noise to make a pattern.

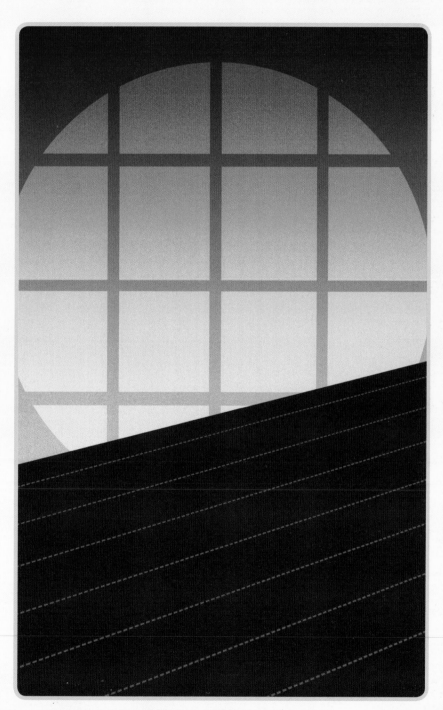

8. FINISHING TOUCHES

To separate the character more from the background, add a white outline around her and the other ingredients. Also decorate the background with some details, such as making the circle look more like a window.

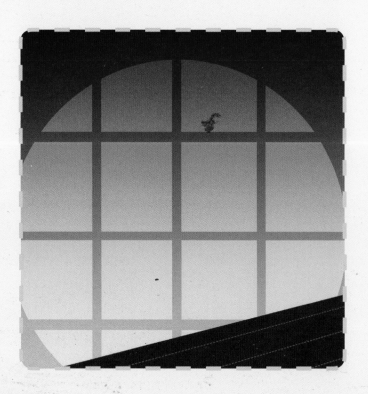

TIPS & TRICKS

• Some elements don't need line art. It would be too overwhelming for some patterns or delicate stuff, like spices in the soup.

• For the broth, add some dark spots, white bubbles, and highlights on the edge to give it a more soup-like appearance.

• Software used: Paint Tool SAI & Adobe Photoshop.

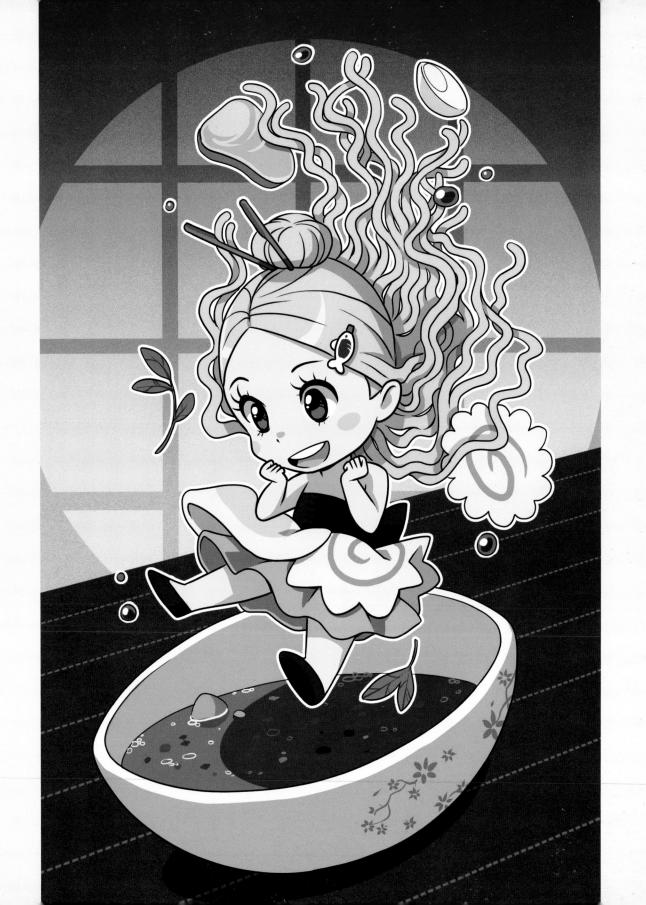

MEET BELLE

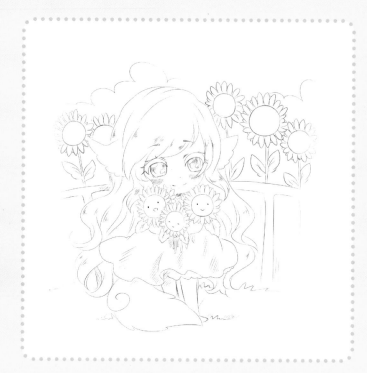

Meet Belle is a big fan of sweets, sushi, and flowers, especially sunflowers.
Due to that passion, she has her own shop in the city, which makes her happy all the time, accompanied by her favorite friends.

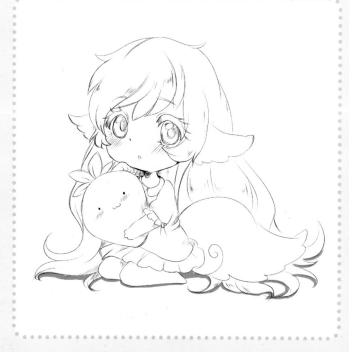

1. SKETCH

For this exercise, the illustrator chose a sketch of Belle surrounded by large cupcakes—her favorite!

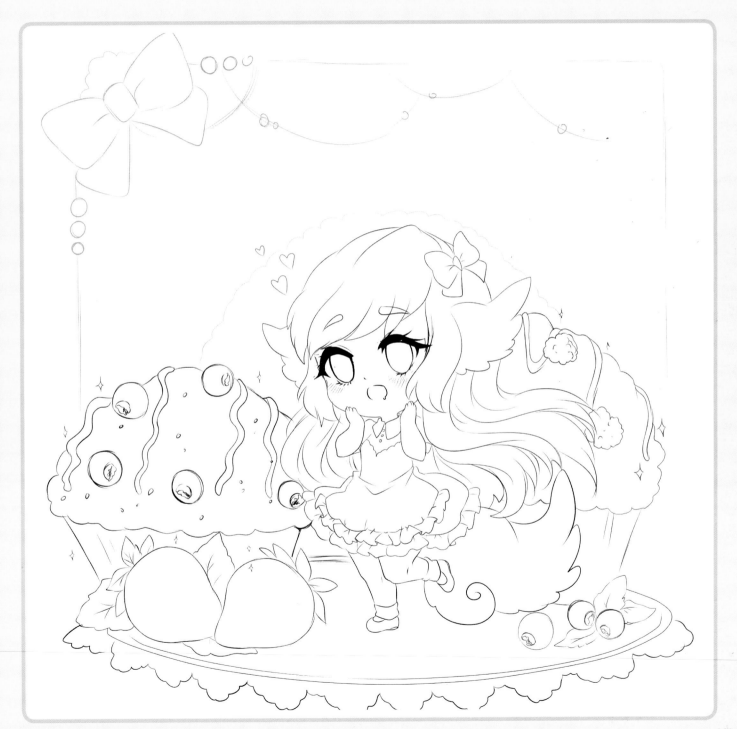

2. STRUCTURE

Begin by sketching Belle's stance. With her hands up toward her face and her leg bent, she looks to be jumping with excitement.

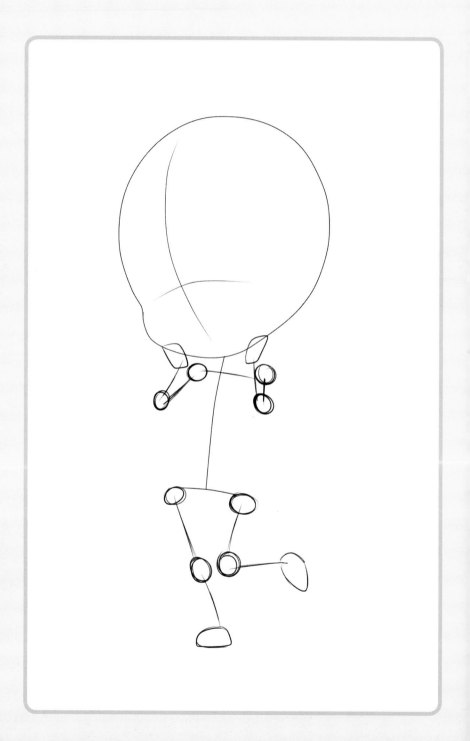

3. VOLUME

Outline the shape of her body and add her facial features. To make her look like a true chibi, make her eyes large.

4. ANATOMY

Next, give Belle beautiful flowing hair and a bushy tail. Don't forget to include her ears!

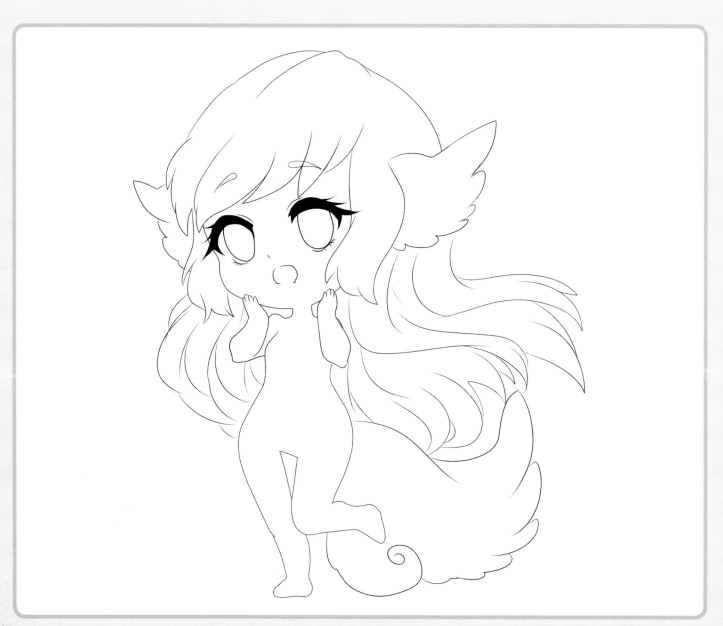

112

5. DETAILS

Now it's time to add details. Dress Belle in a ruffly dress with an apron and, to make her look a extra cute, put a bow in her hair. Next, add the background elements, which include two giant cupcakes and some berries. Place everything on a giant serving dish.

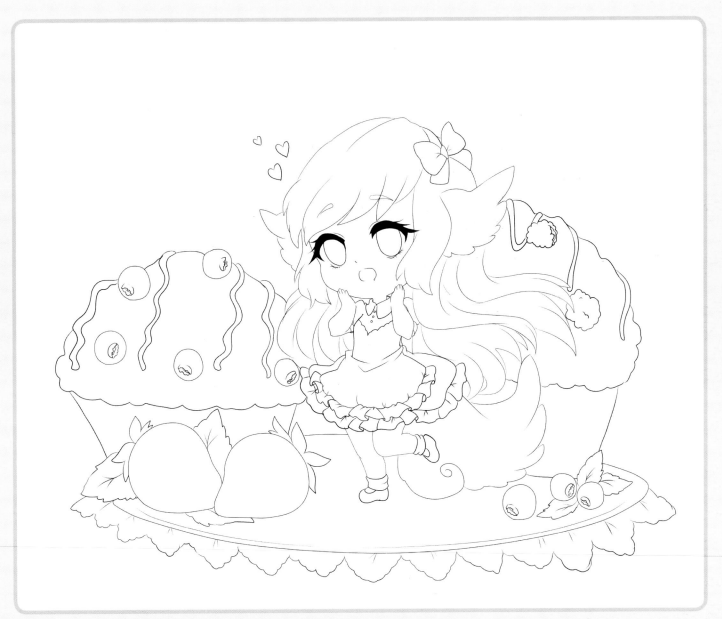

6.1. COLOR

Begin coloring by adding base colors. This is just a step to enjoy and explore, since the final work will be very different.

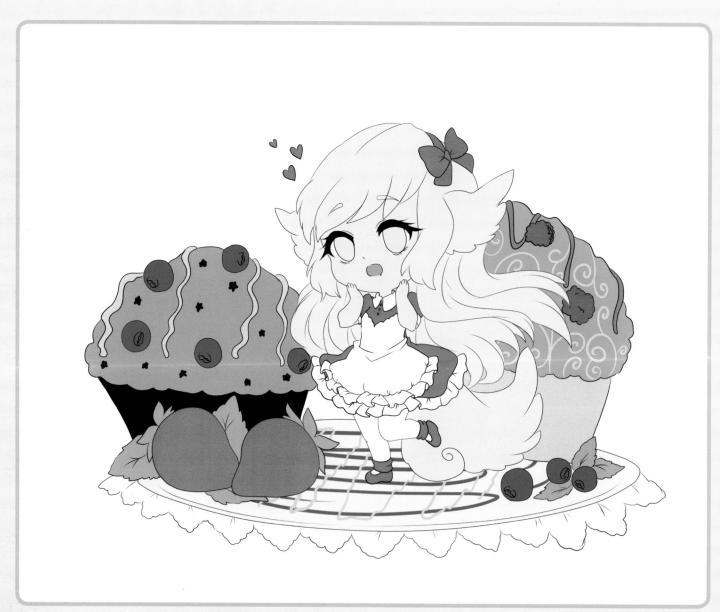

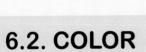

6.2. COLOR

Once you have chosen your final colors, its time to give the image more depth by adding highlights and shadows.
Start to shade by using a solid brush, changing tonality when necessary.

7.1. BACKGROUND

Since the illustration of Belle and the treats is heavily detailed, create a simple background with a fun pattern. Add a bow and beads to give the background some fun details.

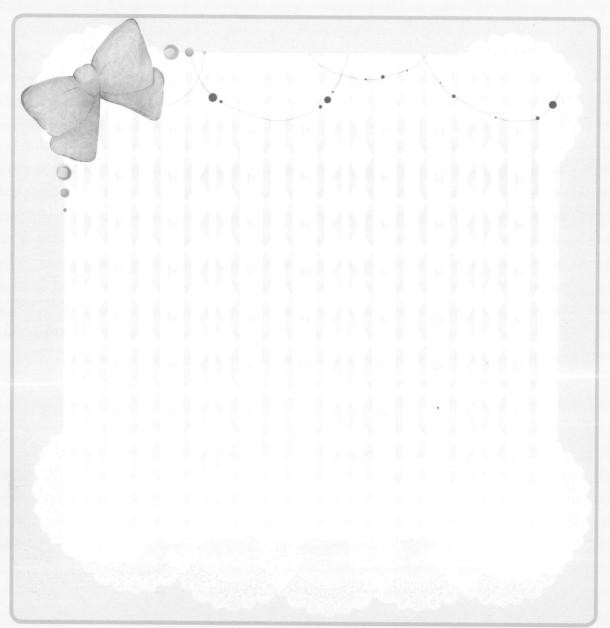

7.2. BACKGROUND

Now the only thing you must do is play with the different layers, until you get a nice contrast between the background and the main scene.

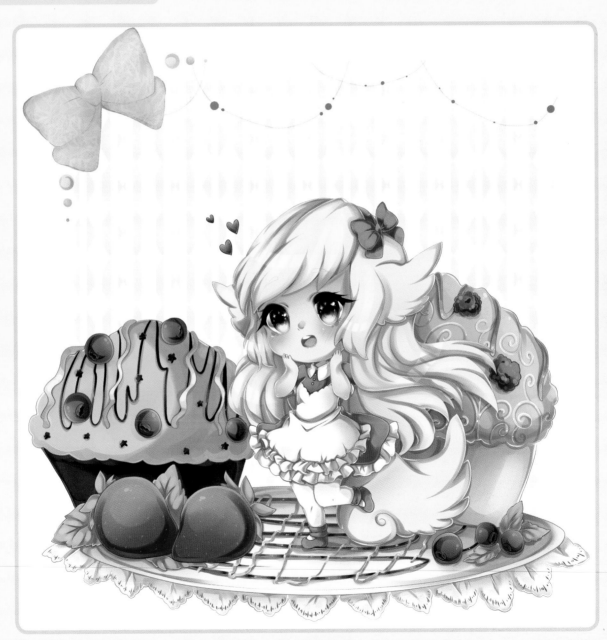

8. FINISHING TOUCHES

White stars are added to the cupcakes to give them a little sparkle.

Merge layers and add effects using Photoshop to make the image saturated.

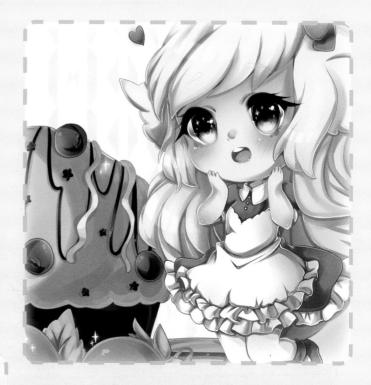

TIPS & TRICKS

- Add reflected lights to her eyes to show she is excited by what she sees. This can also be done by adding some hearts floating near her.

- When drawing food, especially desserts, use bright colors that will attract the attention of viewers.

- To give the whole drawing a soft 3D look, color the edges of each element with slightly darker shades than the base color.

- Software used: Paint Tool SAI & Adobe Photoshop.

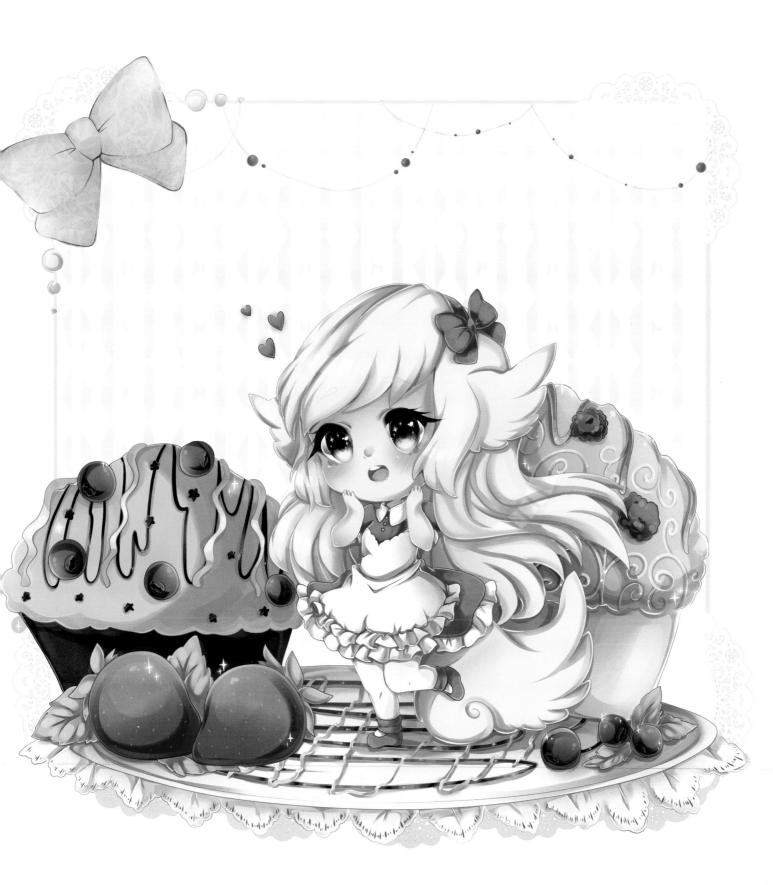

BUNNY BABY

Bunny Baby is an adorable and very playful little bunny. Her body is the color of strawberries and she has caramel on her head. She enjoys playing in the park with her favorite toy rattle.

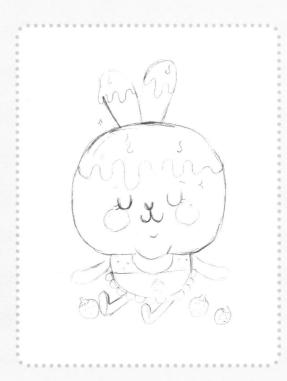

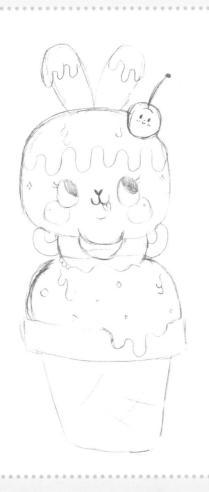

1. SKETCH

After drawing three different sketches, the artist chose the sketch of Bunny Baby standing on a small hill with her toy rattle.

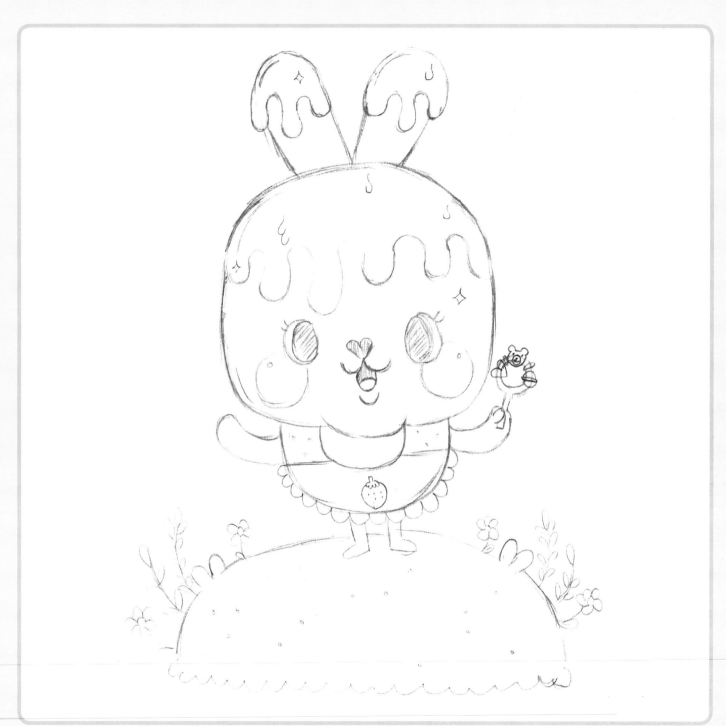

2. STRUCTURE

Use base lines to create the basic structure of the character and to determine its position. In this case, the character is placed in the center.

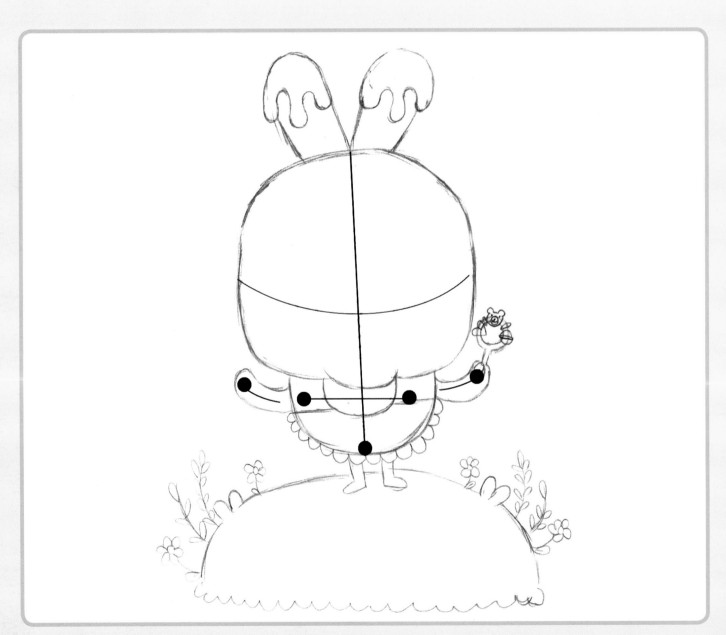

3. VOLUME

Sketch the character's dimensions using the lines drawn in the previous step. Create a donut shape for the body. Be sure to align it with the tips of the ears to create balance.

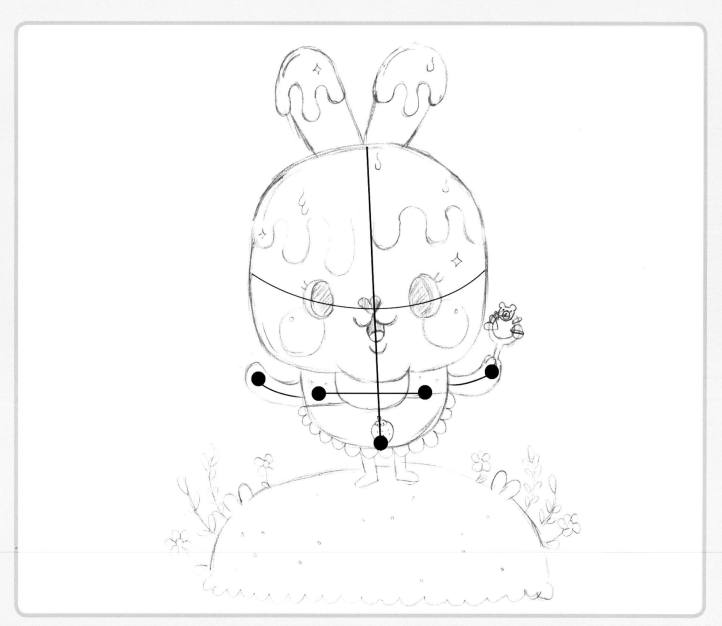

4. ANATOMY

Next, add her eyes, nose, mouth, and two circles to highlight her cheeks. Note the nose is heart-shaped.

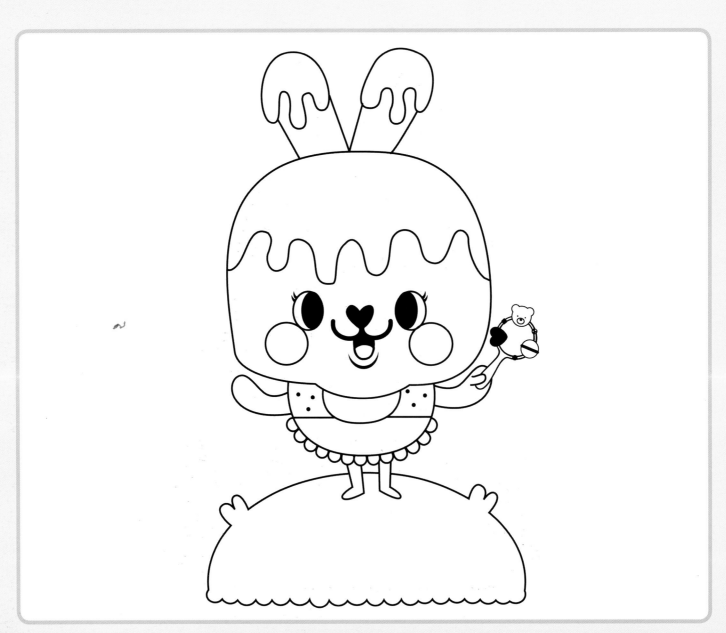

5. DETAILS

Add details such as plants and flowers to the hill, a bib, and her rattle. Include details to the caramel on her head to give it more of a dripping appearance.

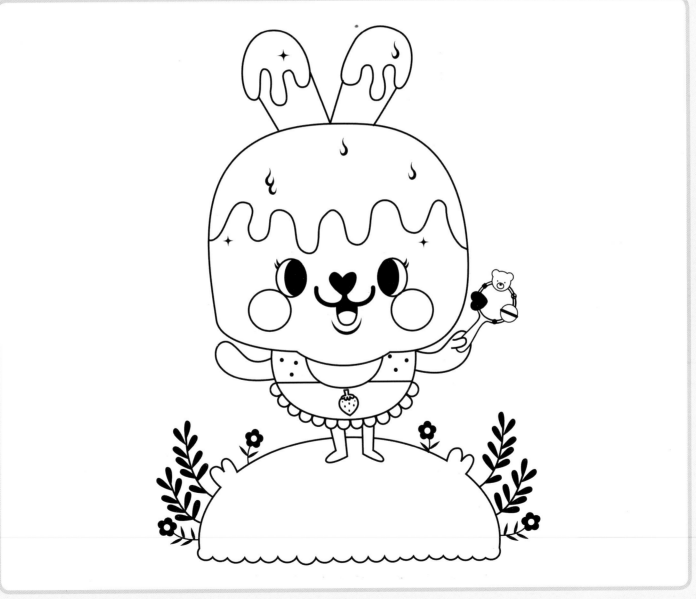

6.1. COLOR

Soft shades of pink are used to make the character look cuter. Choose different colors for the flowers.

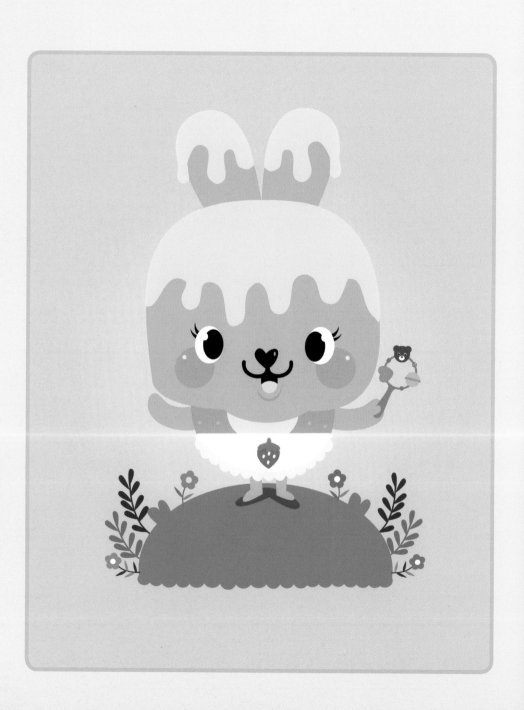

6.2. COLOR

Create white dots and sparkles to give the image an overall charm. For the hill, a yellow dot pattern is used to add texture.

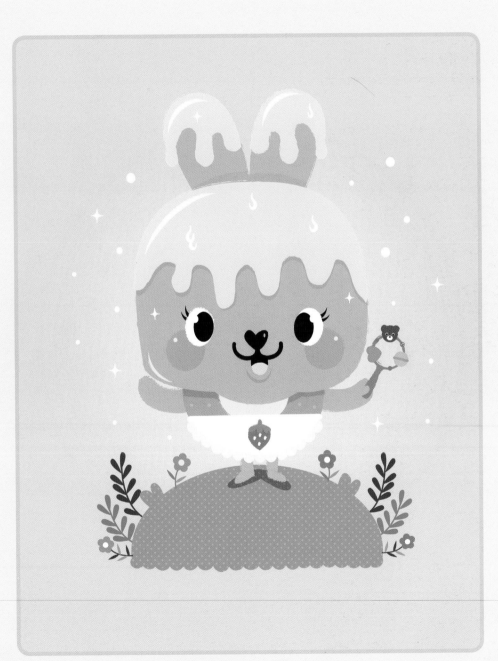

7.1. BACKGROUND

Place the image on a light blue background. White lace details are added to the top and bottom to give it a more complete look.

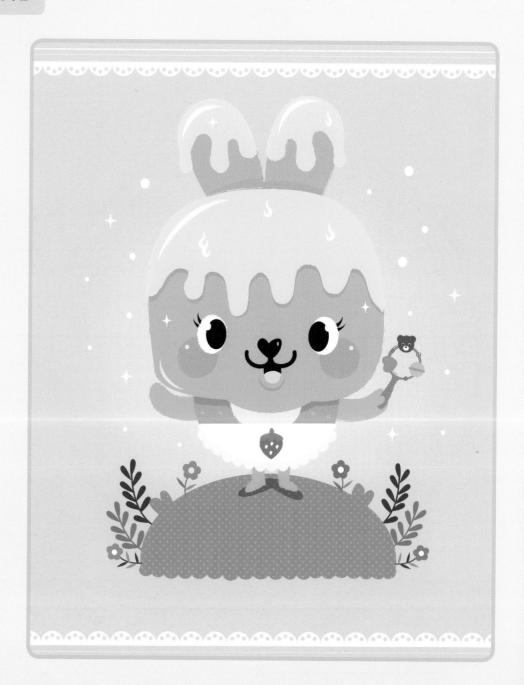

7.2. BACKGROUND

Place a translucent yellow light to the center of the image to give a soft glow around the character. The phrase "Happy Day" is added to the bottom.

Happy Day

8. FINISHING TOUCHES

This is meant to be a fun and cute picture, so don't be afraid to add little details and play around with the color.

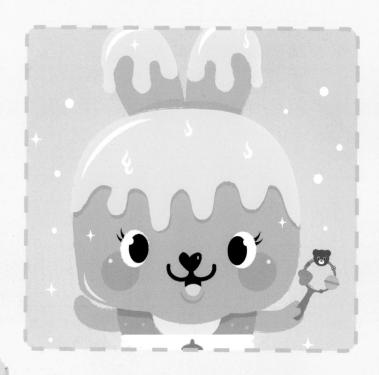

TIPS & TRICKS

• Adding the soft halo of light behind the character creates depth and gives perspective to the artwork.

• Using soft shades of color help to create a warmer, more childlike character.

• By adding a "glow effects" layer, you can apply wonderful glowing brights to the areas you like.

• Software used: Adobe Illustrator.

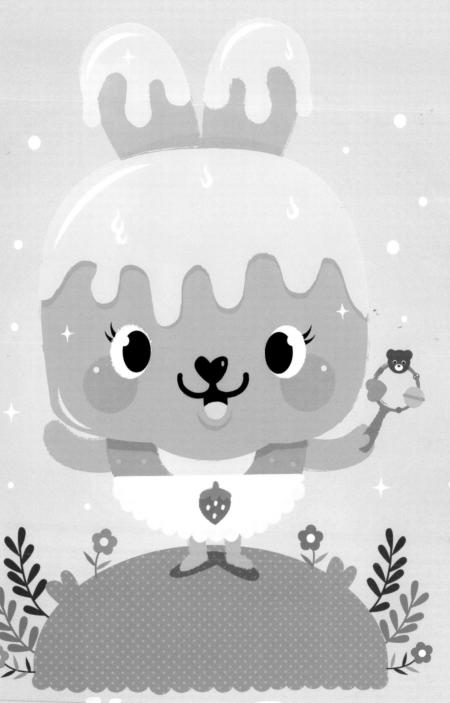

Happy Day

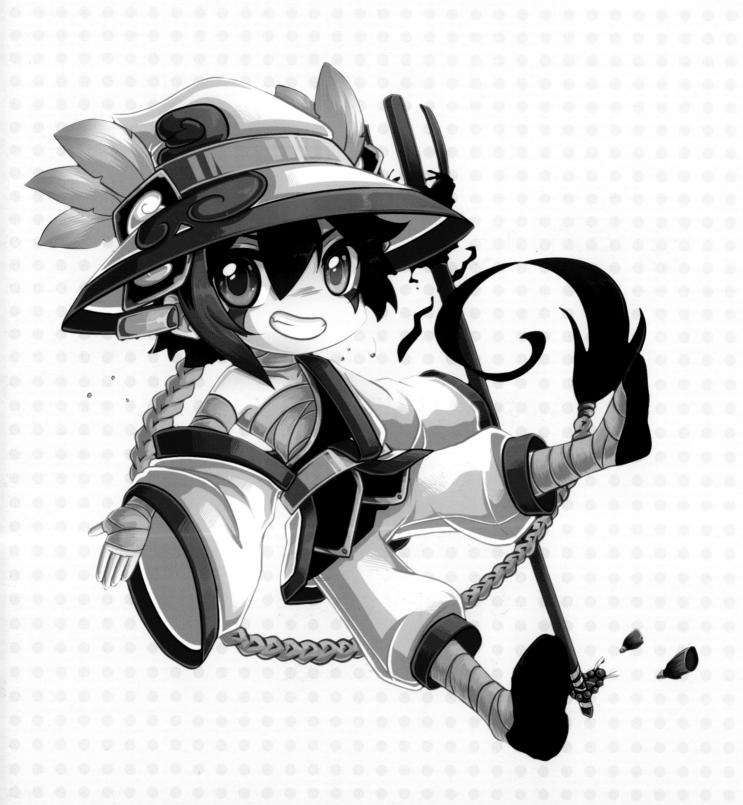

SPECIAL CHARACTERS

LANTERN FESTIVAL GUY

MECHA CHIBI

8TH DIVISION

STARRY NIGHT

GAMER CHIBI

 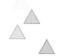

LANTERN FESTIVAL GUY

The lantern festival is a popular Japanese festivity that our character, Shiro, always attends.

He loves to participate in the activities, sample the food, and wander down the street with his torch while admiring the lanterns flying in the sky.

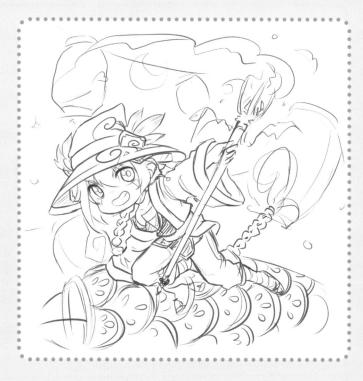

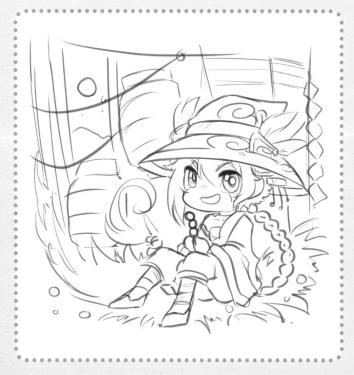

1. SKETCH

After trying several sketches and compositions, let's explore the one on the right, where we have a cheerful Shiro posed with the lanterns in the background.

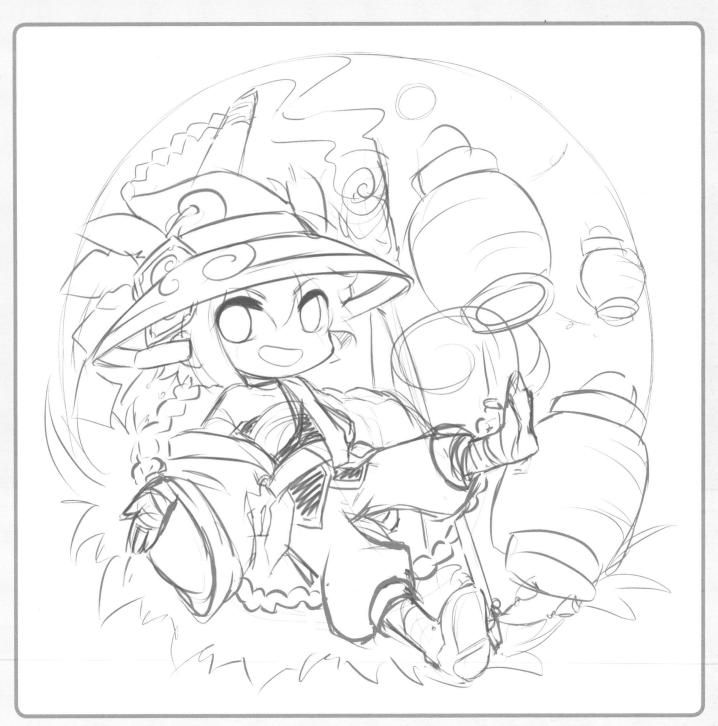

2. STRUCTURE

Draw the characters outline to use as a guide for his pose. Shiro is a young and cheerful boy, so the pose you need to get is carefree and friendly.

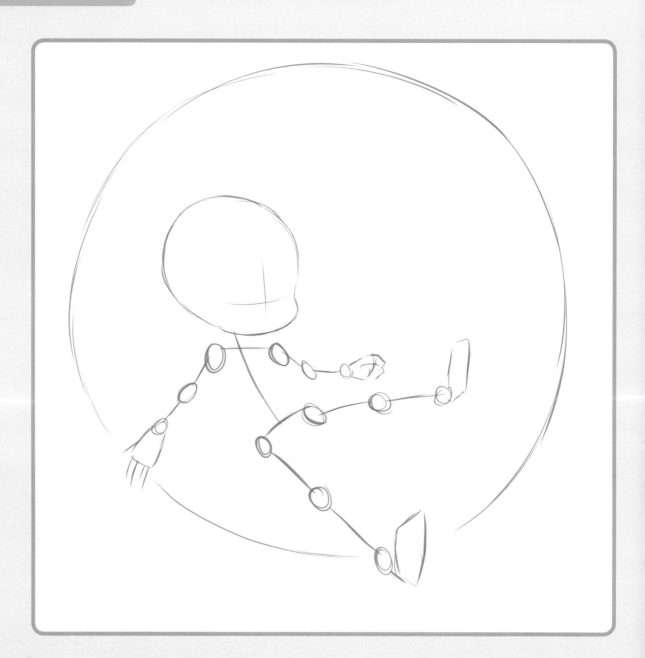

3. VOLUME

Next, let's get the volume of our character. Place the eyes and mouth on the face, with a mischievous expression, and also draw the hair and some details like his very long braid.

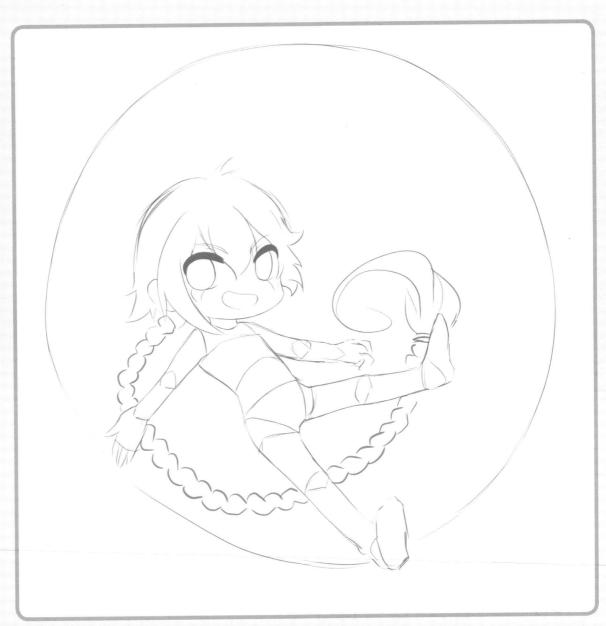

4. ANATOMY

Define Shiro's body. Remember to keep in mind that he is a young boy with a short stature and slender build.

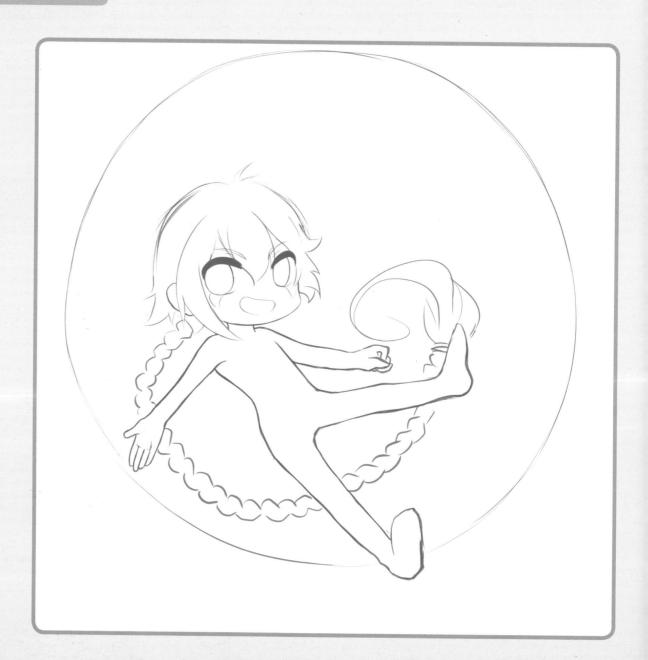

5. DETAILS

It's time to dress up our character and define the details! Since he is a fan of the festival, dress him up in festive clothes. Spending time on this step will give us a nice result.

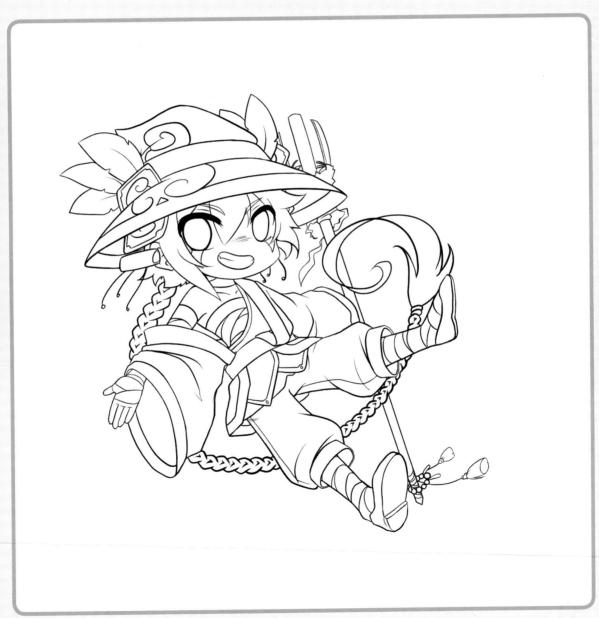

6.1. COLOR

Begin coloring by applying spot colors in separate layers; this will make it easier when we start the shading process.

In order to make the colors pop, especially if the clothes are white such as in this case, fill the background with a dark color.

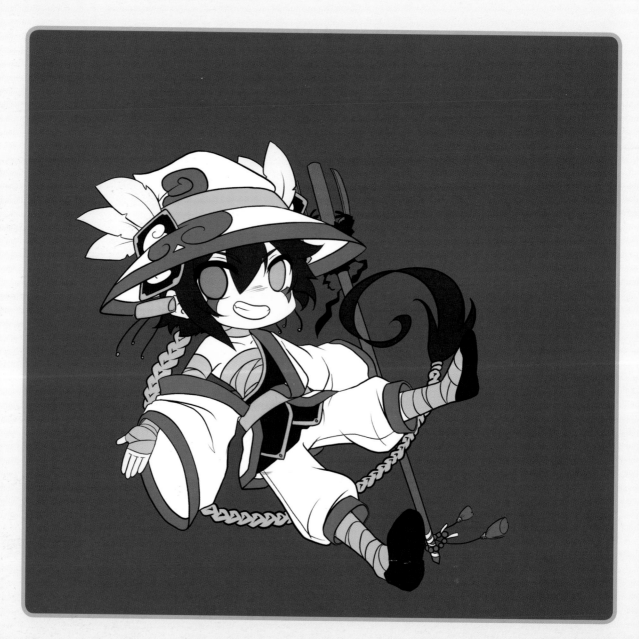

6.2. COLOR

Create a new layer on your image to add the shadows. After you have determined the direction of the light on the character, apply shadows along the edges. In this case, the light is coming from the upper right corner.

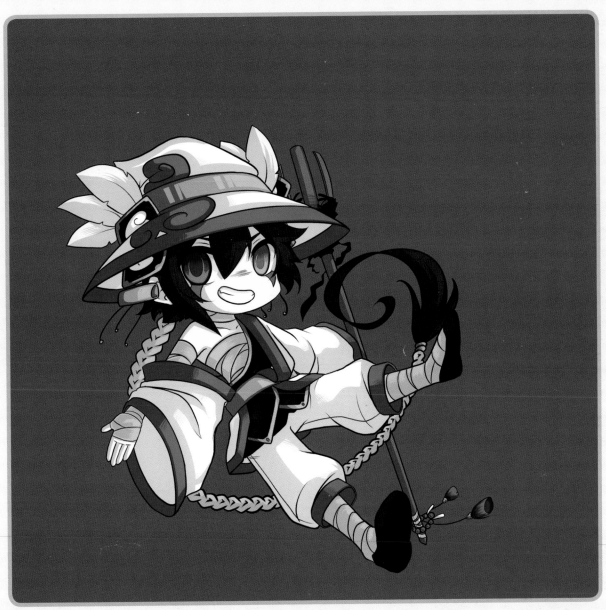

6.3. COLOR

To create more volume, apply other darker shades over the basic shadows. Use lighter shades in the area to represent highlights.

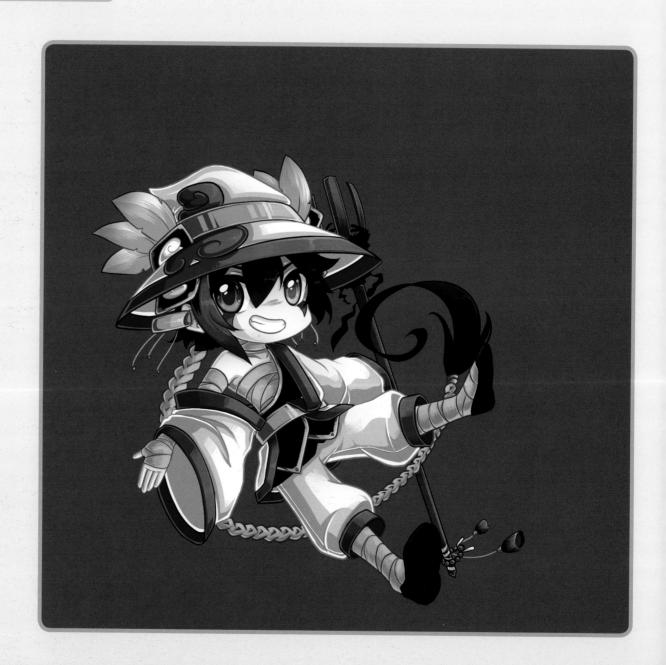

7.1. BACKGROUND

The first step of creating the background is to clearly define other objects in the image, such as the lanterns. Next, create the scene. Add mountains in the background and grass in the foreground.

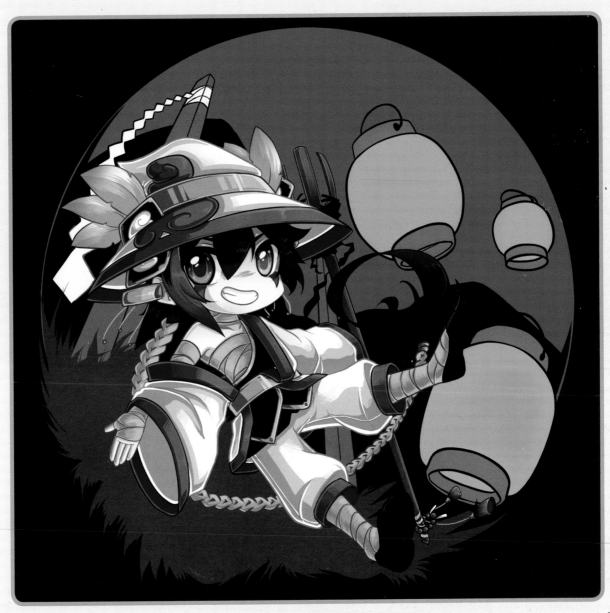

7.2. BACKGROUND

As with the character, apply shadows to the lanterns and grass to give the picture more depth. Don't forget to add fire to the character's torch.

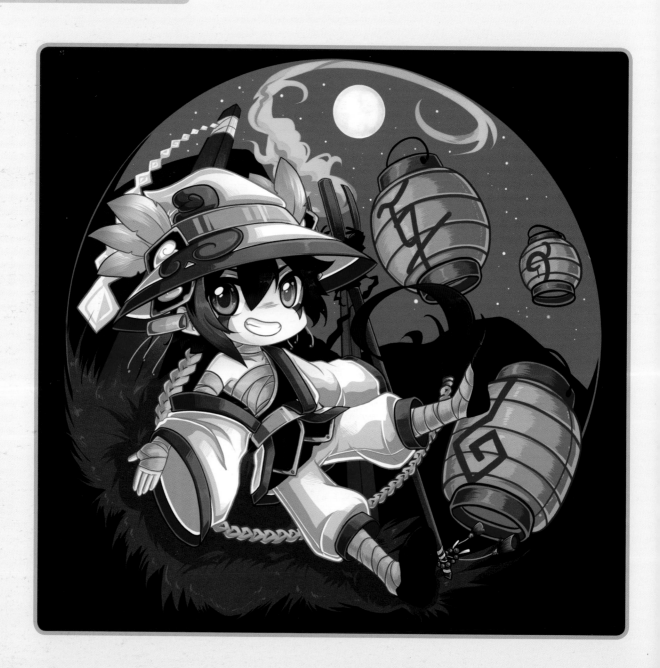

7.3. BACKGROUND

Finally, apply gradients to the sky by using lighter shades of blue, as well as lighter shades to the mountains so that the grass does not blend in with them.

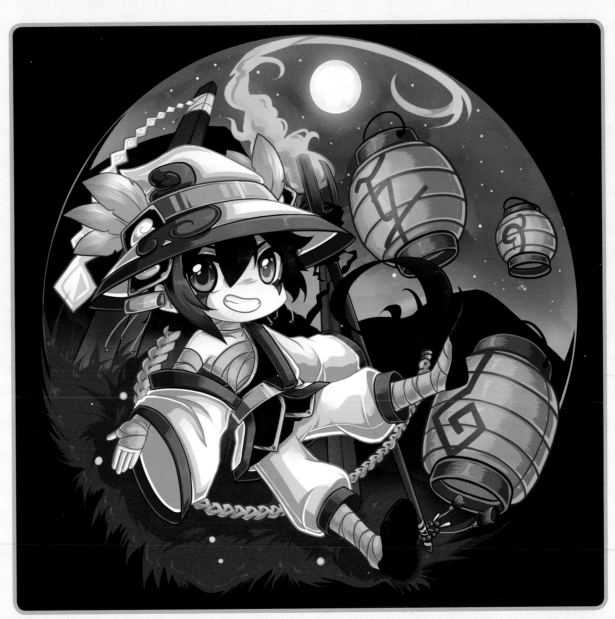

8. FINISHING TOUCHES

Include a thin white border to the character so he stands out against the background.

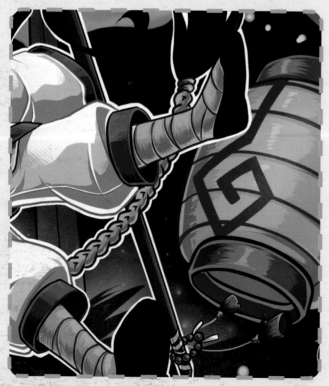

TIPS & TRICKS

- Use bright and saturated colors to give more life to the drawing.

- In order to give the effect of light to lanterns, create a new layer, and with a soft brush or airbrush, just paint over it with a strong yellow.

- His eyes are what give life to the character, so they should be as expressive as possible. You can add saturated tones to bring them out, or some glitter.

- Software used: Paint Tool SAI.

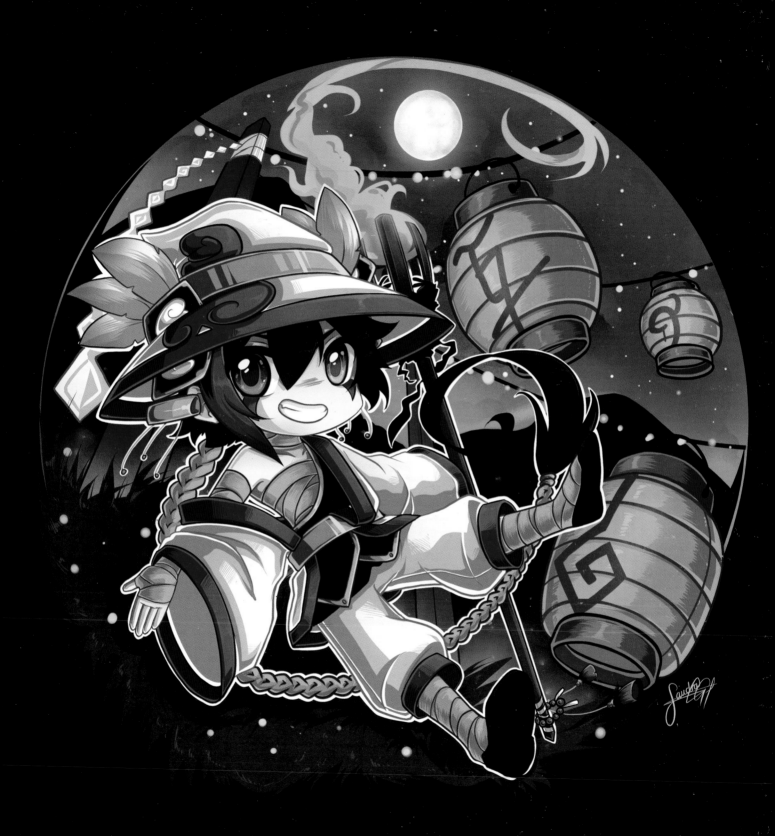

MECHA CHIBI

Mecha (robots) are very popular around the world, but especially in Japan and America.

This Mecha is a fighter. He often goes to battle with other robots and is used to getting injured, but he's a tough fighter who refuses to give up!

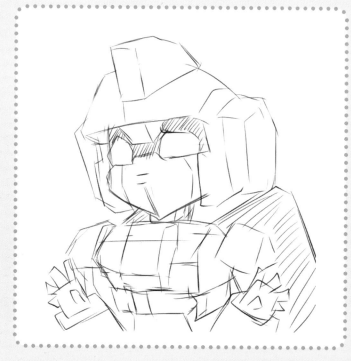

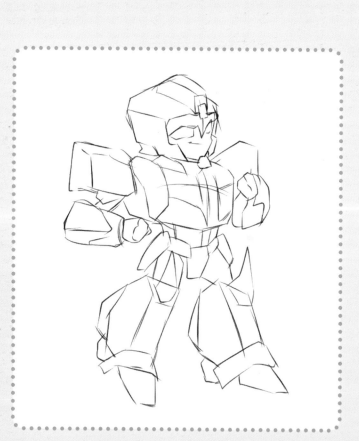

1. SKETCH

Explore some different options for how you want your robot to look. It's best to keep your lines neat so that you have a clear understanding of what the character should look like.

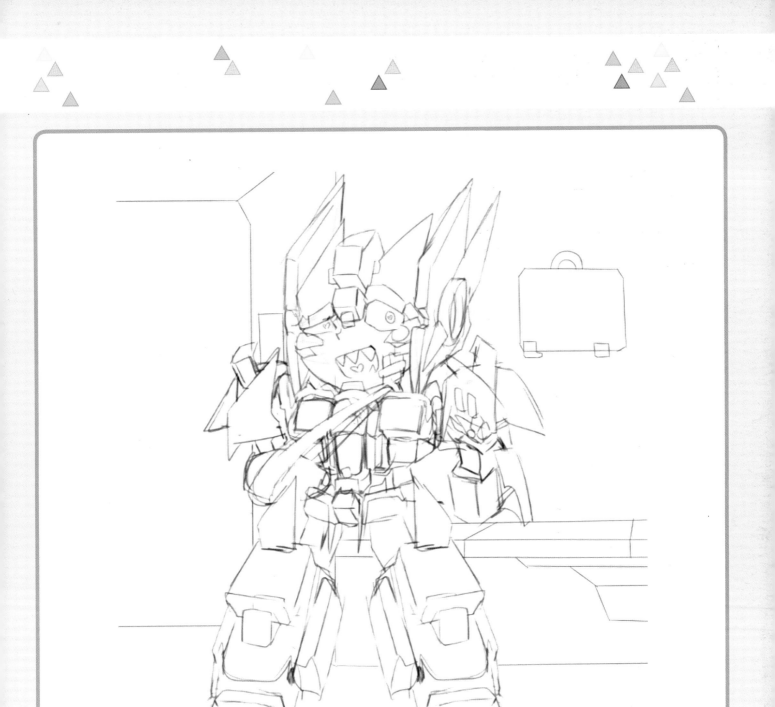

2. STRUCTURE

Begin by drafting the Mecha's pose using simple lines and points. Don't forget to take into account how tall you want him to be.

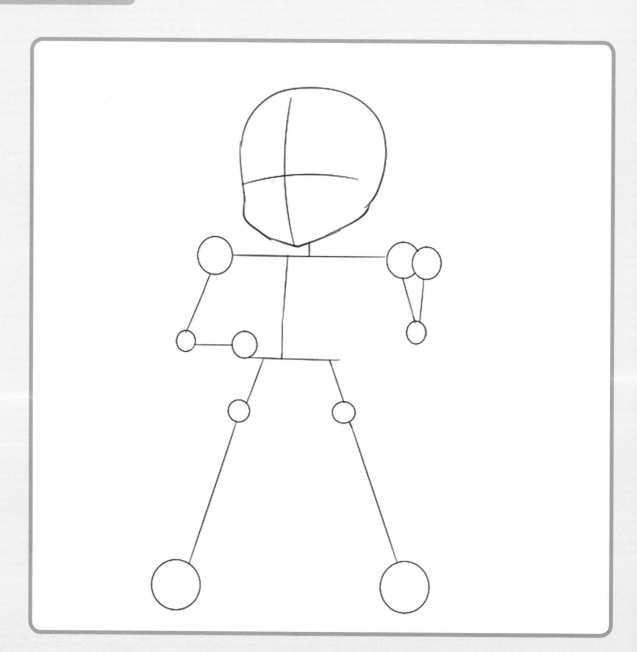

3. VOLUME

Robots are usually blocky. Focus on using basic geometric shapes to create the Mecha's body.

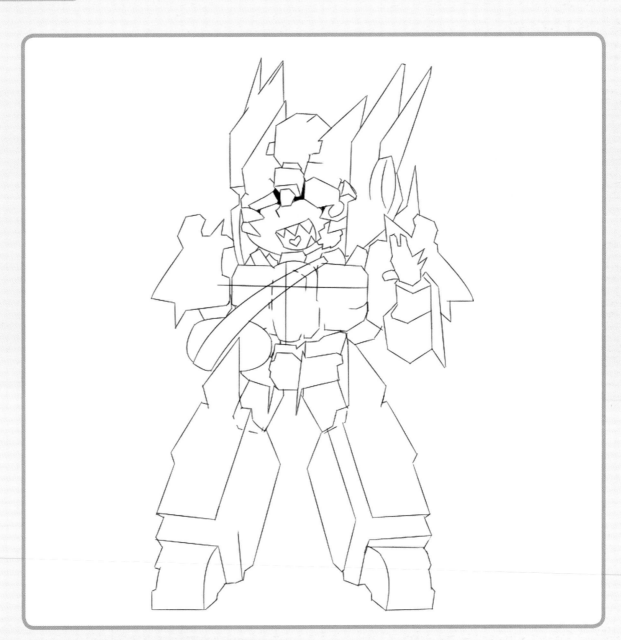

4. ANATOMY

After merging certain shapes together and defining his features, the Mecha should look nearly complete.

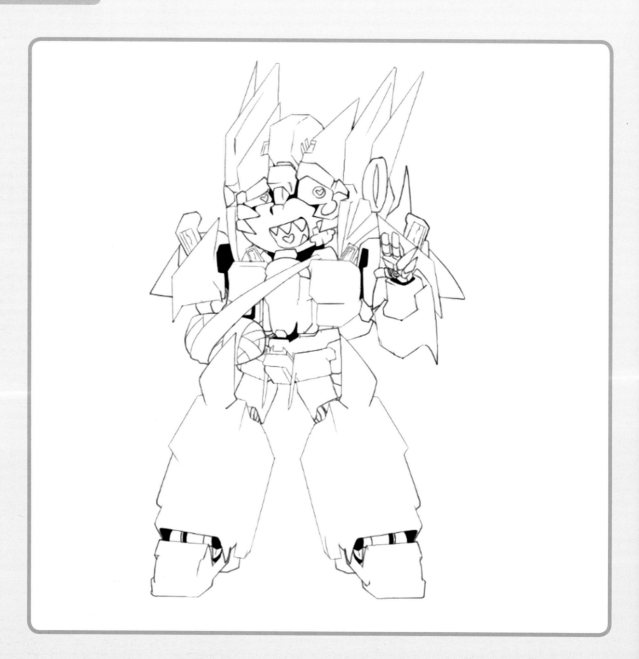

5. DETAILS

Once the Mecha's body has been fully designed, add details such as scratches and bandages to show he's an experienced fighter.

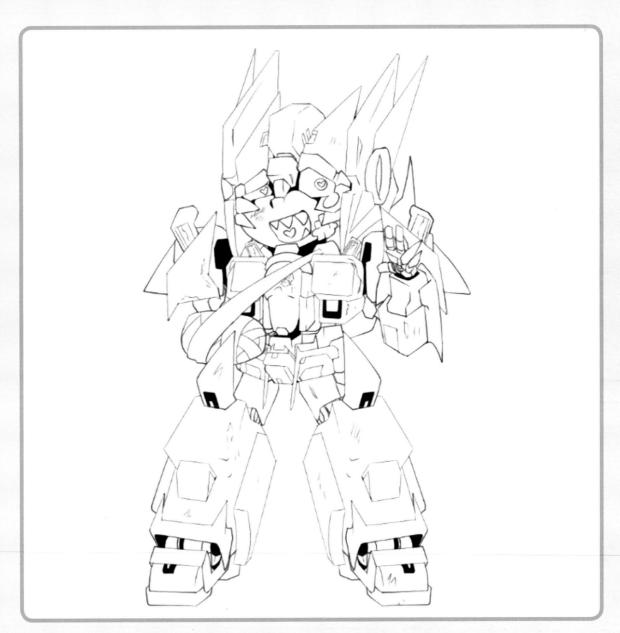

6.1. COLOR

Now, apply flat color. Pick multiple colors to fill in the different parts of the Mecha's body so that they stand out.

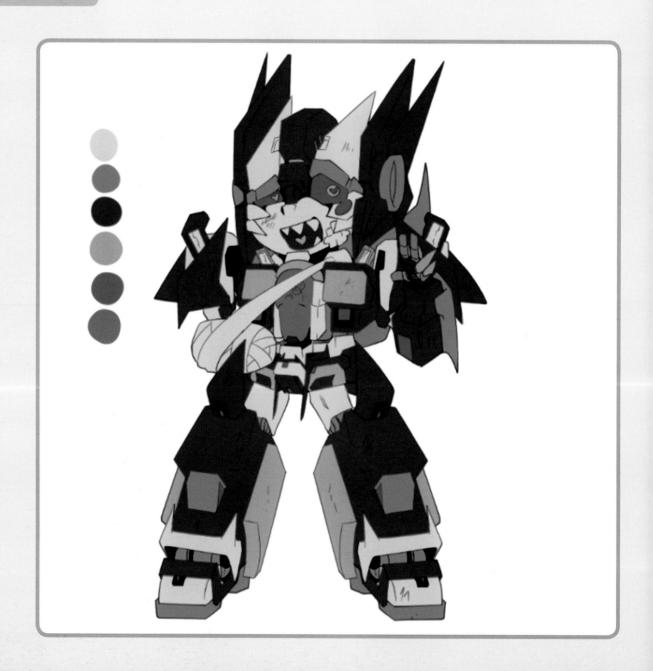

6.2. COLOR

After distinguishing where the source of light is coming from, add shadows and reflective light to the Mecha. Note that the Mecha has a glossy metallic finish.

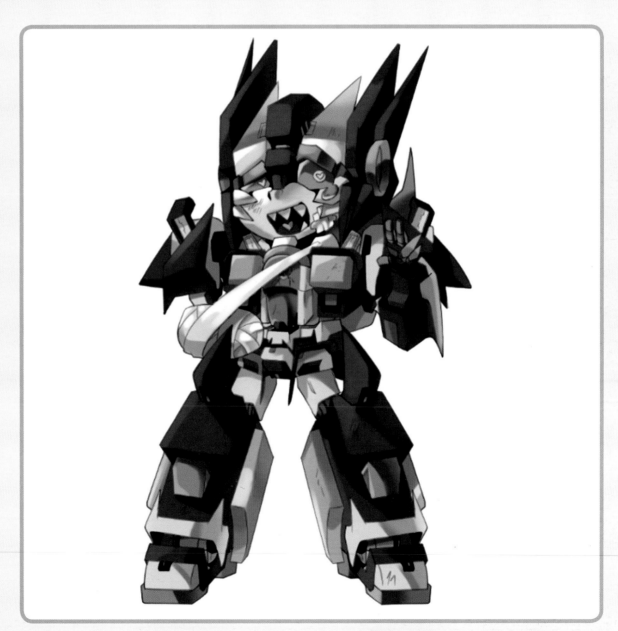

7.1. BACKGROUND

Design a background for your Mecha. Since the Mecha is injured from battling, the artist chose to create an infirmary.

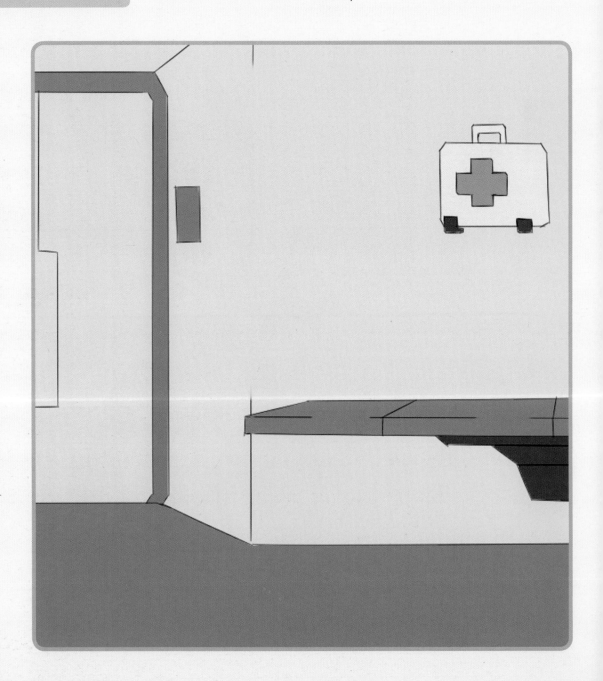

7.2. BACKGROUND

While shading the background, keep the light source in mind. You want the shadows to match the shading of the Mecha.

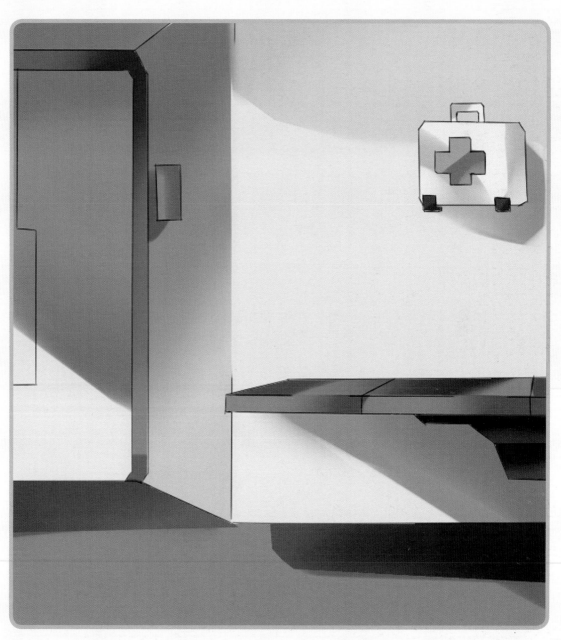

8. FINISHING TOUCHES

After merging together the background layer and the character layer, play with different color filters and lighting effects to give the Mecha a more robotic effect.

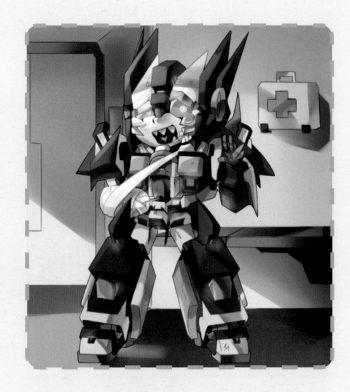

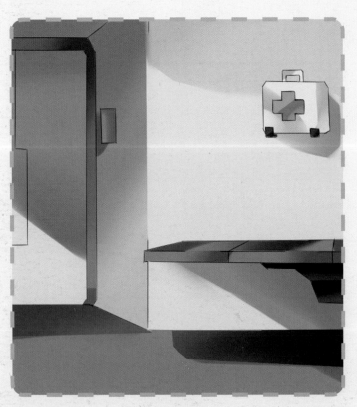

TIPS & TRICKS

- By adding a "glow effects" layer, you can create a cool glowing look to certain areas.

- Software used: Manga Studio 5.

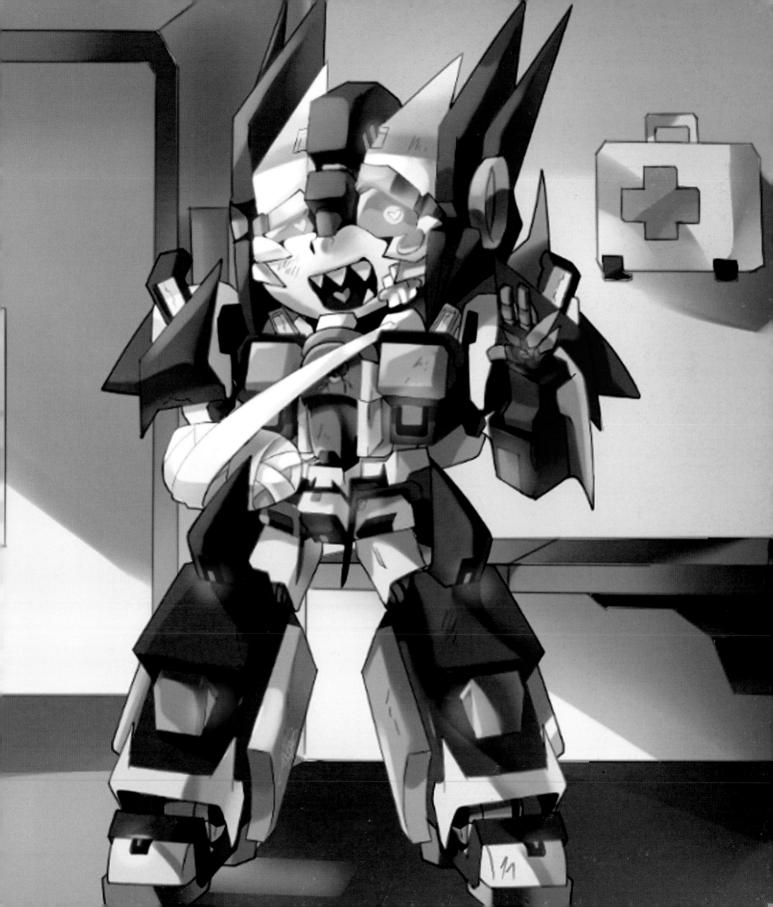

8TH DIVISION

This group of friends is nicknamed "8th division". They work together to create chaos by performing antics and pranks.

Pokka, as the only girl in the division, often gets mad at the other guys due to the fact they don't want to act as she would like, which would be even naughtier.

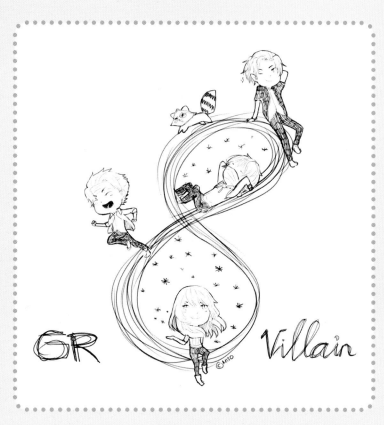

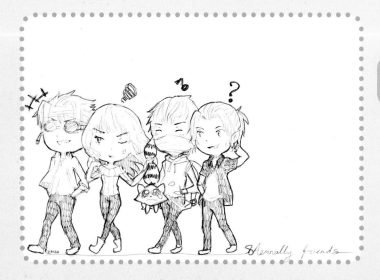

1. SKETCH

Try to find a good atmosphere for the group that showcases each character.

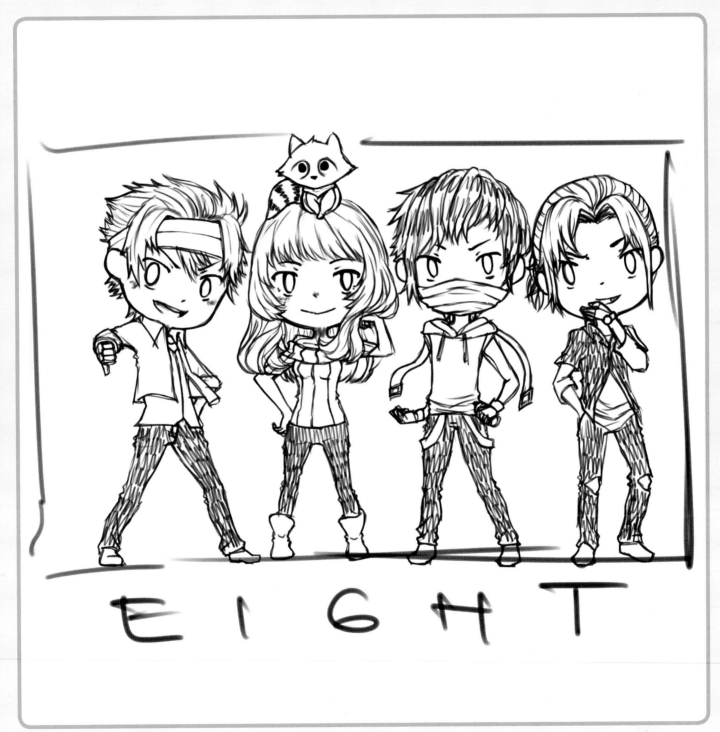

EIGHT

2. STRUCTURE

Sketch simple lines to draft each character's pose. Here, the joints are marked with circles.

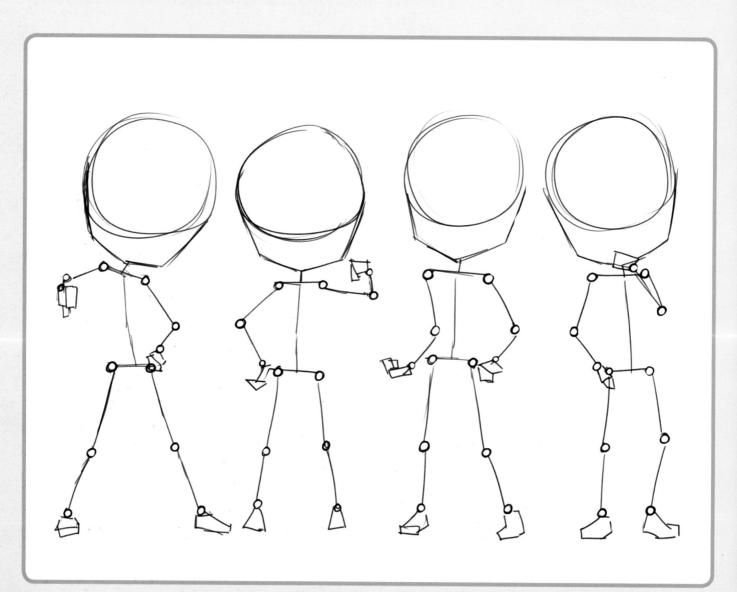

3. VOLUME

Using the lines as a guide, give the characters volume. The head should be larger than the body.

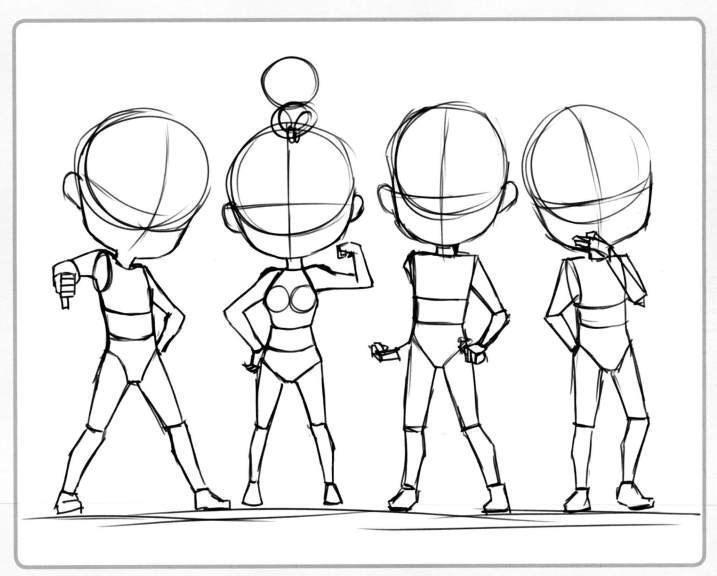

4. ANATOMY

Working with layers, remove the guidelines from the initial steps. Give the characters distinctive and various traits to differentiate them. Add the eyes and the eyebrows.

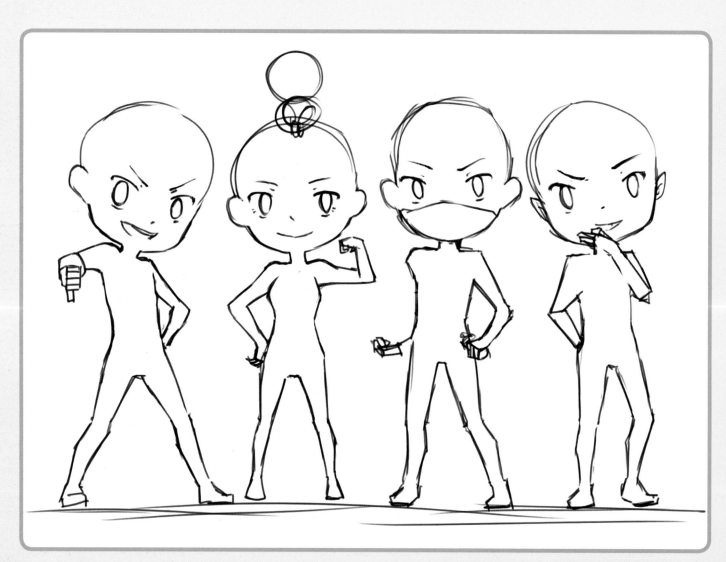

5. DETAILS

Spend time adding more details to separate each character from the rest and to give them unique personalities. Each has a different look and pose. Add the clothes and hair.

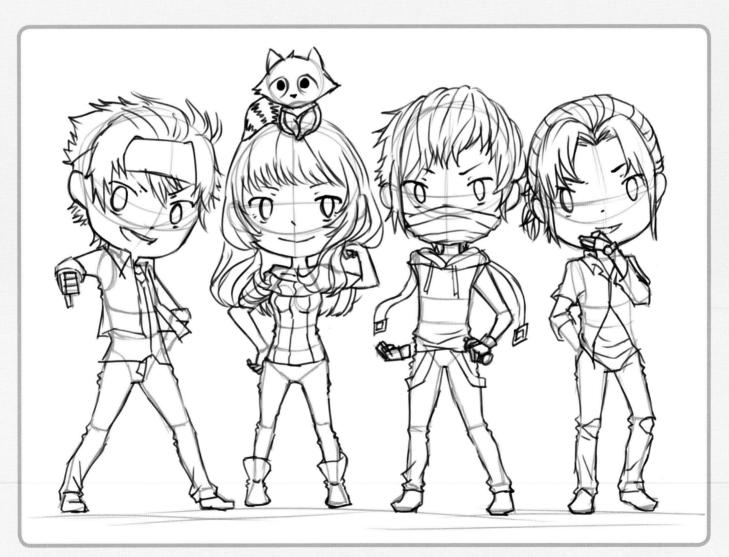

6.1. COLOR

Color in the characters flesh. You should add variety by making some lighter or darker than the others.

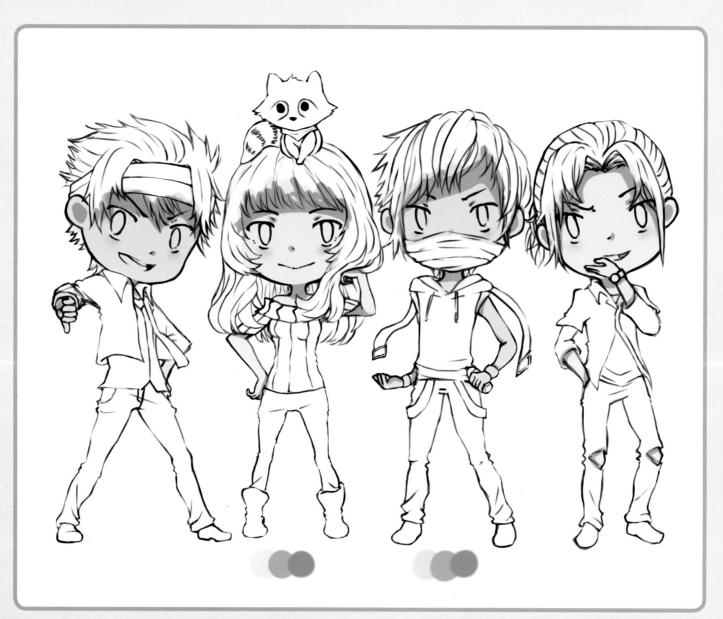

6.2. COLOR

Once you've chosen your color palette for each character, color in their hair, clothes, and eyes. After determining the light source, add darker and lighter shades to represent shadows and reflections.

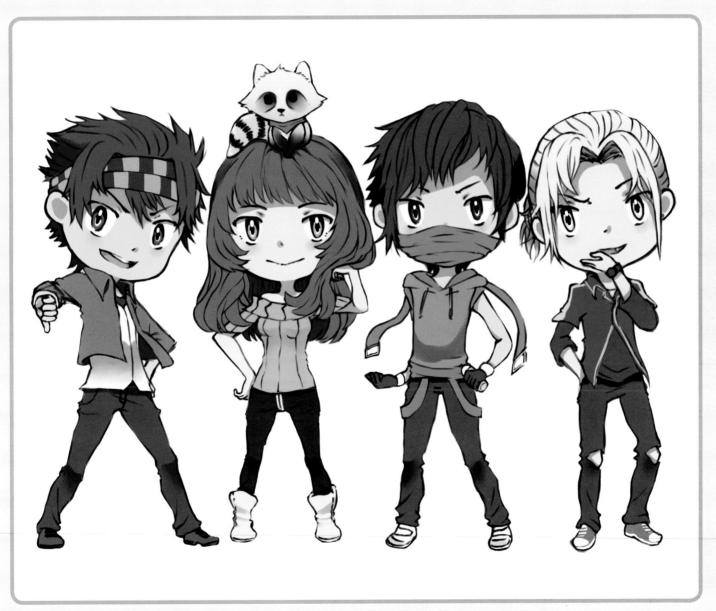

6.3. COLOR

White is added to the characters eyes and hair to make them shine. Be aware of the direction of the light source.

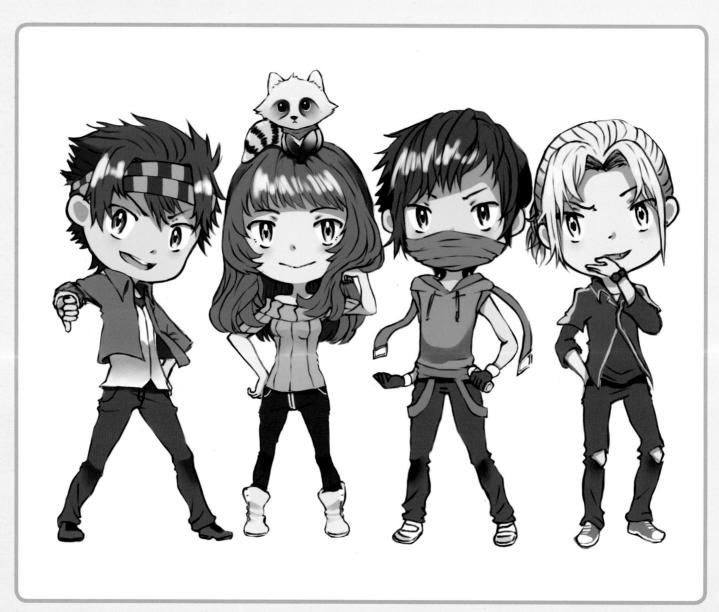

7. BACKGROUND

For the background, try to make it as simple as possible, this way the characters are the main focus of the image.

E I G H T

8. FINISHING TOUCHES

After creating the background layer, place the characters over the top of it and outline them in a thin black line to really make them stand out.

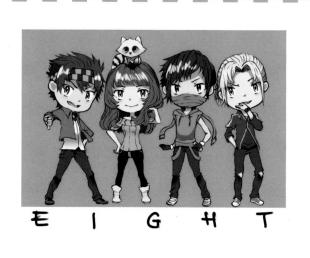

TIPS & TRICKS

- Add a rotated number 8 behind the characters as a reference to their name, the 8th Division.

- Another reference is made to the group's name by typing the word "eight" below them. Choose a subtle font that is consistent to the style of the characters.

- Software used: Paint Tool SAI & Adobe Photoshop.

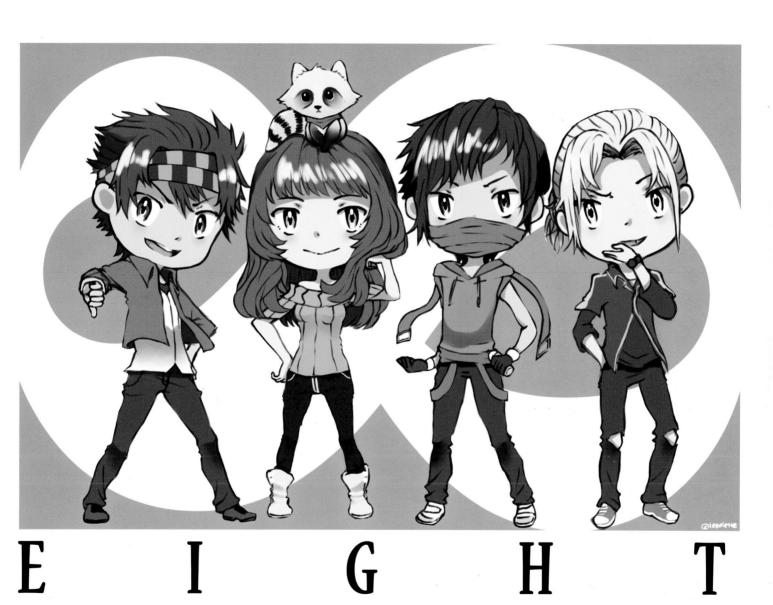

E I G H T

STARRY NIGHT

Sasha is one of Queen Luna's daughters. She is always very cheerful and friendly to everyone she meets. Every night, she gazes up at the stars from her balcony and dreams about meeting a prince.

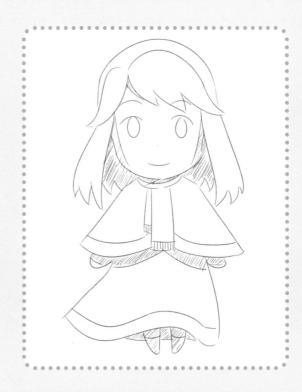

1. SKETCH

Choose an image that is representative of Sasha and what she enjoys to do: stargazing. The pencil sketch on the right is perfect!

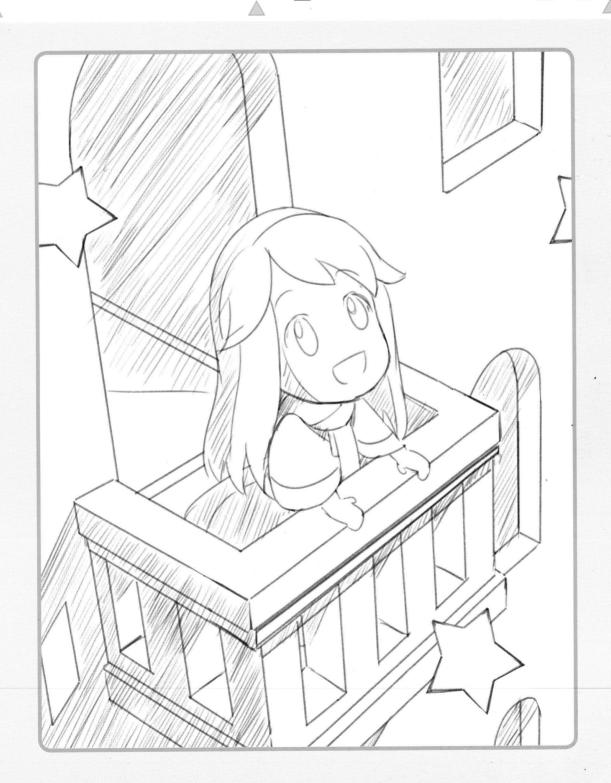

2. STRUCTURE

Outline her pose. You want her to appear to be leaning over the balcony and looking up eagerly.

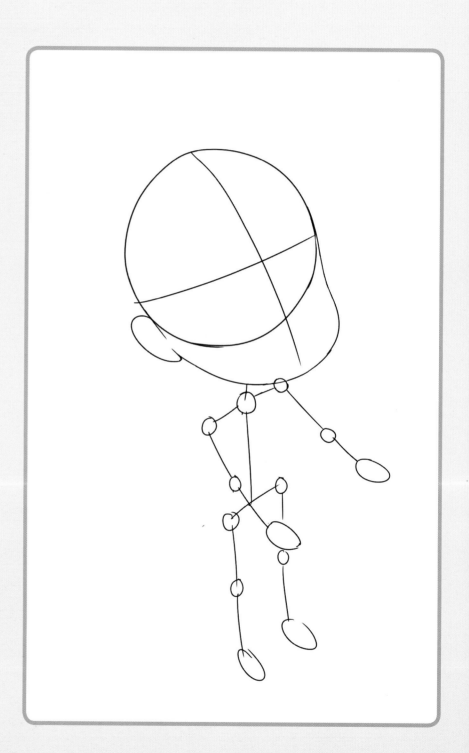

3. VOLUME

Using thin lines, draw her body based on the outline created in the previous step.

4. ANATOMY

Add hair and large, expressive eyes, and then her mouth.

5. DETAILS

Now draw the balcony and her clothes. Since she is a princess, she should be dressed in a royal gown.

6.1. COLOR

Start to fill in some basic colors for the hair, skin, and clothes.

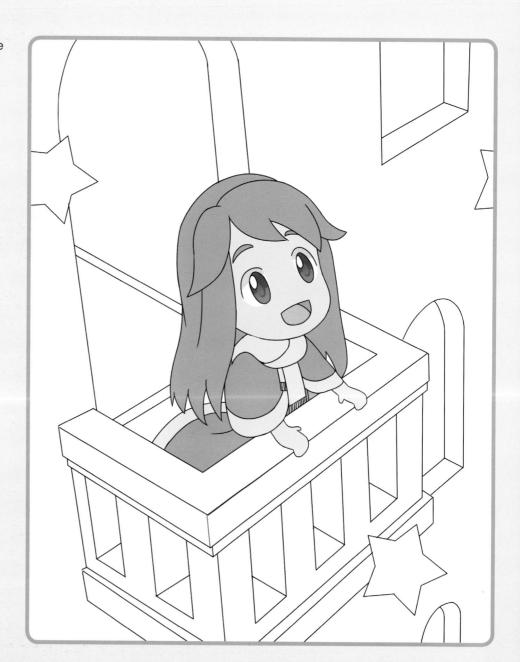

6.2. COLOR

Chose the source of light, in this case above the character, and then add shading to give her more depth.

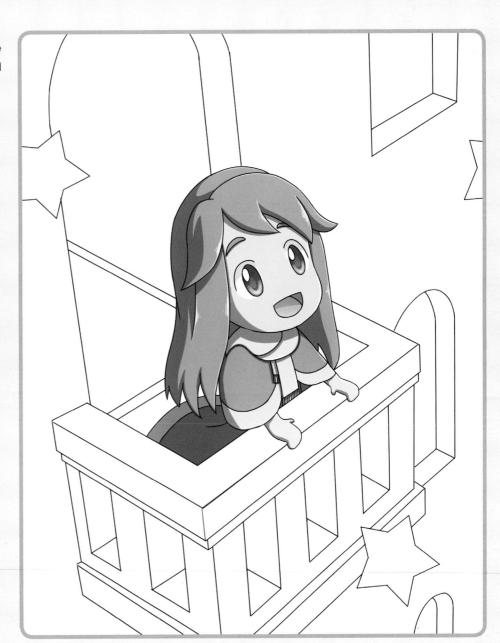

7.1. BACKGROUND

Explore some basic colors for the background. The scene is set at nighttime, so dark colors should be used for the castle.

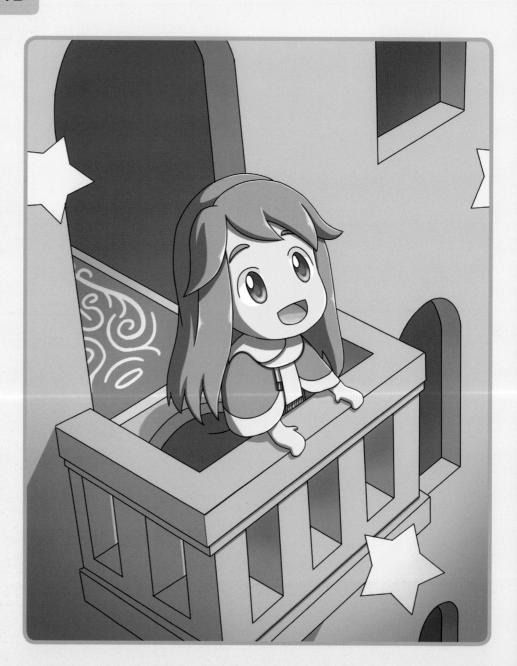

7.2. BACKGROUND

Add some details to the wall. The bricks will give the building the look of a castle.

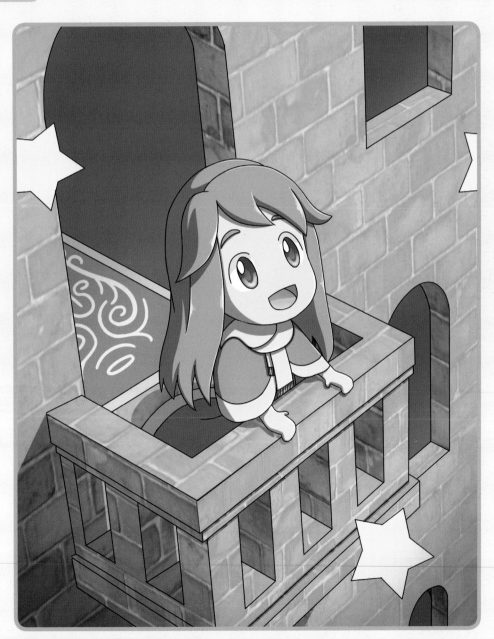

8. FINISHING TOUCHES

All that remains is adding a glowing effect to the stars, and then the image is done!

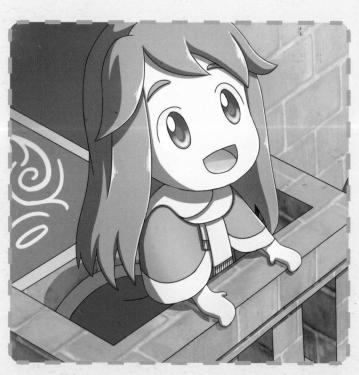

TIPS & TRICKS

• Don't forget to color the outline to make it better.

• To make a glow effect, you can use "color dodge" in the "layer option" menu.

• To make shadows, you can use dark colors or use "multiply" in the "layer option" menu.

• Software used: Clip Paint Studio & Photoshop CC.

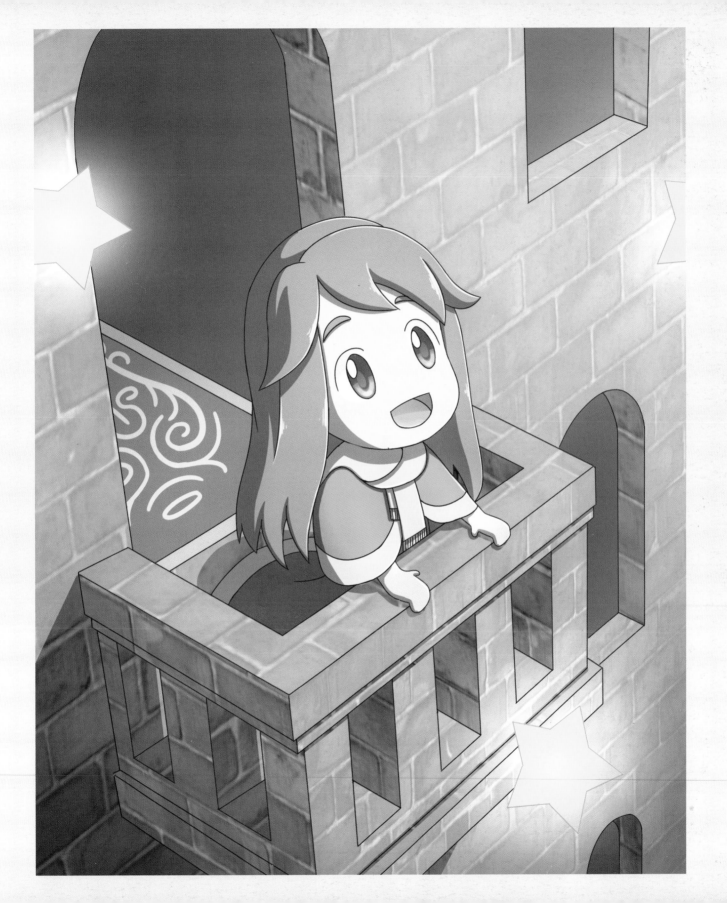

GAMER CHIBI

This gamer girl is just like any other gamer. She likes playing all sorts of games and spends most of her time locked in her room. She doesn't need anything else besides her game player and plenty of free time.

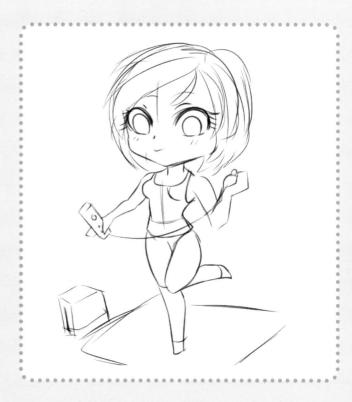

1. SKETCH

Make a quick, but clear, sketch of how you want your chibi to look and where she should be—in this case, sitting in her room and playing a video game.

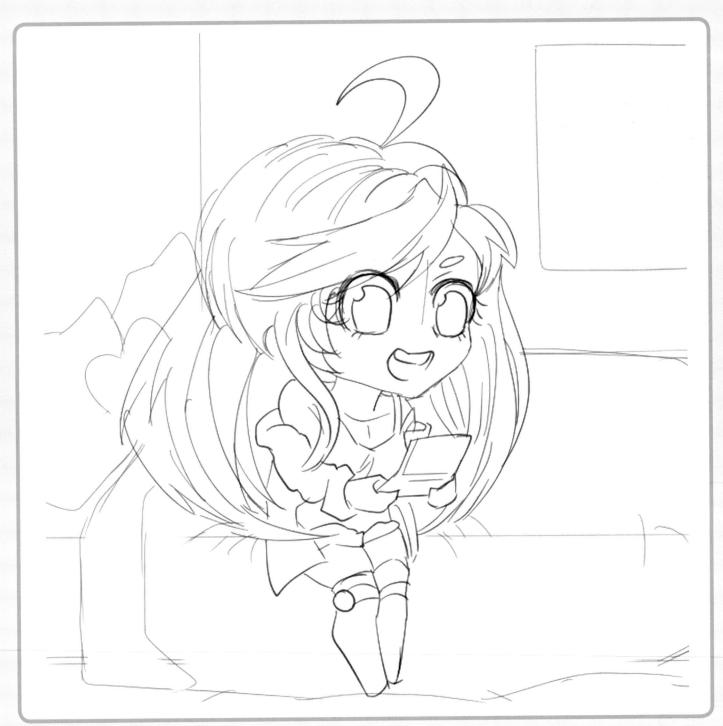

2. STRUCTURE

Map out the pose of your character using lines and circles as reference points.

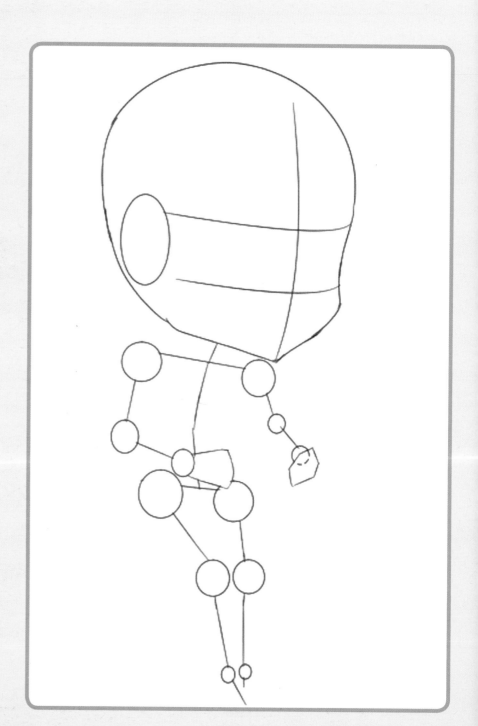

3. VOLUME

Once you've drawn her body, clean up the lines and add very large eyes and a mouth.

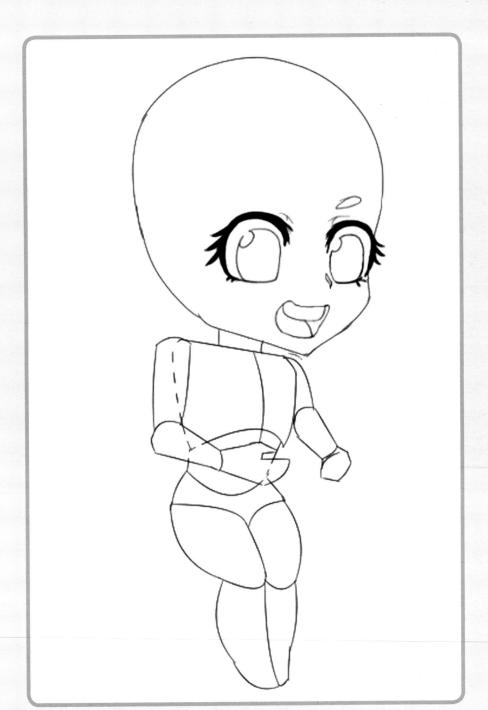

4. ANATOMY

Add lush hair to the character and refine her body to make sure your proportions are correct.

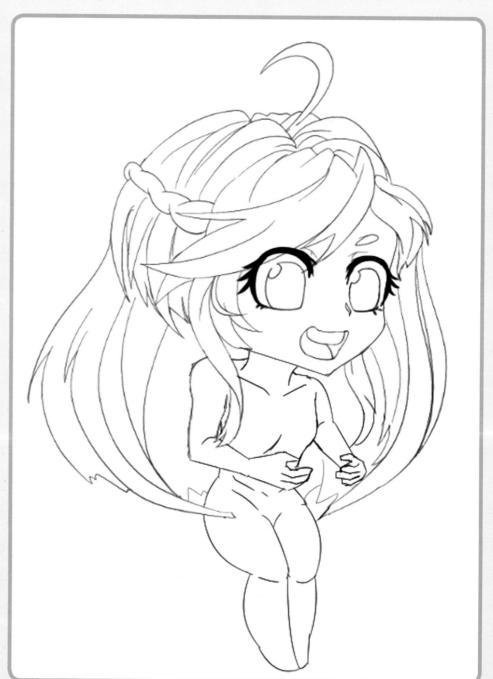

5. DETAILS

Now it's time to give her clothes and other details such as her video game. The basic drawing of your chibi is now complete.

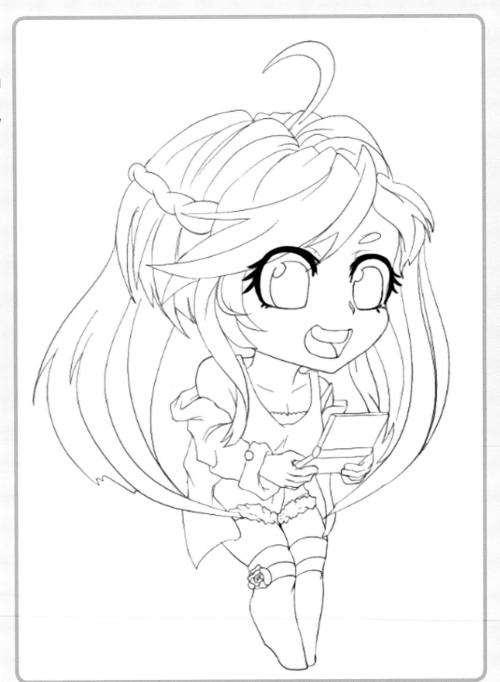

189

6.1. COLOR

Use a bunch of bright colors to fill in your chibi. To make her more fun, give her a cool hair color.

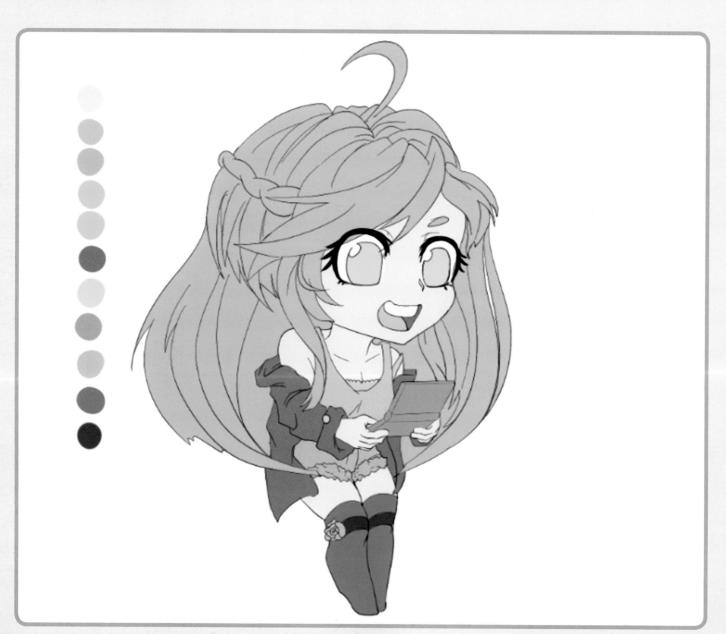

6.2. COLOR

Now add basic shading to her hair, face, and clothes. Note the heart shape in each eye. This shows how much she loves her game.

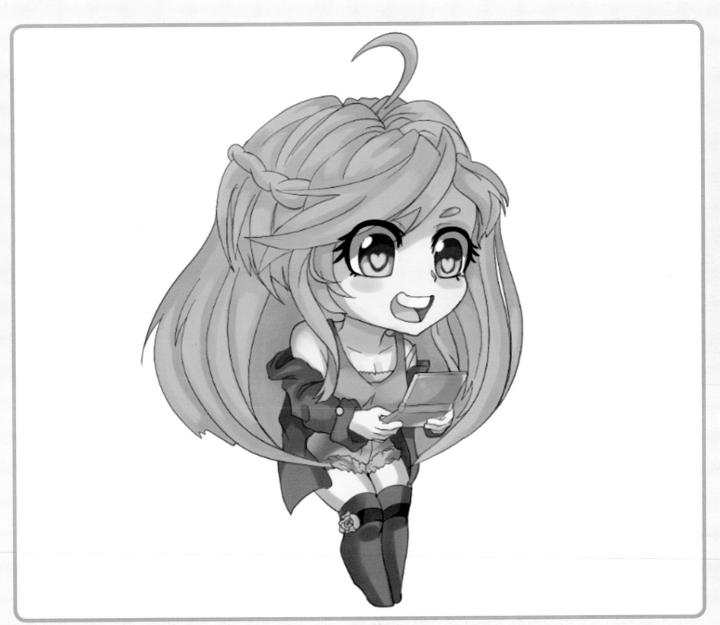

7.1. BACKGROUND

In a new layer, create the character's bedroom, which will serve as the background.

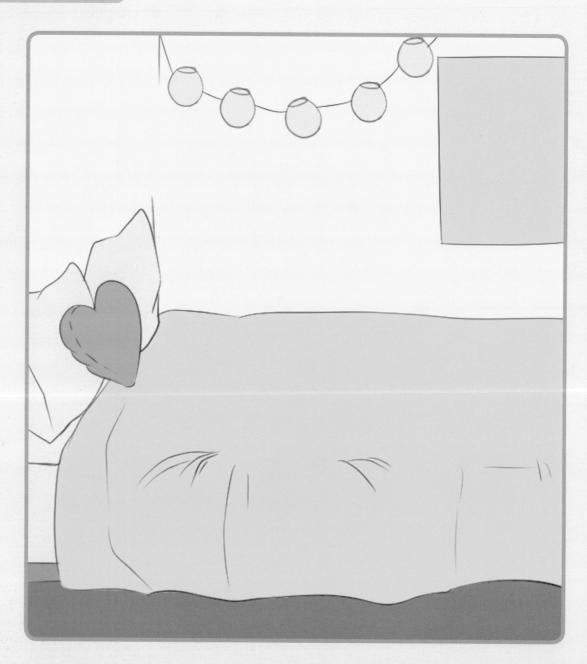

7.2. BACKGROUND

After you've colored the room, apply shading to give it more depth.

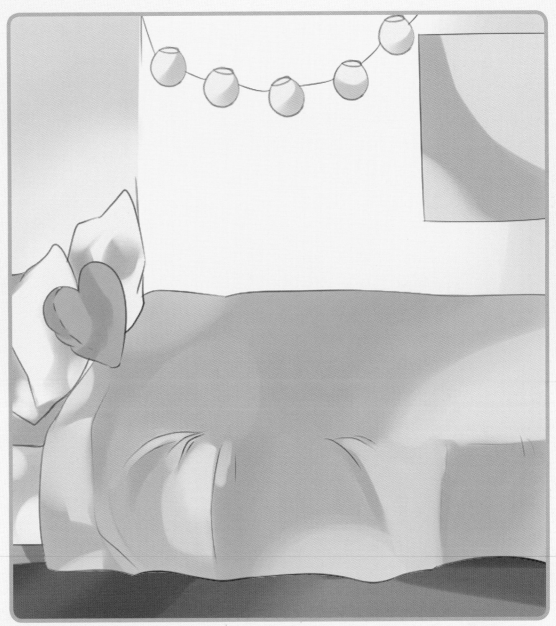

8. FINISHING TOUCHES

After you've merged the character layer on top of the background layer, add some color filters and lighting effects.

Create several layers and do as many samples as you want until you get the right one.

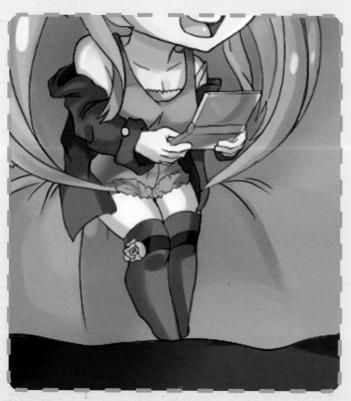

TIPS & TRICKS

• By using an "overlay" layer with different colors, you can experiment with making different objects in the image stand out.

• Software used: Manga Studio 5.

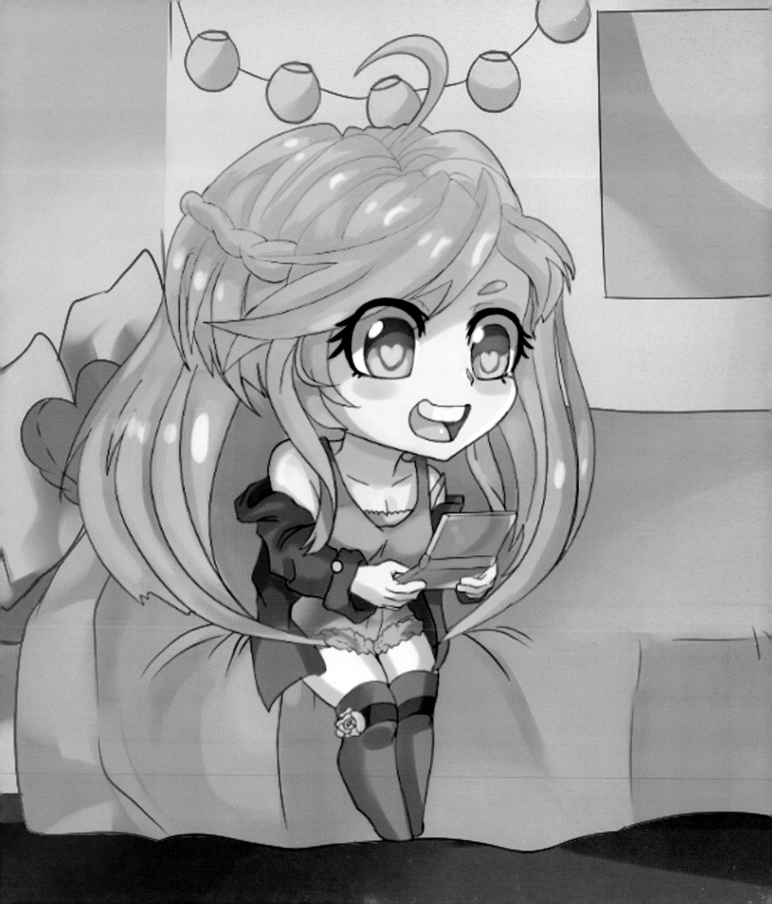

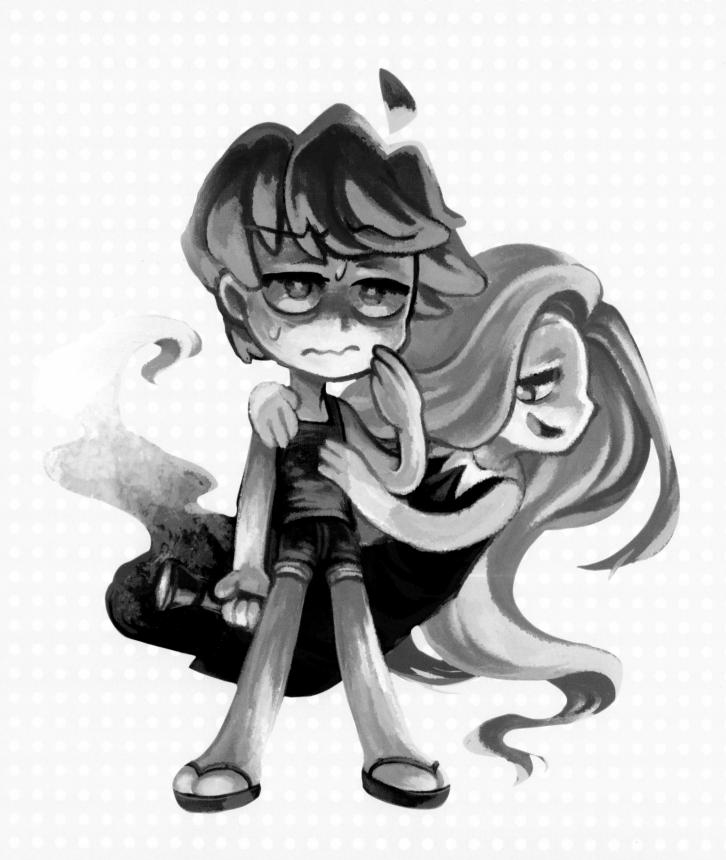

FANTASTIC WORLD

SPOOKY NIGHT

SIREN

THE FAIRY OF BRINY TEARS

MAGIC FOREST GIRL

LITTLE FAMILY

SPOOKY NIGHT

The little boy is being haunted by a ghost who has fallen in love with him. He has tried to escape countless times, but the ghost girl loves him too much.

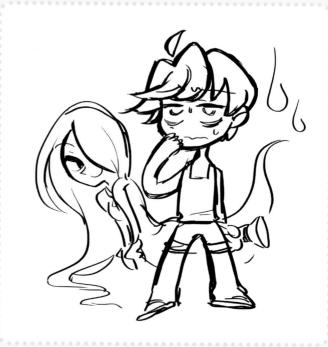

1. SKETCH

After sketching a few different options, the one on the right is chosen because of how funny it is.

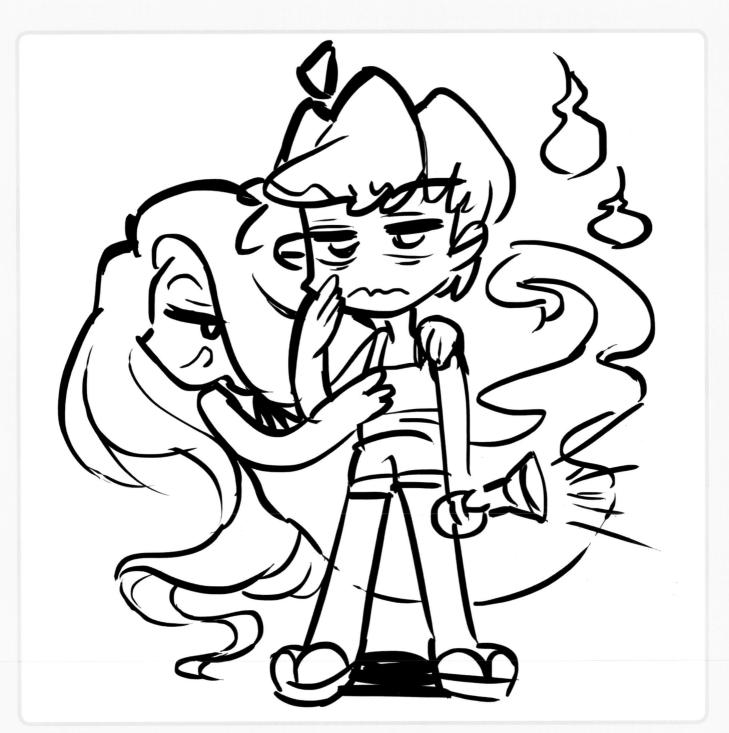

2. STRUCTURE

Outline the two figures. The boy is placed in the center of the drawing with the ghost appearing behind him.

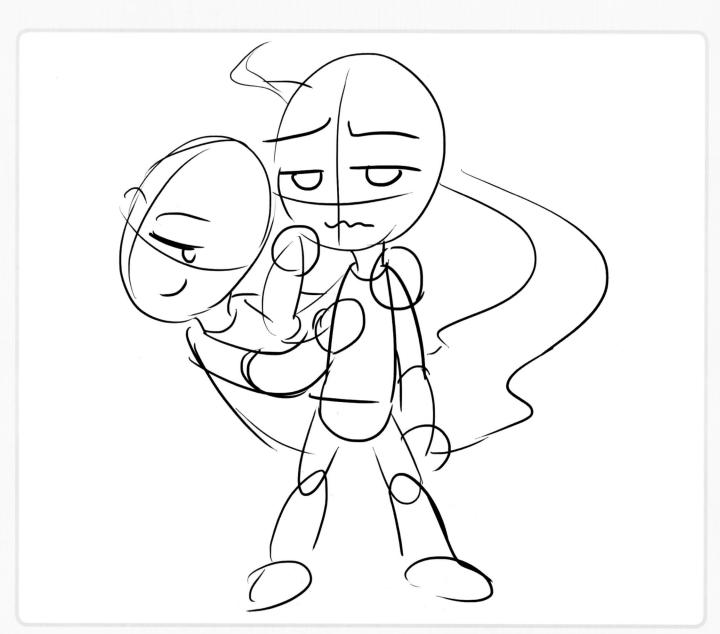

3. VOLUME

Add hair and other physical traits.

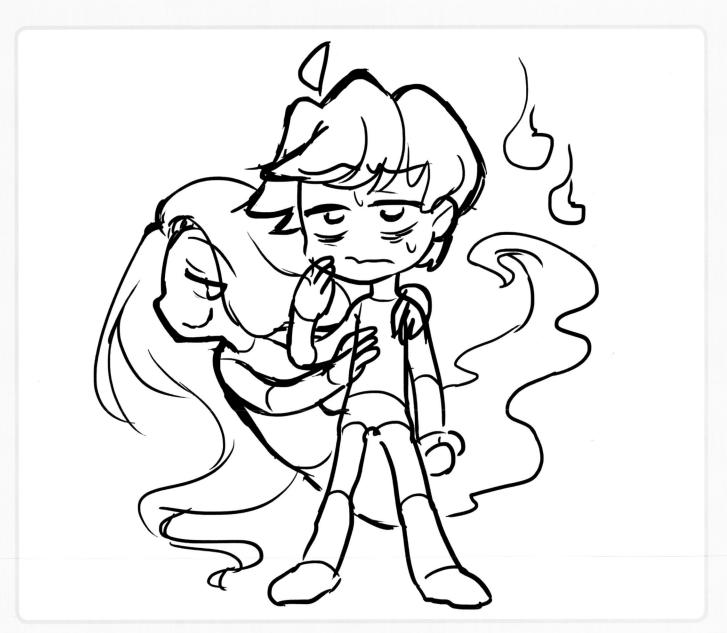

4. ANATOMY

Create the clothes for our characters. Shorts and T-shirt for him, and a dress that mixes with the smoke of the body for the ghost girl.

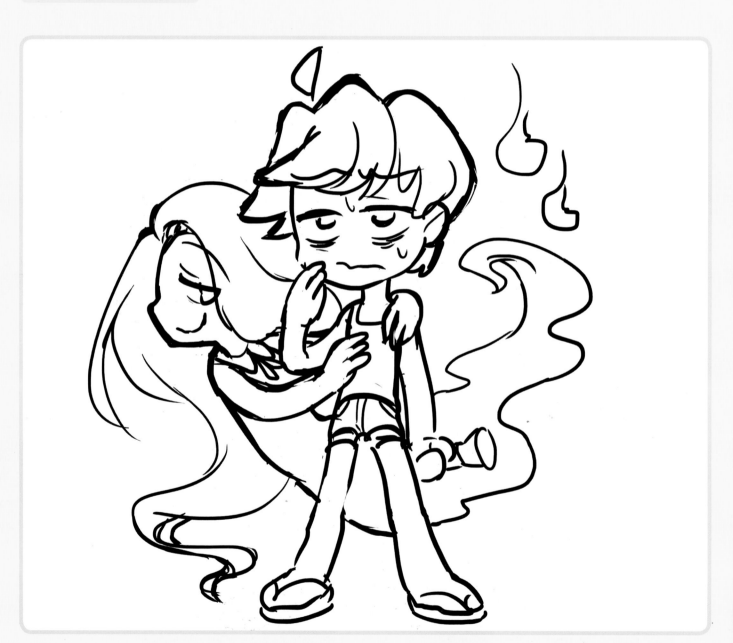

5. DETAILS

Fill inside the characters using a black base color. This will help when adding shadows to create depth later.

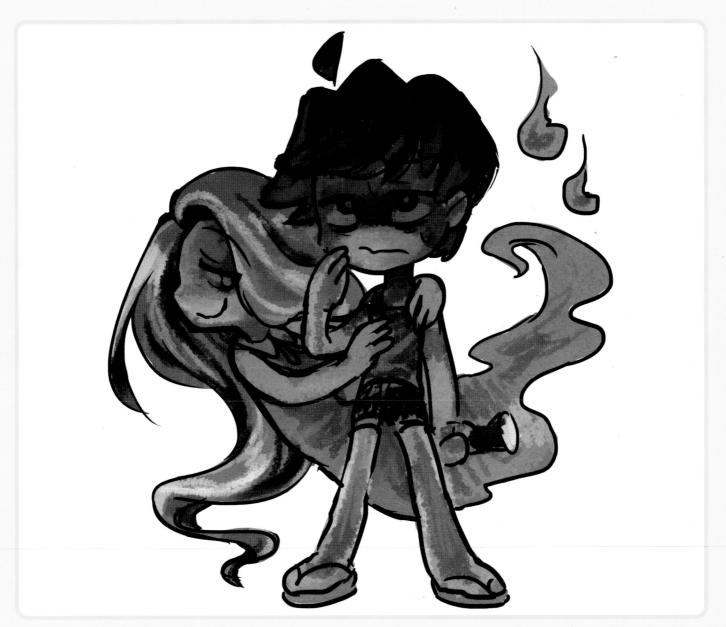

6.1. COLOR

Make the background black and then use light shades of color to color in the boy and the girl.

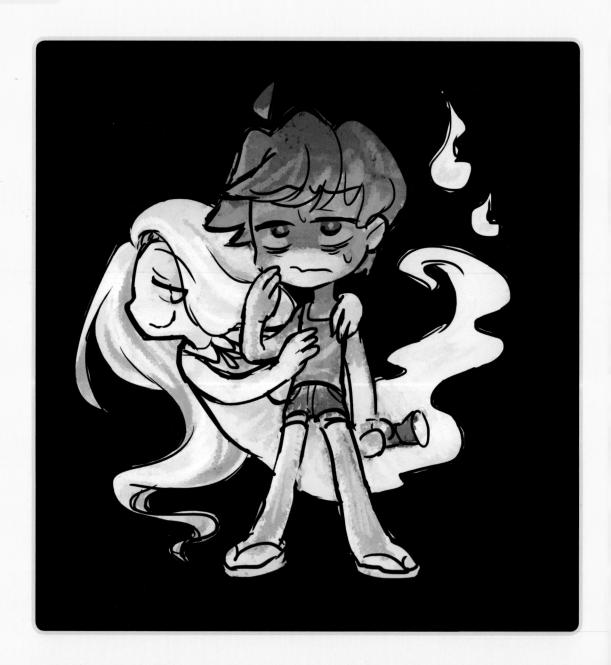

6.2. COLOR

To make the ghost girl appear more translucent and eerie, a greenish color is used for her hair and a light blue for her skin. Add highlights and shadows to the characters, and color in the clothing.

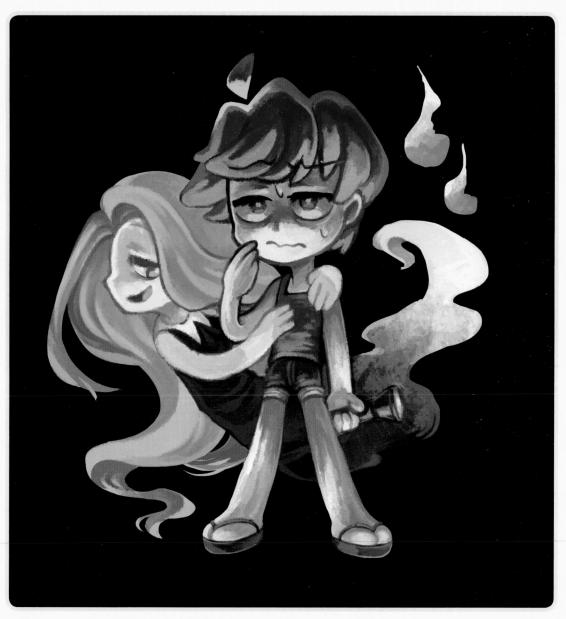

7.1. BACKGROUND

In the background layer, use violet tones to create the night sky.

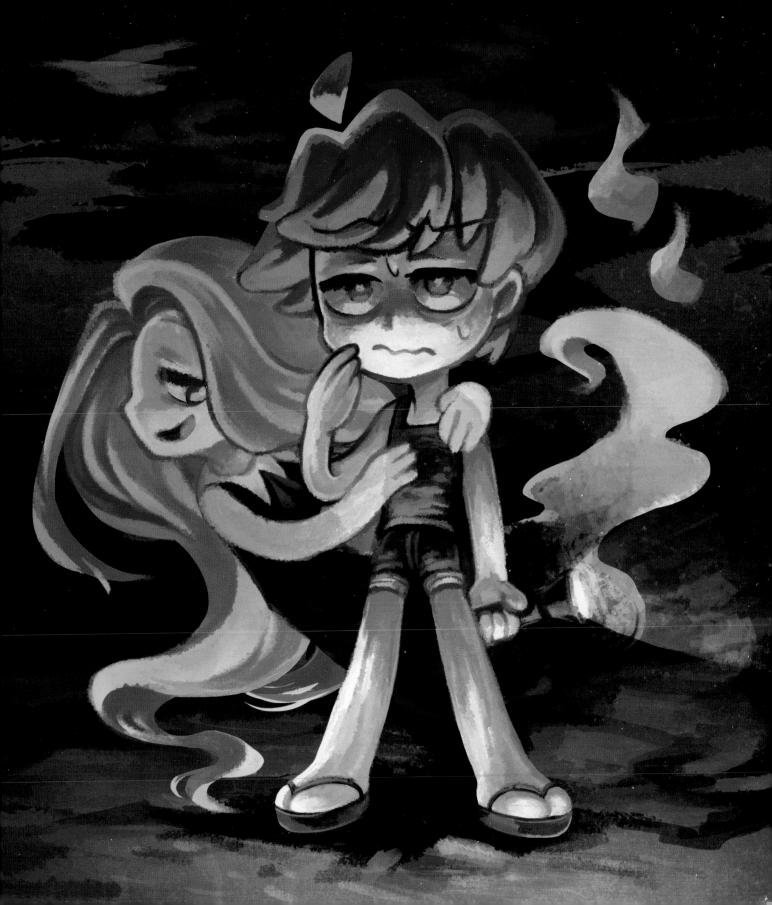

SIREN

Siren is a sweet little mermaid who lives in the tropical sea. She is helpful, carefree, and friendly, and is loved by other sea creatures. She loves to make new friends, and is always ready to help anyone who is in trouble. You can count on her for anything.

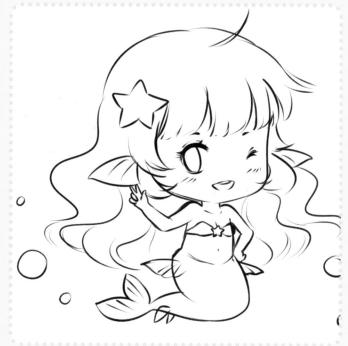

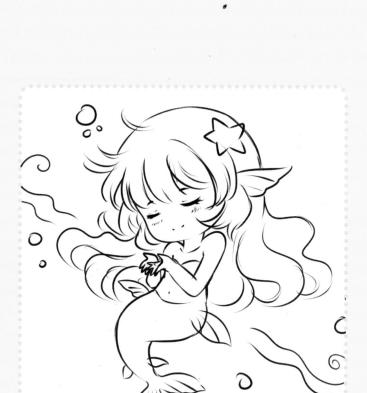

1. SKETCH

A mermaid is a mythical creature that is half beautiful girl and half fish. They are usually portrayed as being very joyful. Explore various poses before picking one you like best.

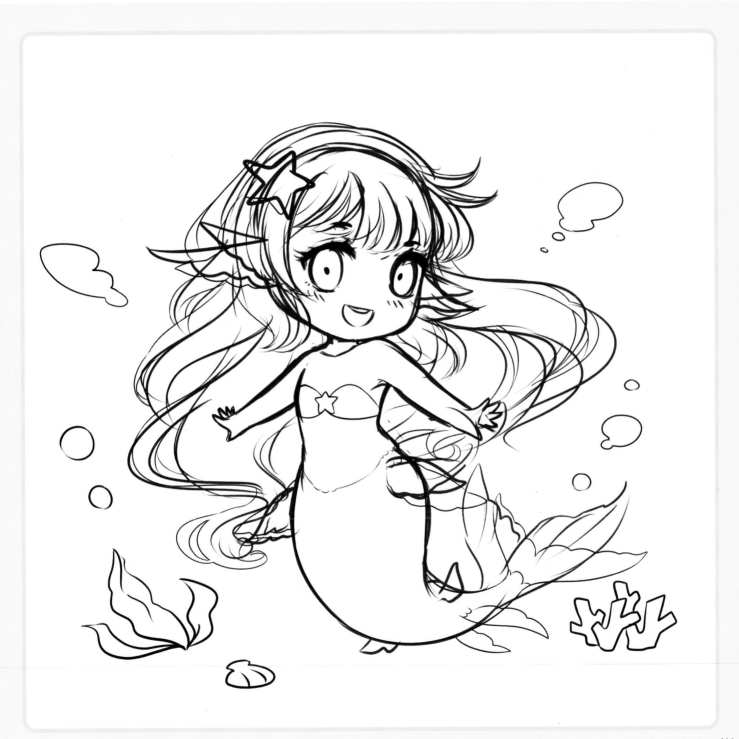

2. STRUCTURE

You want to make the impression that she is happily swimming in the ocean, so you need to create a dynamic pose.

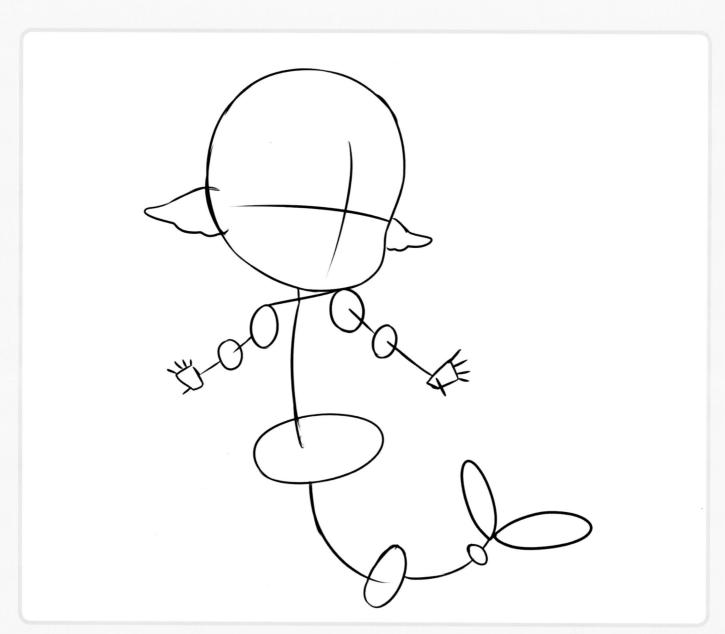

3. VOLUME

Long, flowing hair and a small body make a cute chibi. Add big eyes, and note that although this is not the "detail step," add a sea star to her hair.

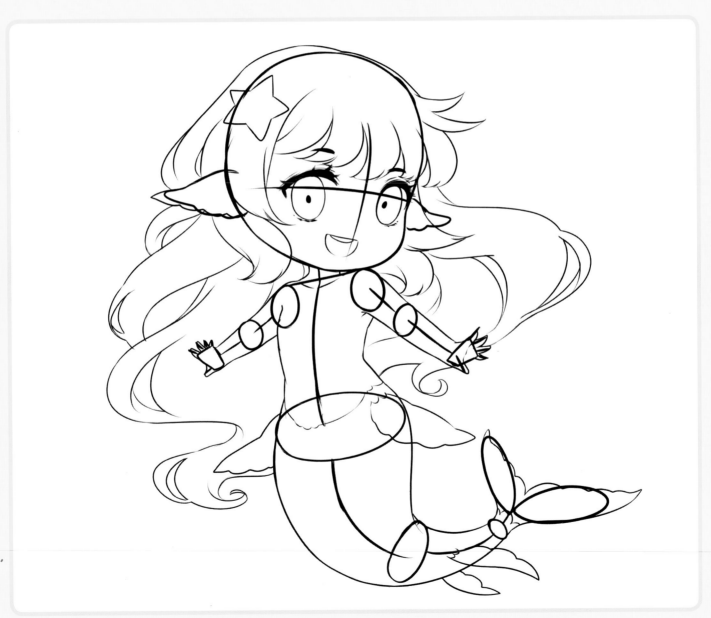

4. ANATOMY

Now refine her body line. Give her a joyful expression.

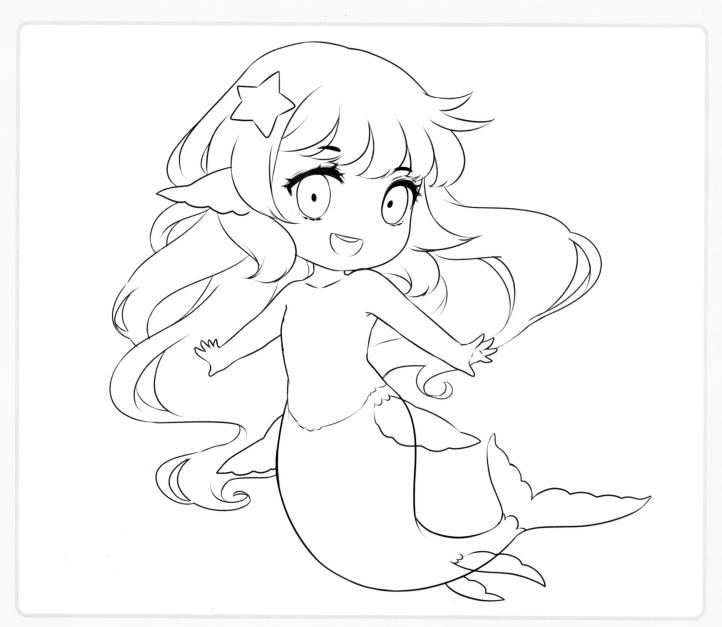

5. DETAILS

Add all her distinctive features, such as her mermaid tail and fins, her cute top with a star, and some underwater objects like seaweed, bubbles, and coral.

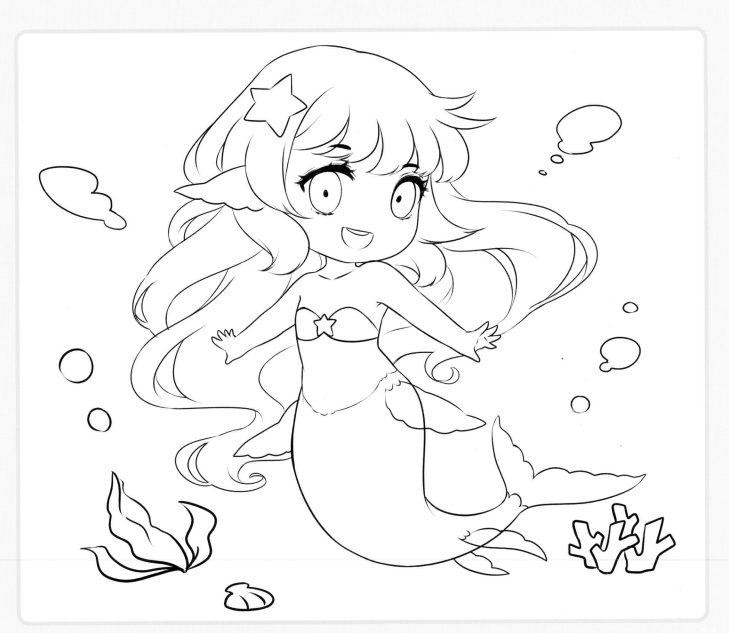

6.1. COLOR

Start by using base colors for her skin, hair, tail and other details. Each new base color should be put on a different layer.

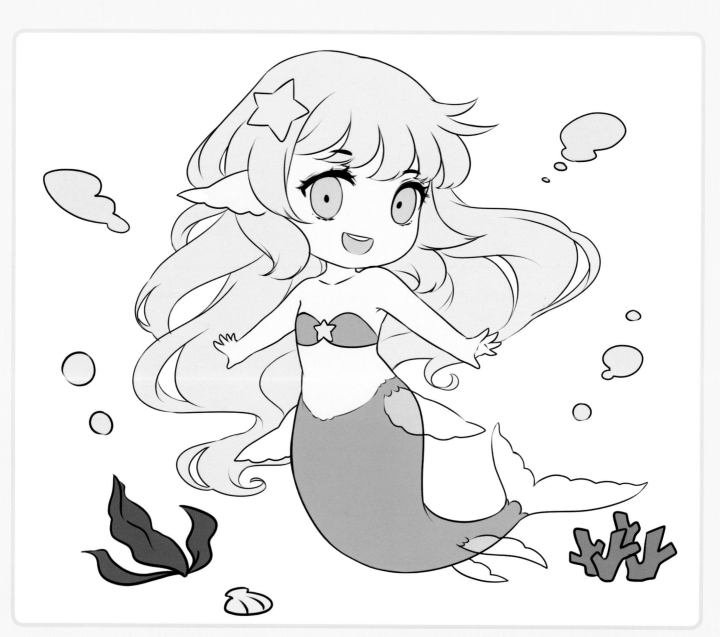

6.2. COLOR

Decide your light source. Use darker colors to add shadows. Reduce the opacity of the fin layer to get the transparency, and then touch up with some highlights to create a shiny effect on her hair and tail, as well as on her eyes to show the direction of her gaze.

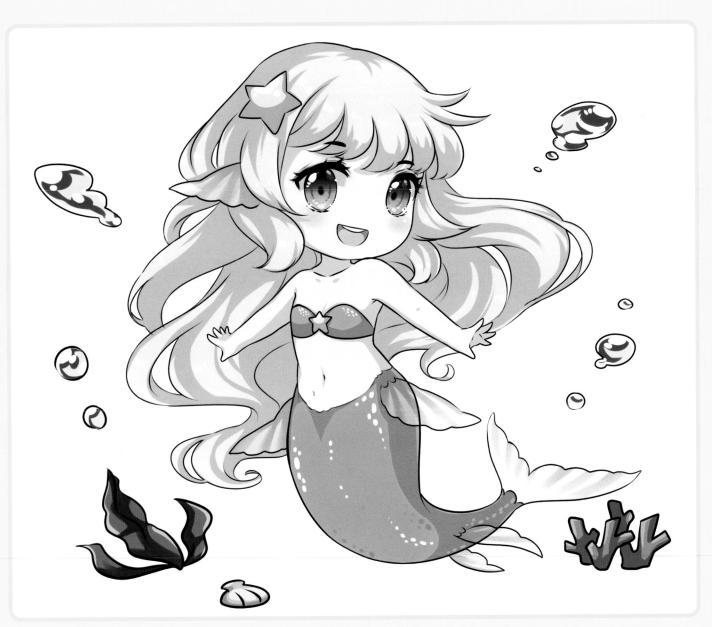

7.1. BACKGROUND

To get the ocean floor, first you need a dark-grayish yellow for the sand. Use a darker and lighter blue for the water and then make a gradient from the darker blue to the lighter blue to create depth. Also, smudge/blur the edge of the sand floor to get a more harmonious feeling.

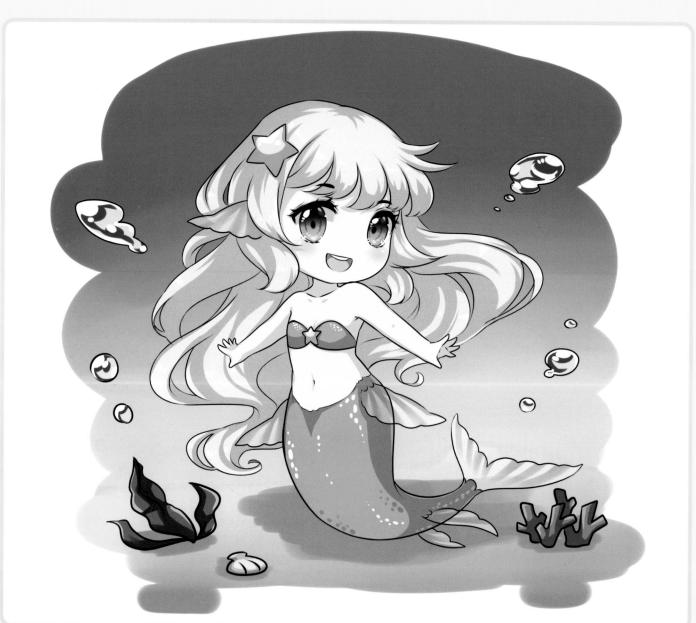

7.2. BACKGROUND

Add some dark fish-shaped dots to create a school of fish in the background, and then play with the opacity. Make some coral shapes and decrease the opacity to get some depth effect.

8. FINISHING TOUCHES

Use different shades of brown to create Siren's shadow on the sand. Keep in mind it should be a bit unfocused to give the feeling of being underwater.

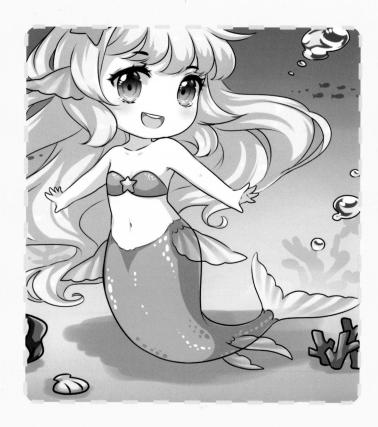

TIPS & TRICKS

- Always use pastel colors as a base and then add shade by using darker colors.

- The gradient helps to create depth.

- Adjust the opacity until you like it. This helps to create depth and transparency.

- Software used: Paint Tool SAI.

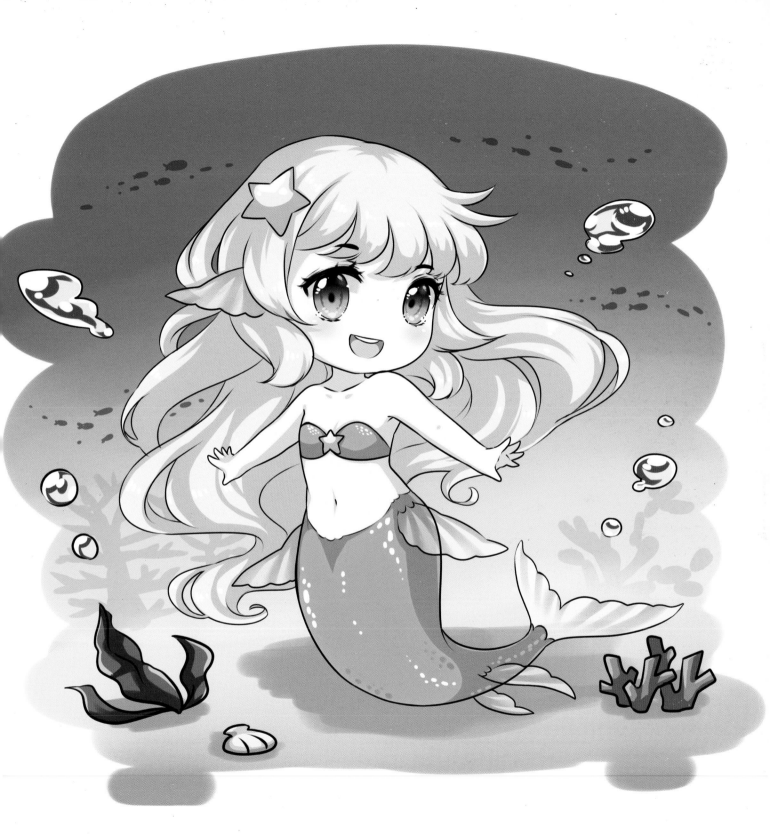

This poor little fairy was bought in a bazaar by a boy during the Christmas sales. She lives in a bottle and, even though she can be naughty, the boy loves her anyway.

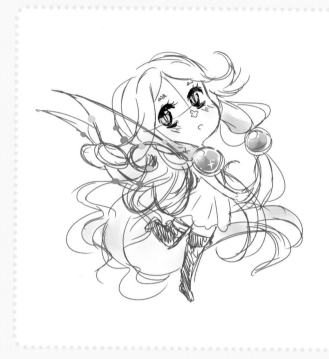

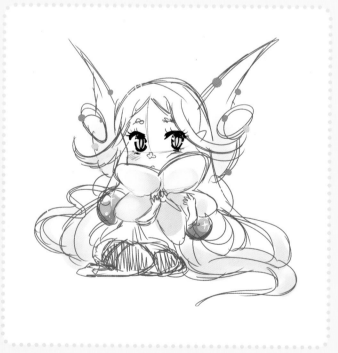

1. SKETCH

Play around with several sketches and then pick one to develop.

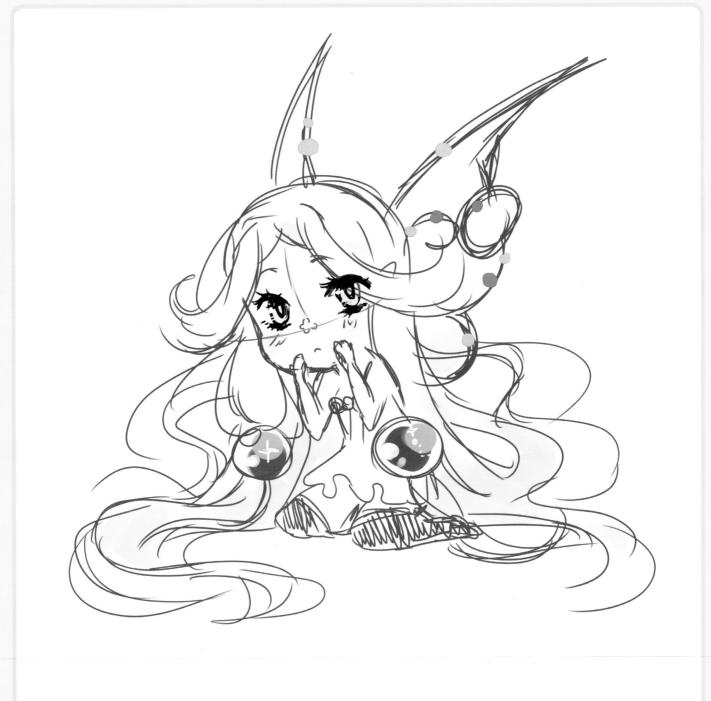

2. STRUCTURE

Sketch the body structure of the little fairy. At this stage, it's good to explore different angles until you get the exact pose you want.

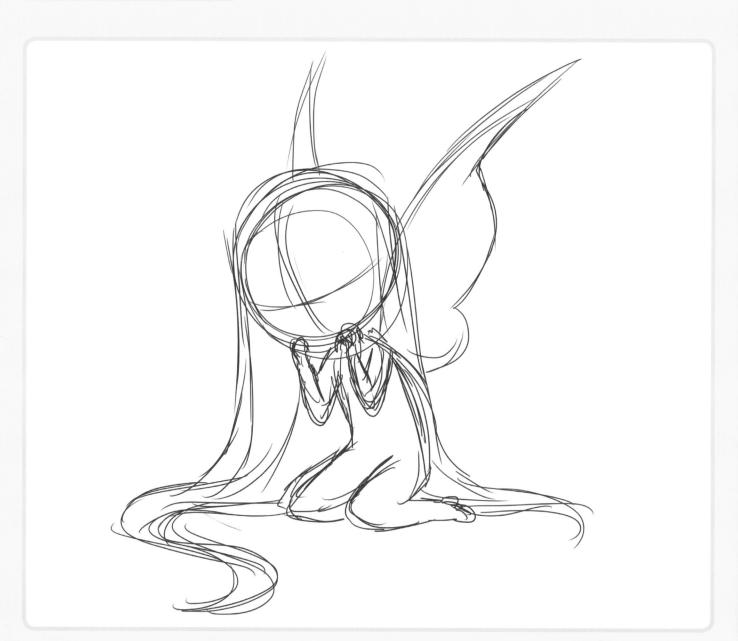

3. VOLUME

Make your sketch clearer by drawing eyes, hair, and little details, such as the spheres.

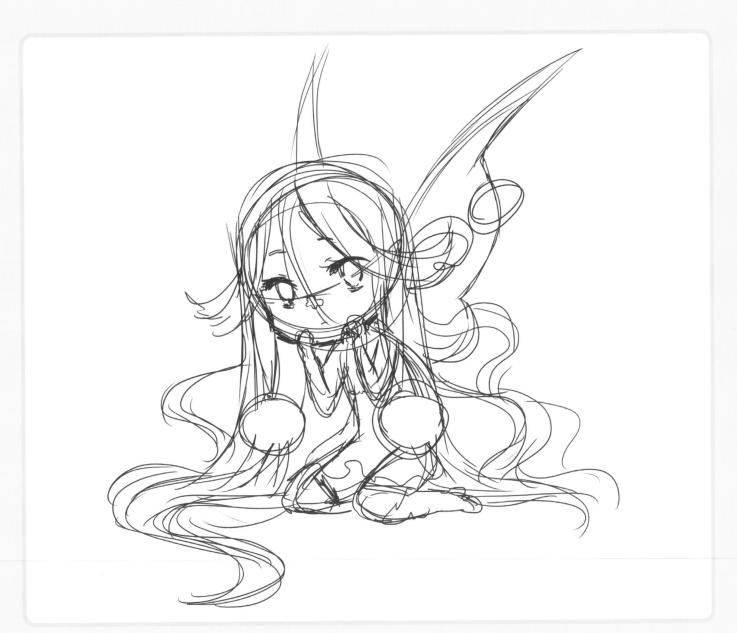

4. ANATOMY

Next, carefully define the chibi. Clean up the edges and apply a light outline.

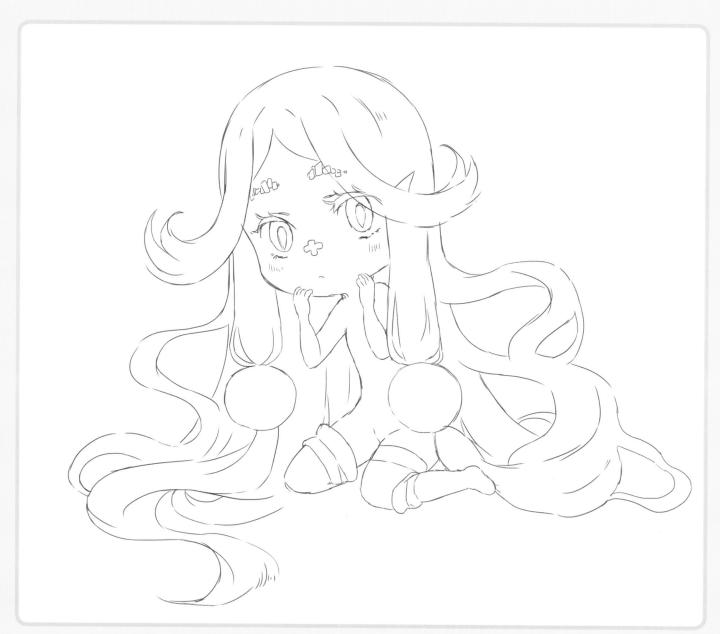

5. DETAILS

Give the character two dazzling wings with lots of details. in a new layer, draw a fun little dress.

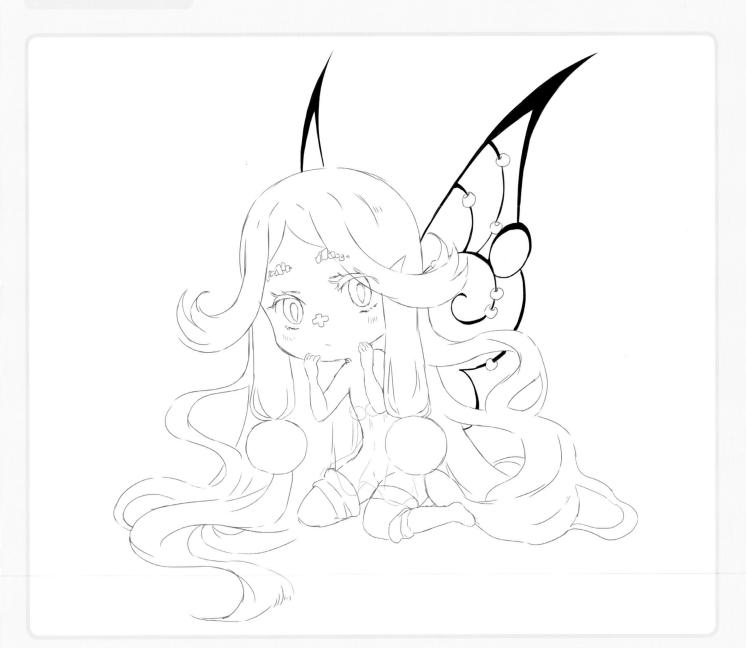

6.1. COLOR

Begin coloring the different areas of the fairy. Use very soft translucent colors at this stage.

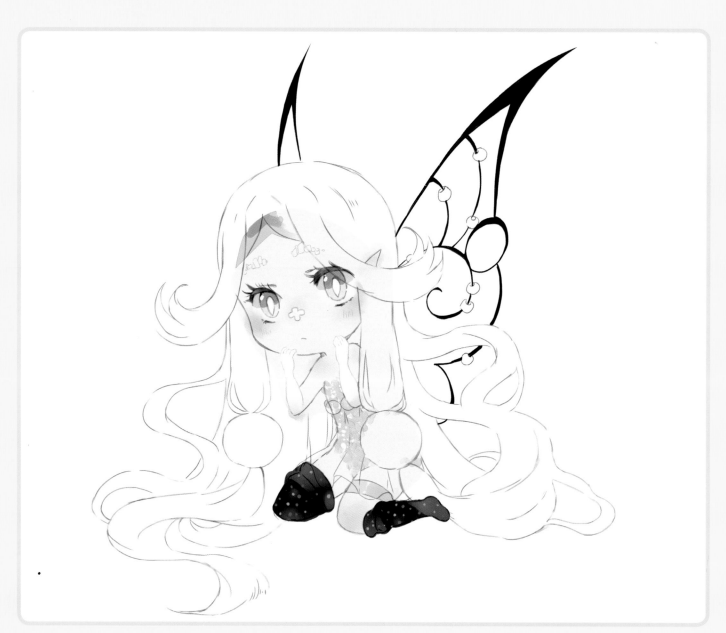

6.2. COLOR

Add more color to her hair and dress. At this stage, her wings should be the only thing left. Play with the translucency of her dress.

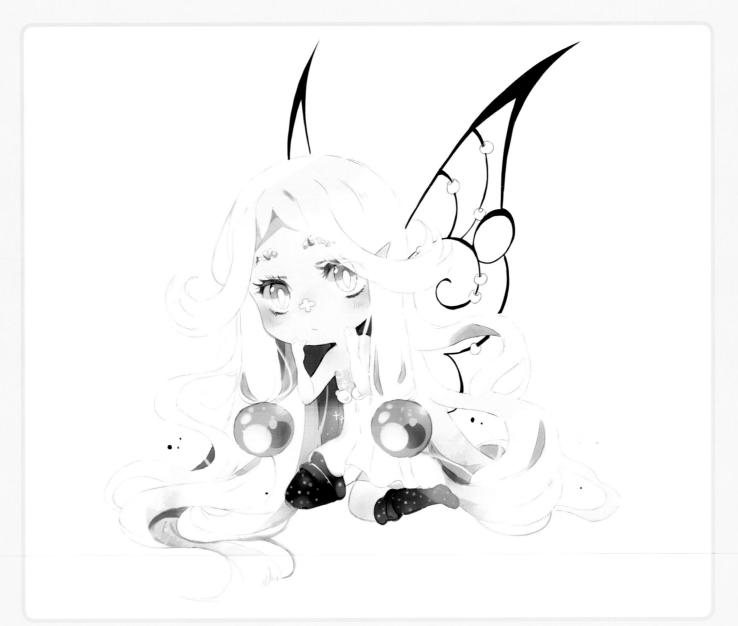

7.1. BACKGROUND

In a new layer, draw a flower by using the "Custom Shape Tool" in Adobe Photoshop. Duplicate this flower to make a sightly bigger second one. Apply some gradients.

7.2. BACKGROUND

Add glitter using a night sky texture.

8. FINISHING TOUCHES

Apply a fun texture to the background to give it more depth. When you combine the layers, notice how the dots and blue tones fuse perfectly.

TIPS & TRICKS

- Give the character a thin white outline to highlight it against the background.

- Use different gradients to create a more interesting look on your fairy.

- You can add little flashes in different areas on the character and the background to give the image a more magical touch.

- Software used: Paint Tool SAI & Adobe Photoshop.

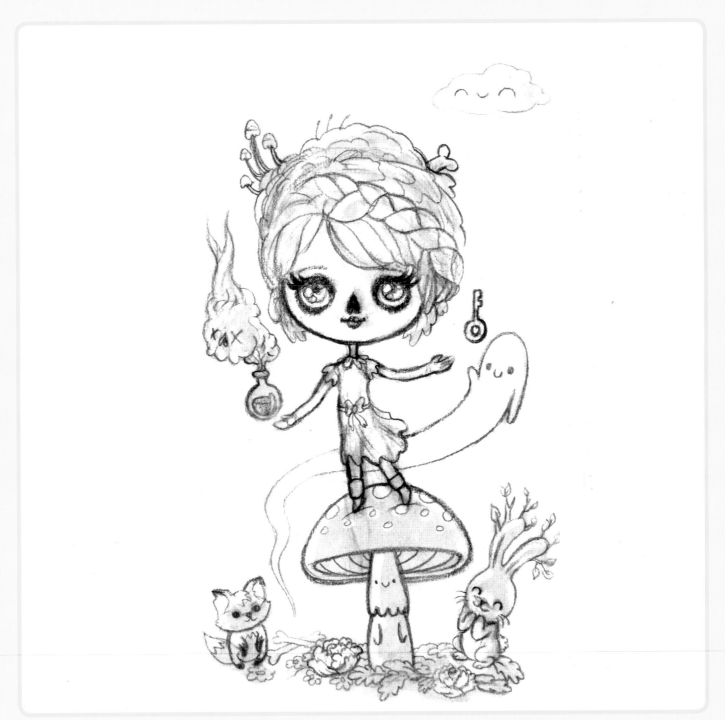

2. STRUCTURE

Since this is a chibi style, her head is exaggerated in size to be very large in proportion to the body, which is exaggerated to be small and is approximately the same size as her head. The same attention to detail should be shown for the other creatures in the scene.

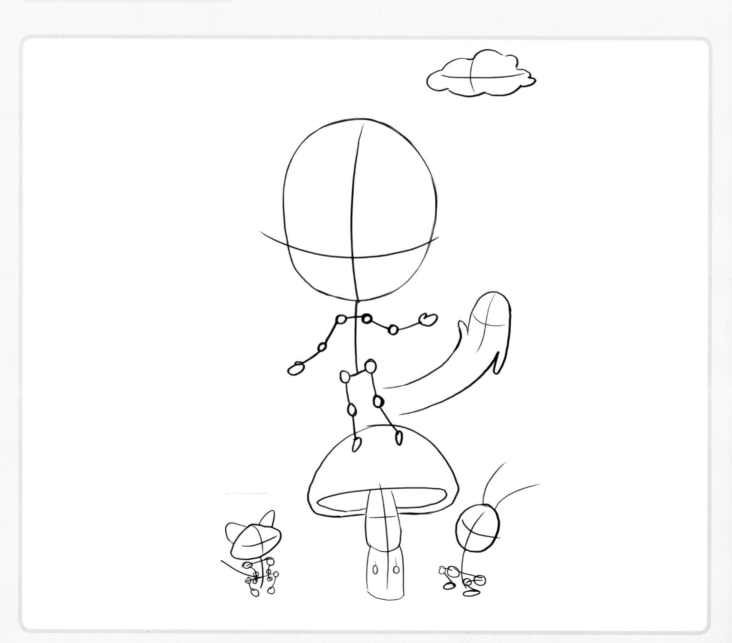

3. VOLUME

Draw her body and hair. Rounding the overall shapes of the bunny and the fox makes them cuter and gives them more of a chibi style. Erase some of the structural guidelines that you no longer need after you have developed the volume lines around them.

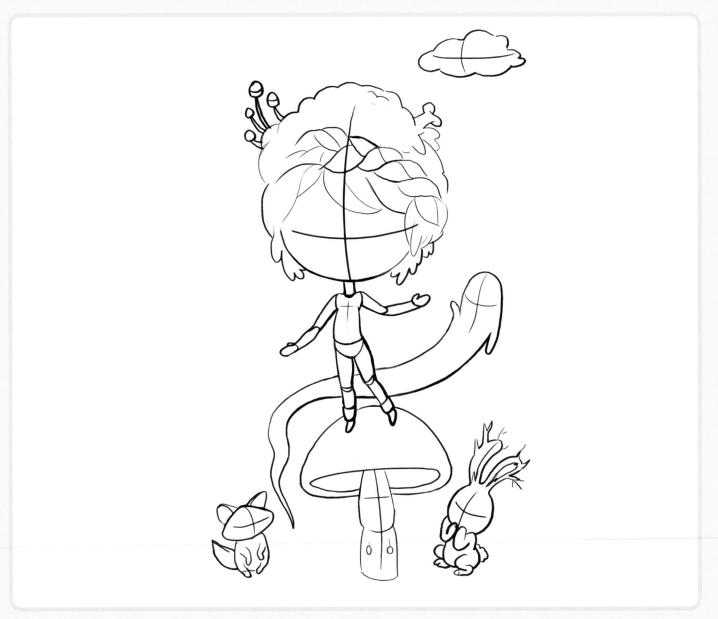

4. ANATOMY

After you've established the proportions, use some of the remaining guidelines to add physical features such as eyes, a mouth, a nose, and fingers.

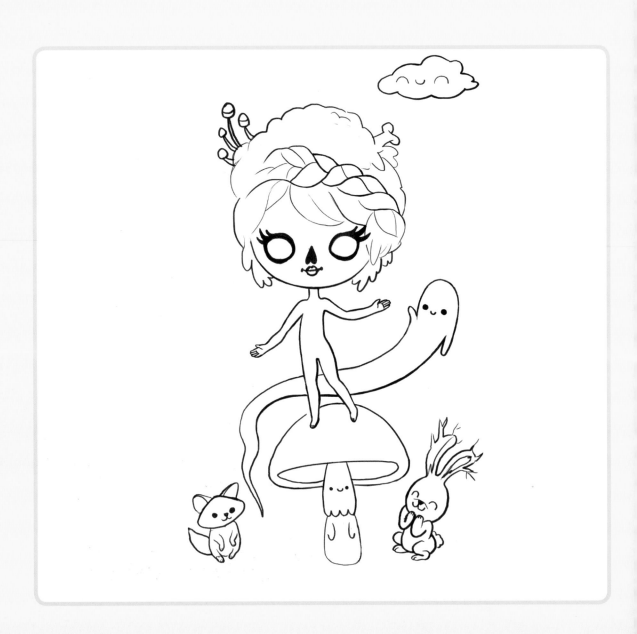

5. DETAILS

When you have finished her features, add more details such as the design of the character's outfit, accessories, hairstyle, eyelashes, reflective light in the eyes, and so on. Additional details like a background character's fur, whiskers, or spots should also be added.

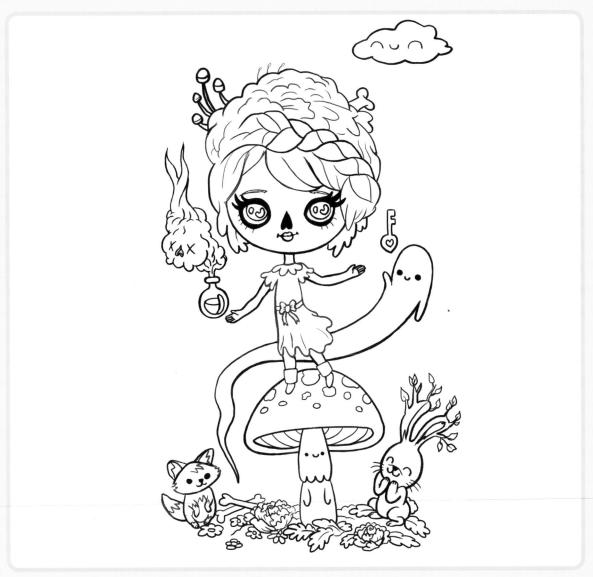

6.1. COLOR

With Adobe Photoshop, create a palette of color swatches in the swatch window. Make a new layer and label it "color." Select areas from your "detail" layer with the magic wand tool and then reselect your color layer. Use paint bucket and color picker tools to drop colors into the selected areas.

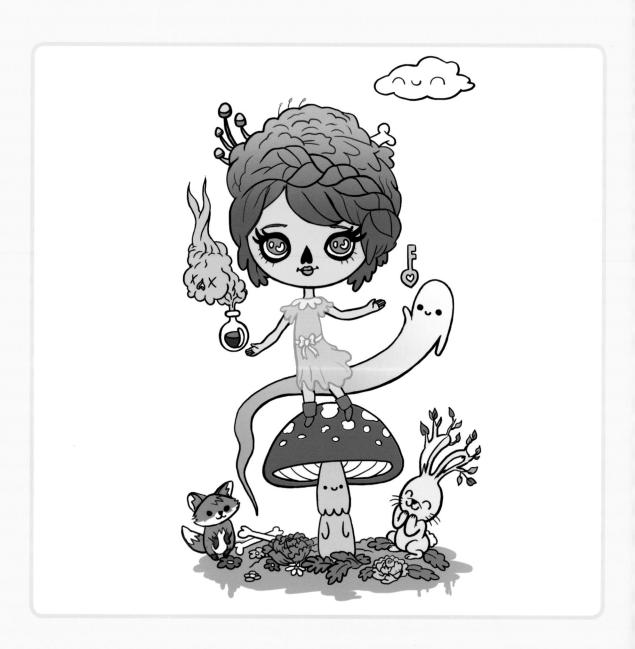

6.2. COLOR

Select all of the line work and then paint or even do a gradation of colors that will complement your fill colors. Try to go much lighter or significantly darker for a more dramatic outline effect.

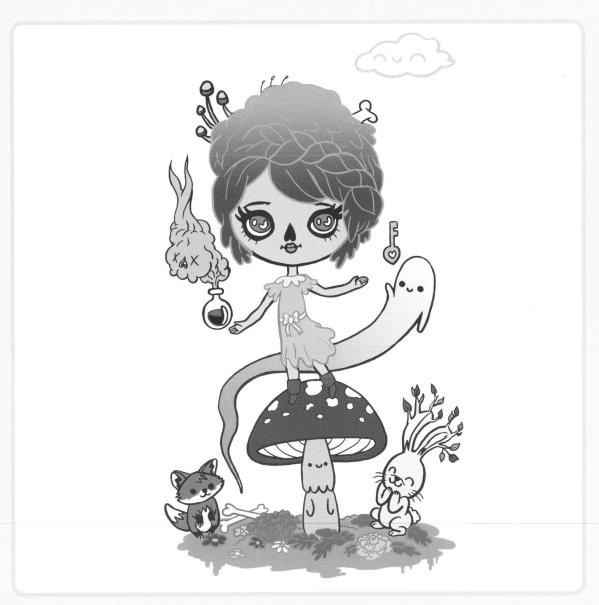

7.1. BACKGROUND

This character's environment is a deep, dark and magical forest, so you need to draw tree shapes with two different colors on the background layer. Choose cool colors like purples and blues that contrast with the warm colors of the character. Also, keep all layers at a lower opacity while working on the background so that you can keep an eye on your composition.

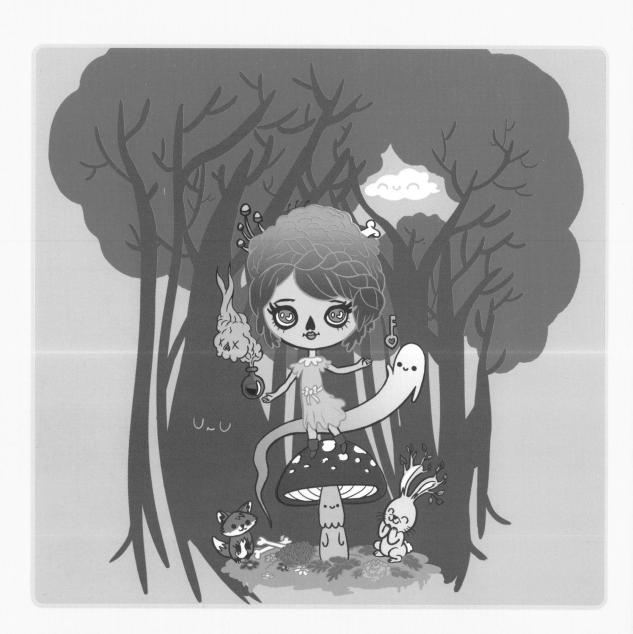

7.2. BACKGROUND

For an added effect, make and scan paint brush stroke textures, change to gray scale and the layer blending style to "multiply" and then copy and paste your texture into your working file as a new layer above the background layer—after selecting the areas outside of the forest shape, reselect the texture layer and delete the texture from that negative space around the forest—it is then ready to merge the two layers as one.

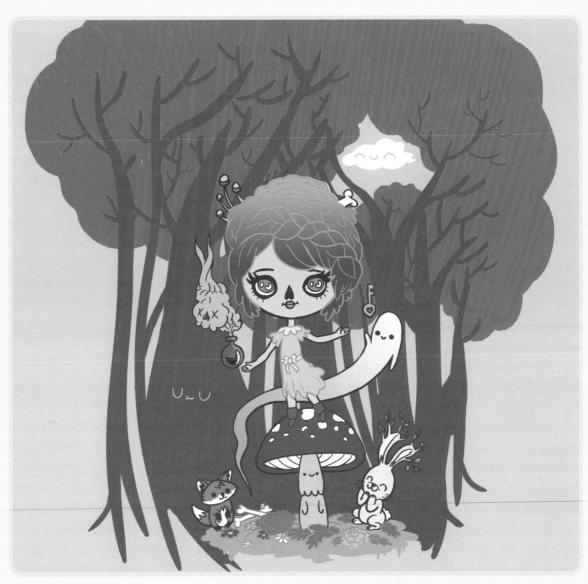

8. FINISHING TOUCHES

Make a new layer for creating shadows and highlights. Give your artwork more depth with this step, otherwise it will have a flatter look. Make shadows with a gray shade. Afterward, use the "blur" filter to blur these layers to make them appear softer.

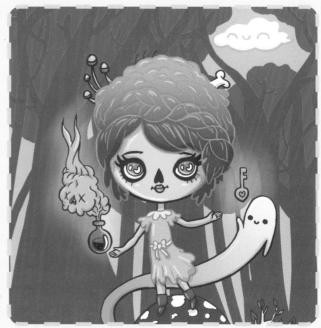

TIPS & TRICKS

- Adding sparkles around the potion, squiggly energy lines on the key, floating flowers, and a hidden face on the tree in the background give the artwork a more finished effect.

- To streamline the process, try drawing a variety of flowers and then copy and paste them, scaling some of the copies and rotating them to make them a little different from each other.

- Software used: Graphite on paper for the sketch & Adobe Photoshop.

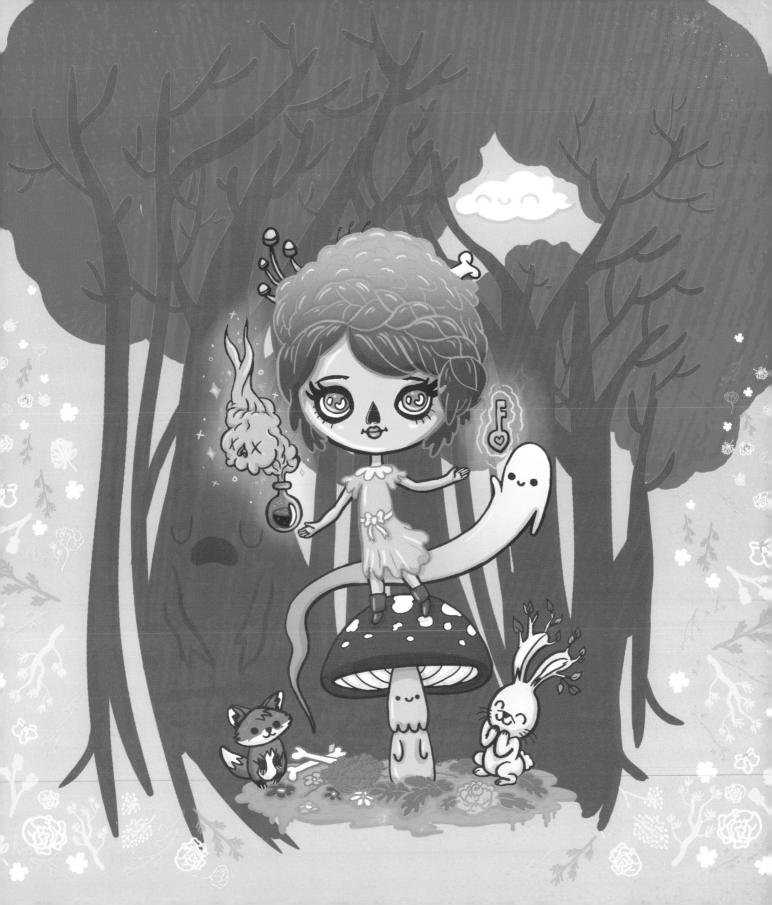

LITTLE FAMILY

Here we have a little brother and sister that is the envy of all others in outer space. They are always playing together and having fun accompanied by their favorite pets, a rabbit, a mouse, and an octopus.

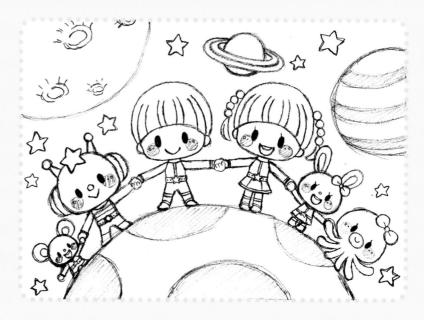

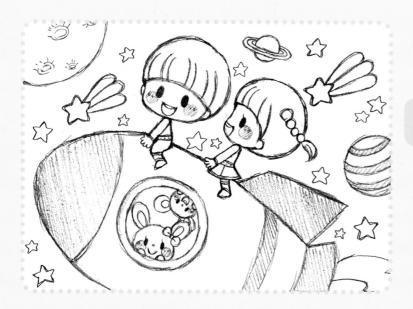

1. SKETCH

Since they are always having fun, let's draw them doing what they do best in the most dynamic way possible.

246

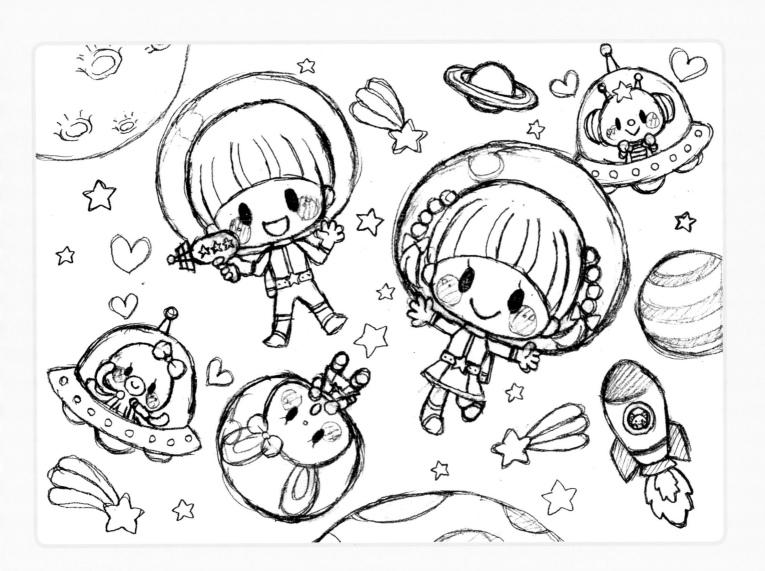

2. STRUCTURE

Simple lines always make it easier when you start creating a new drawing; there will always be time to modify and add details later.

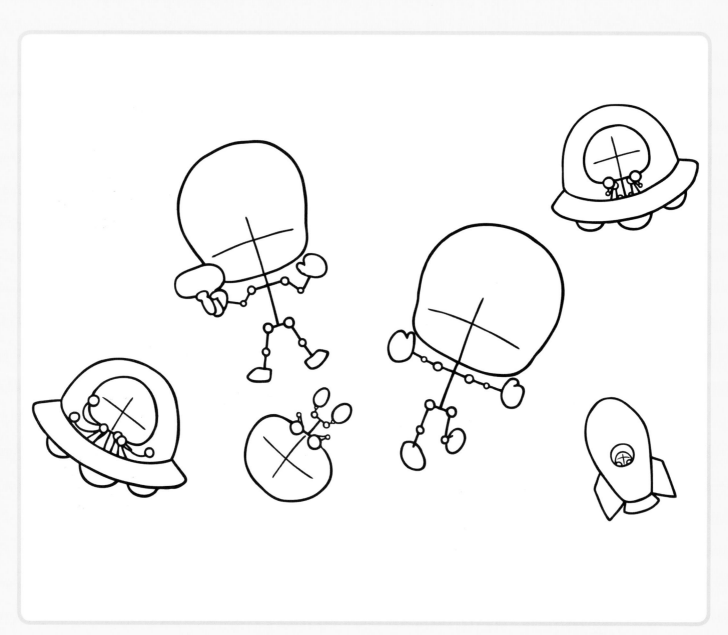

3. VOLUME

Continuing in the same way, outline the heads and bodies. Remember, you can always make changes later, and don't be afraid to have some fun: for example, add some pigtails to the girl.

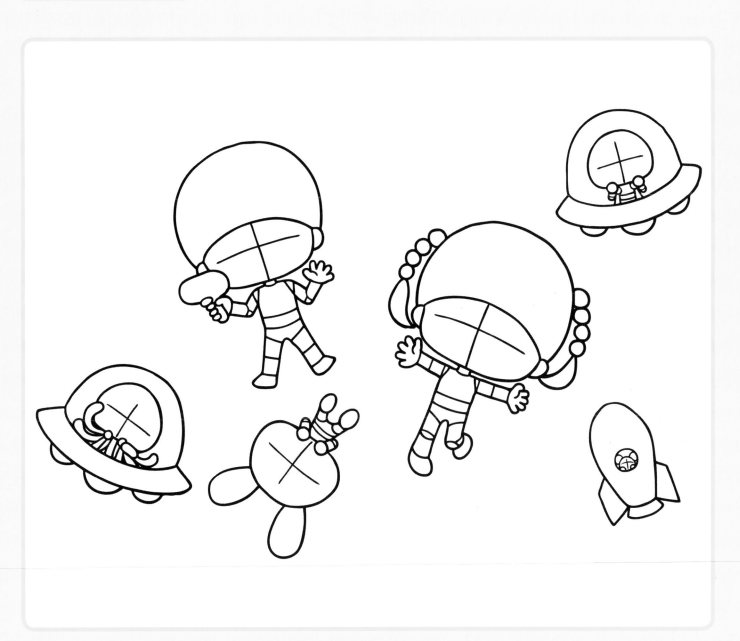

4. ANATOMY

Next add eyes, mouths, and noses to each character.

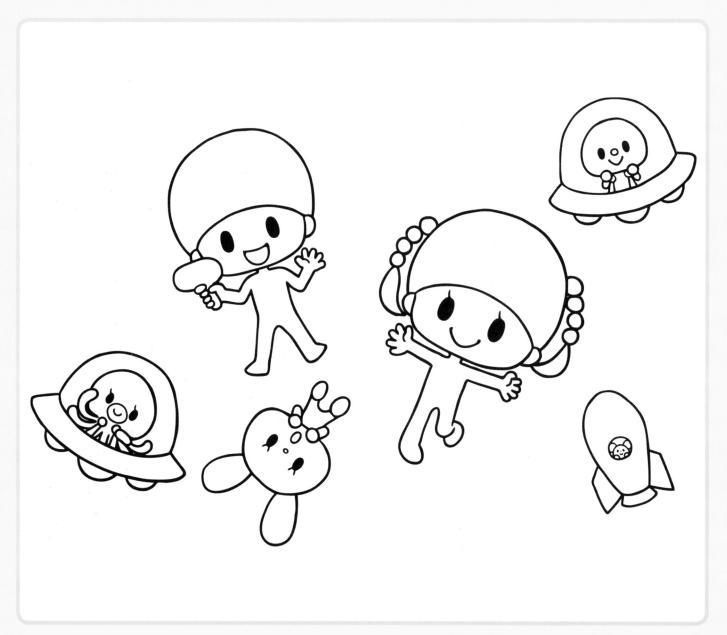

5. DETAILS

Now its time to dress our characters! Style fun space suits for each one and embellish the various spacecraft.

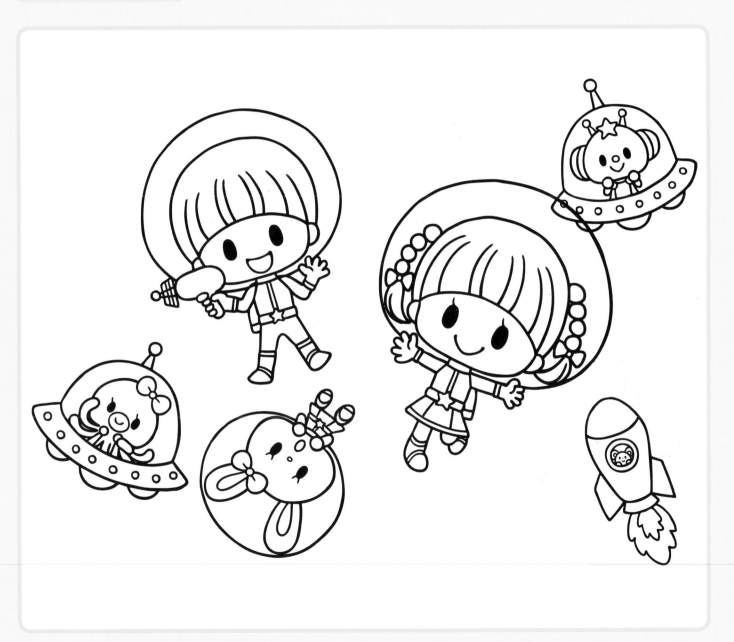

6.1. COLOR

Choose a palette of cute colors and enjoy combining them.

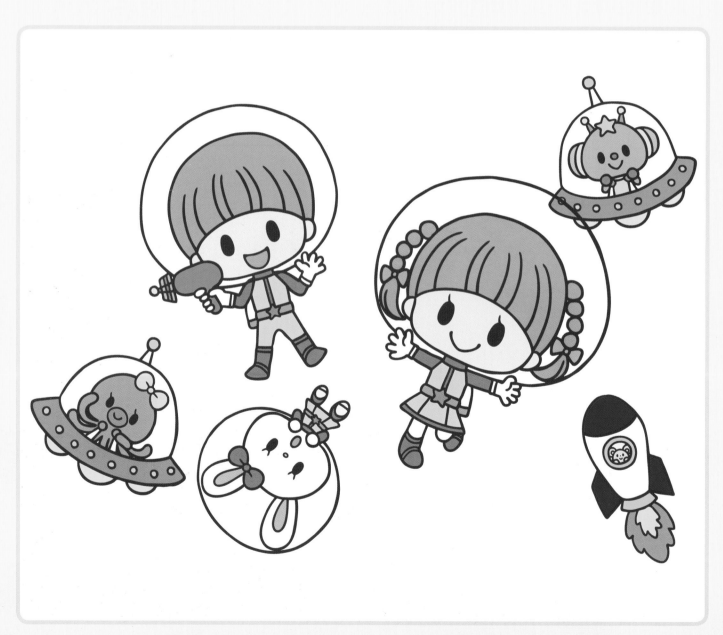

6.2. COLOR

Fill in the background with a solid dark blue color and add little highlights to the characters' helmets. Play around with fusion layers to get the right opacity.

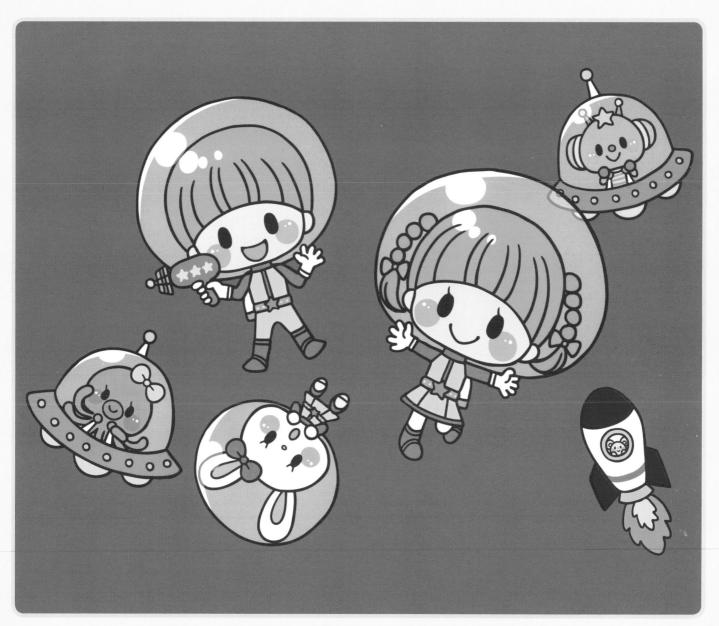

7.1. BACKGROUND

A subtle blue and green gradient suggests outer space.

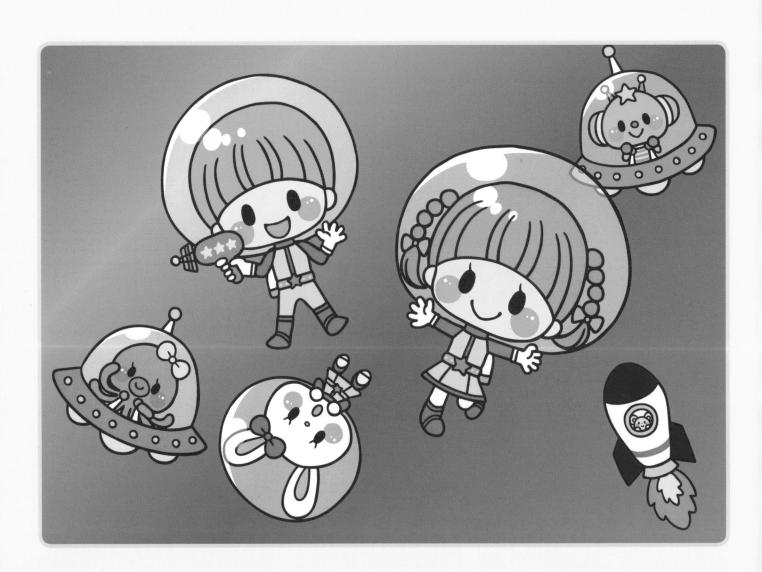

7.2. BACKGROUND

Next add different colored planets, shooting stars, and hearts.

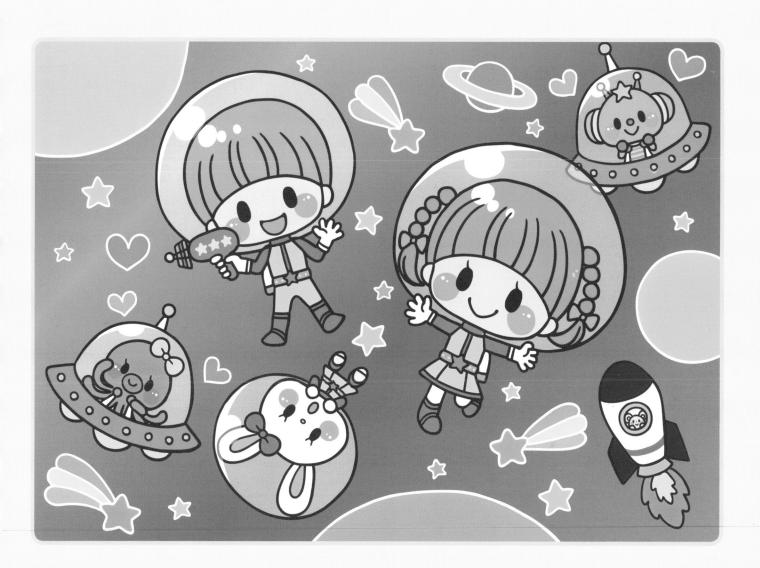

8. FINISHING TOUCHES

Add a thin black outline to the characters to make them stand out more against the background. The addition of tiny translucent white dots gives the image more depth and makes it look more like an outer space scene.

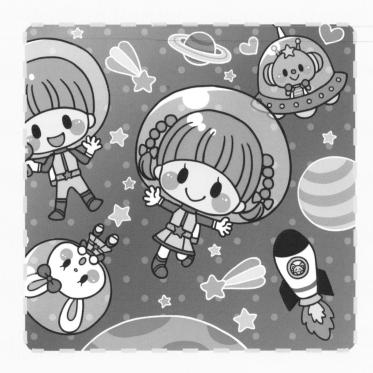

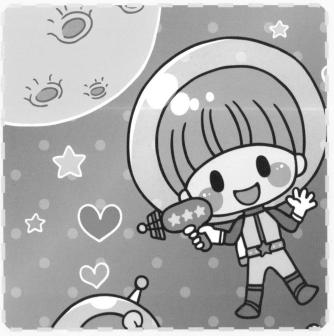

TIPS & TRICKS

• Adding craters gives the moon a more realistic look.

• Experiment with fusion effects: you might be surprised with what you come up with!

• Software used: Adobe Illustrator & Adobe Photoshop.

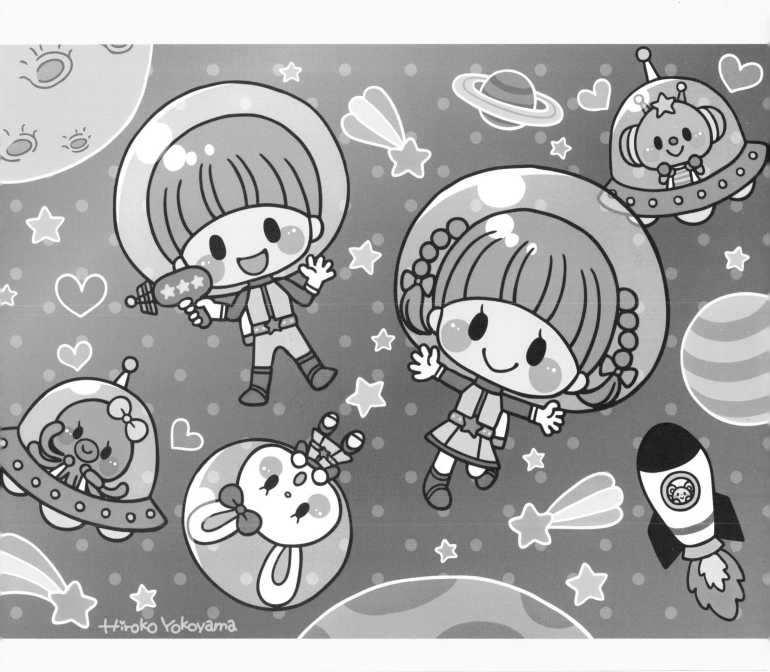

Hiroko Yokoyama

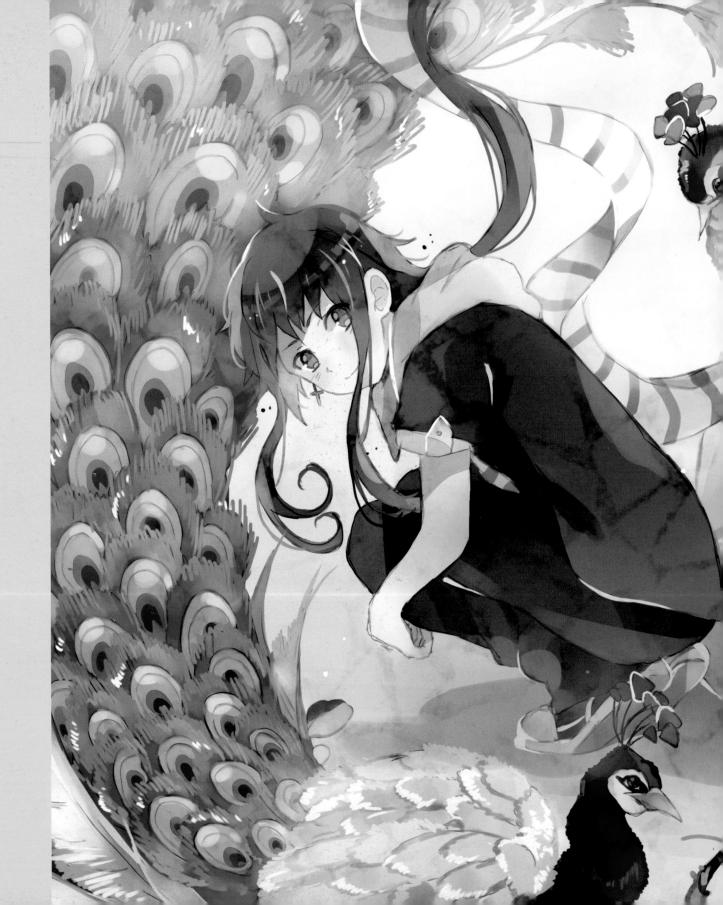

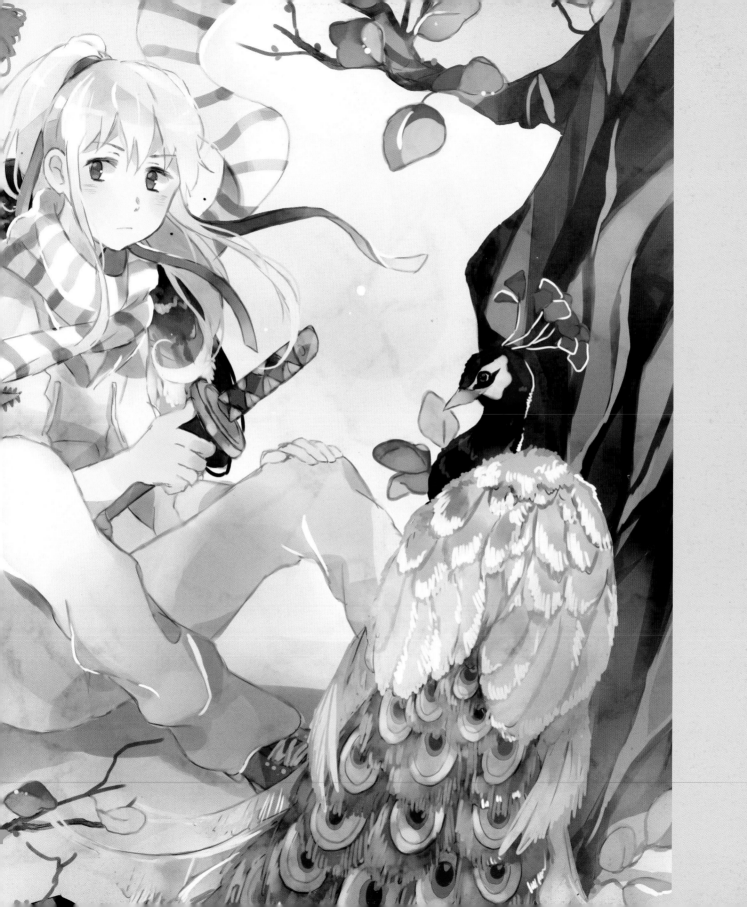

EXTRAS

CREDITS

ARTISTS

FINAL GALLERY

CREDITS

Chapter 1:

RACCOON GIRL
Ame

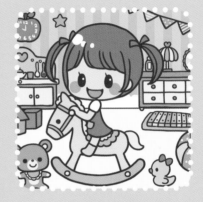

PLAYROOM
Hiroko Yokoyama

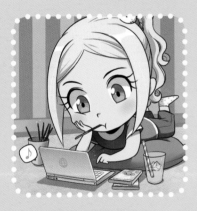

MINA
Meago

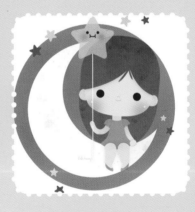

BLUE MOON
Luli Bunny

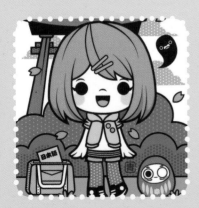

TORII GIRL
Azul Piñeiro

Chapter 2:

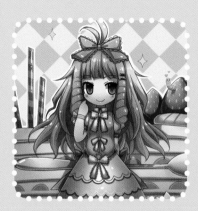

KAWAII PASTRY LOLITA
Emperpep

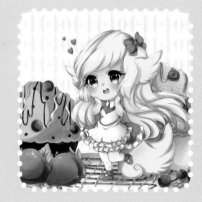

MEET BELLE
Ame

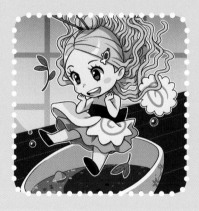

RAMEN CHIBI
Meago

BUNNY BABY
Olla Boku

CREDITS

Chapter 3:

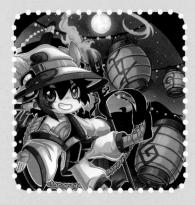

LANTERN FESTIVAL GUY
Sandra G.H.

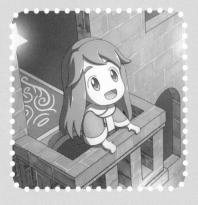

STARRY NIGHT
Harousel

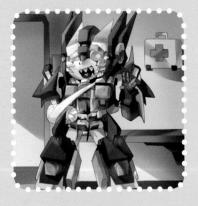

MECHA CHIBI
Amanda Schore

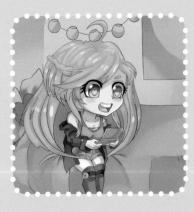

GAMER CHIBI
Amanda Schore

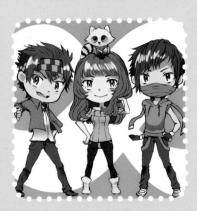

8TH DIVISION
Legalette

Chapter 4:

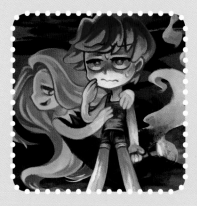

SPOOKY NIGHT
M

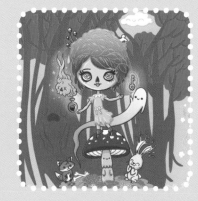

MAGIC FOREST GIRL
Mumbot

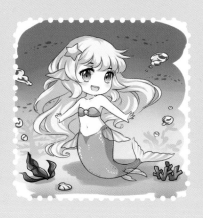

SIREN
Dat Le

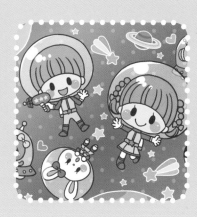

LITTLE FAMILY
Hiroko Yokoyama

THE FAIRY OF BRINY TEARS
Hetiru

ARTISTS

AME

Ame was born in Moscow, Russia, and currently resides there. One of her passions, besides drawing and traveling, is animals, especially rodents, which is why a lot of her artwork is based on them. However, what she really likes most of all is drawing, and she does it every single day!

Web: www.ladollblanche.deviantart.com

AZUL PIÑEIRO

Azul Piñeiro was born in Buenos Aires, Argentina. A lover of animation, her audiovisual work soon began to focus on illustration. In her work, she has an affinity toward Japanese culture, kawaii, and children. She has created illustrations for books, brands, games, animation, and theater. She is also the cofounder of Studio Kudasai, an illustration and design studio where she creates characters and illustrated product design, all inspired by Japanese culture and visual aesthetics.

Web: www.estudiokudasai.com
www.be.net/azulpineiro

DAT LE

Damien is a self-taught artist and illustrator for a mobile game company. He had studied to be a translator/intepreter, but because he loves to draw anime and manga, he decided to apply for a job at a game company as a 2D artist, and has been working there for three years.

Web: www.wingsie.deviantart.com

EMPERPEP

Emperpep is a freelance manga illustrator from Thailand. He graduated as a fine arts major, and his favorite mediums to work with are watercolor, oil, colored pencil, and acrylic. He believes that traditional mediums can link his artistic spirit closer to nature than digital mediums can, though he does occasionally enjoy digital painting. His hobbies are cooking, gardening, playing the electric guitar and violin, and listening to sermons.

Web: www.emperpep.deviantart.com
www.emperpep.tumblr.com

ARTISTS

HAROUSEL

Alfous Christie, pen name Harousel, is a freelance illustrator who works on a tn of small projects, concept art, and video games. He started drawing when he was in high school, and is an avid adventurer.

Web: www.harousel.deviantart.com

HETIRU

Hetiru is a self-taught artist from Russia who enjoys drawing, drinking cocoa, and reading entomology books. Since childhood, she loves creating her own stories, and she dreams of one day becoming a mangaka: a Japanese cartoonist.

Web: www.hetiru.deviantart.com

HIROKO YOKOYAMA

Hiroko Yokoyama is a self-taught Japanese illustrator. She began working on freelance projects in 2006. Her work consists of drawing kawaii illustrations for media, such as books and magazines. She enjoys creating illustrations that make people happy.

Web: www.yokoyama-hiroko.com

LEGALETTE

Miso, aka Legalette, is an Indonesian girl who is currently studying architecture and design. She loves to draw manga illustrations and stuff from Japanese culture as a hobby.

Nowadays, she teaches manga in a Japanese club and sometimes organizes manga events in Indonesia. She has always dreamed of combining illustration and architecture as one art.

Web: www.legalette.deviantart.com
www.facebook.com/legalettemiso

ARTISTS

LILLIN

Amanda Schore was born on 1998 in New Jersey. Raised in Los Angeles, she was surrounded by different types of art schools, animation studios, anime conventions, and anime in general. Amanda grew up watching anime shows, which made her want to learn to draw and become an animator.

For the most part, she is self-taught, and today she enjoys drawing Transformers and Cundam. She also loves drawing other people's characters.

Web: www.ladollblanche.deviantart.com

LULI BUNNY

Luli Bunny was born in Buenos Aires, Argentina. Her works includes illustrations of rabbits, bears, and other cuddly and colorful characters. She has done designs for many companies, such as Momiji, Philips, AVENT, Tattyoo, Ivy Press, Monoblock, Momish Toys, Tesco, La Lectoría, and Puerto de Palos Publishers. She likes rodents, and her muse is her small hamster, Dimitri.

Web: www.lulibunny.com

MEAGO

Magdalena 'Meago' is an illustrator based in Poland. When she was nineteen, she published her first comic. She likes drawing manga and cartoons mostly, but she works in other styles as well.

She is known for her dollicious series, which features girls dressed and stylized as a type of food. Currently, she works at a game development company as a 2D concept artist. She loves cats, pictures of food, and in her free time, she works on her own or other client's projects.

Web: www.meago.deviantart.com
www.facebook.com/meagolicious

M

Momo Chan, who is also known as Kutaraa, likes drawing both creepy and cute illustrations. When she first began illustrating, she specialized in the anime style, and has since transitioned into drawing cartoons. She enjoys challenging herself and finding new methods for creating her art.

Web: www.facebook.com/momoartclub

ARTISTS

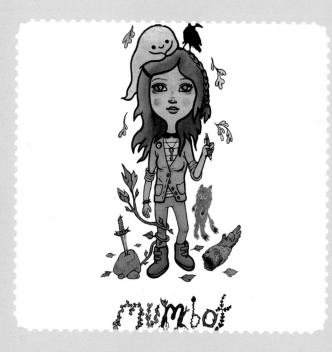

MUMBOT

Mumbot, aka Jade Kuei, is a new media artist, designer, illustrator, and animator. Ms. Kuei graduated from the School of Visual Arts in New York City in 2003, focusing on fine arts and 2D animation. In her free time, she has been hard at work developing powerful creative formulas. Kuei illustrates whimsical yet haunted abstractions of her own dreams and experiences. Her work has often been categorized as kawaii, kimokawa, and creepy-cute. Her kids and their superpowers have been catalysts for inspiration, and they remain the key to unlocking her magnum opus.

Web: www.ladollblanche.deviantart.com

OLLA BOKU

Tzu Hua Wu, aka Olla Boku, works as a freelance illustrator in Taiwan. She loves to illustrate cute and sweet things, and her biggest inspiration is donuts. She has created several characters that have been printed on paper fabrics, and enjoys creating new projects and showcasing her work in exhibitions.

Web: www.ollaboku.blogspot.com

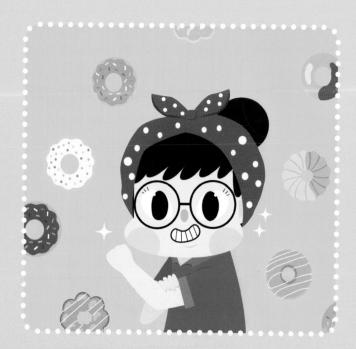

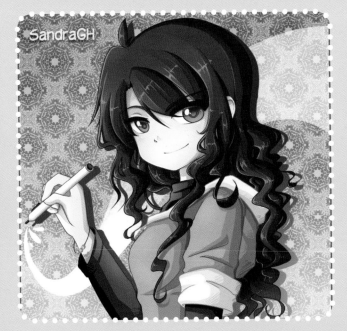

SANDRA G.H.

Sandra has been passionate about drawing since childhood and started painting in high school. Sandra also loves video games—not just playing them, but also developing them. In recent years she has focused more on drawing. She participates in several poster contests for manga shows in Spain and won the 2013 Andalucia. She has participated in fanzines, and hopes to continue learning more and more in the coming years.

Web: www.sandragh.deviantart.com
www.alexysgh.tumblr.com

Azul Piñeiro / *KAWAII E KABUKI*

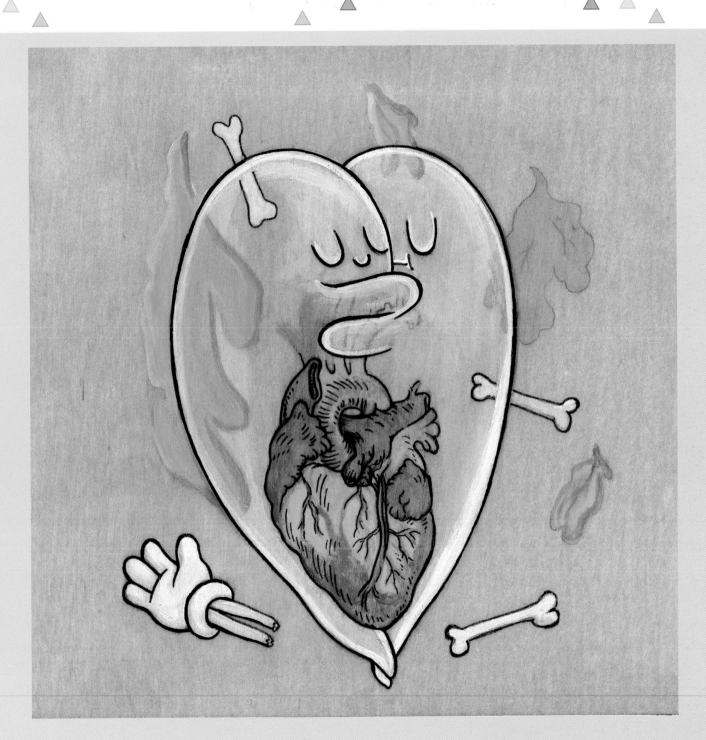

Mumbot / *GHOSTS OF THE HEART*

art and character belongs to
ladollblanche.deviantart.com

Ame / *BELLE AND THE FAIRY*

Hiroko Yokoyama / *TRICK OR TREAT*

Luli Bunny / JAPANESE FOX

Dat Le / *SUZIE*

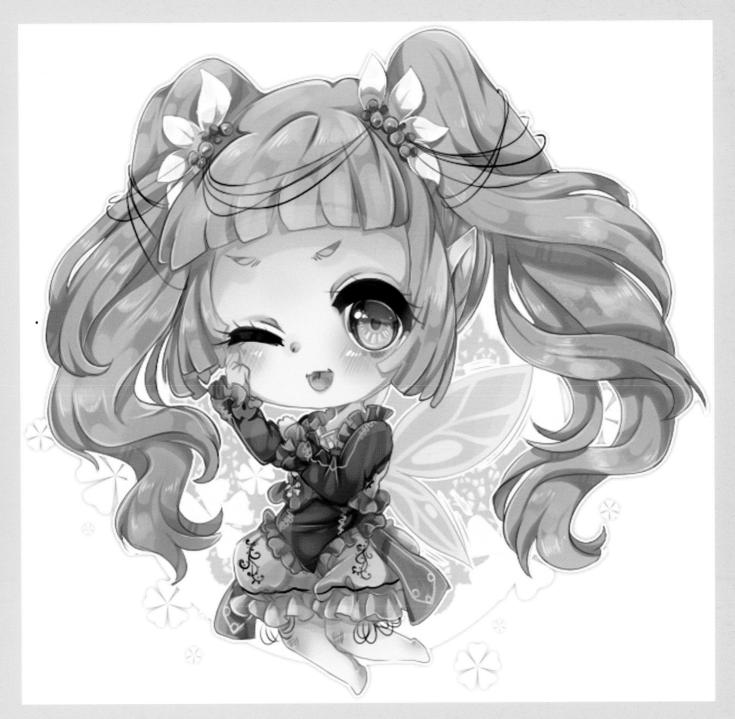

Ame / *CHIBI FAUNA*

Harousel / *VINESA MUFFIN*

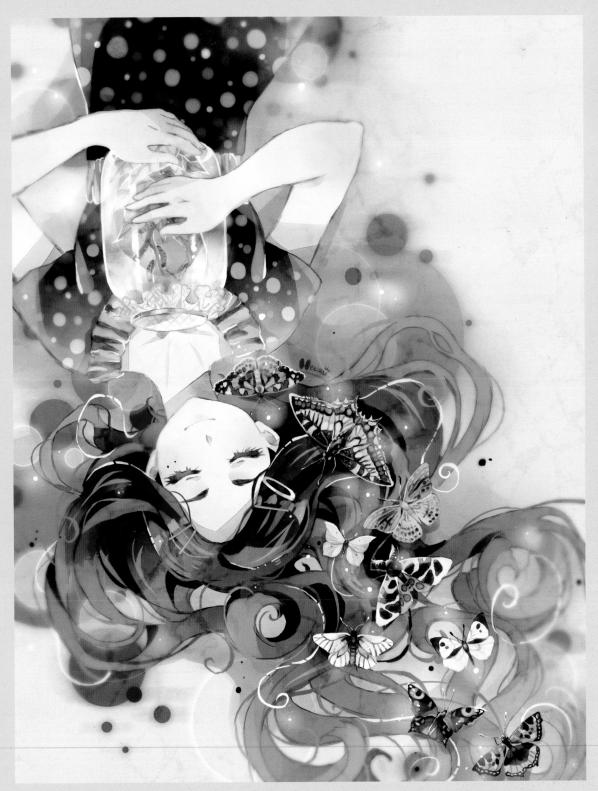

Hetiru / *BUTTERFLIES OF MY CHILDHOOD MEMORIES*

Emperpep / *FAIRY BAZAAR*

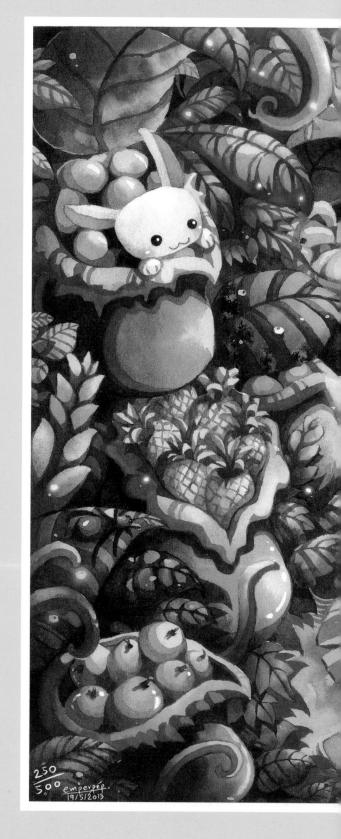

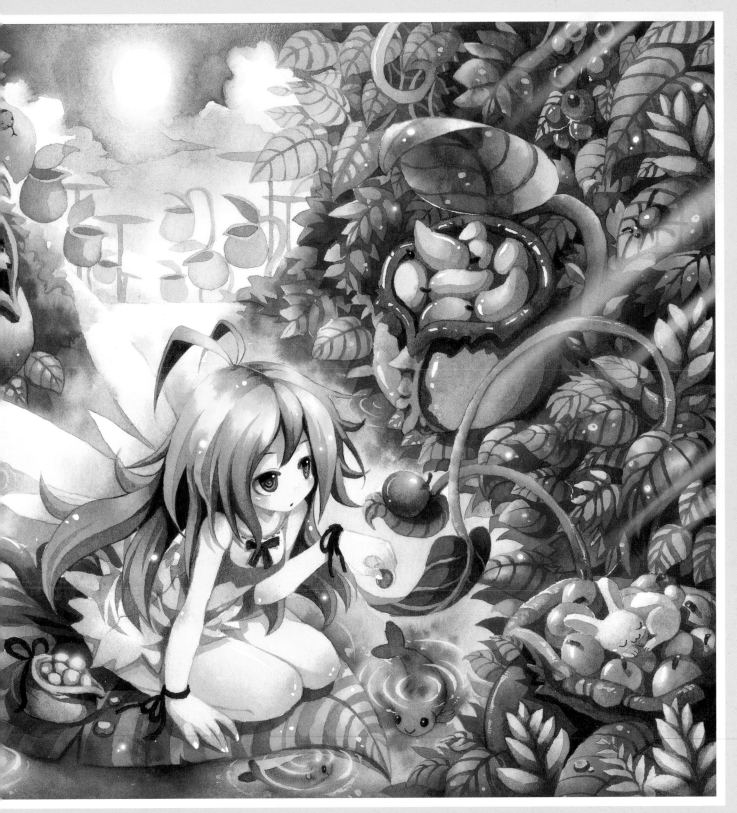

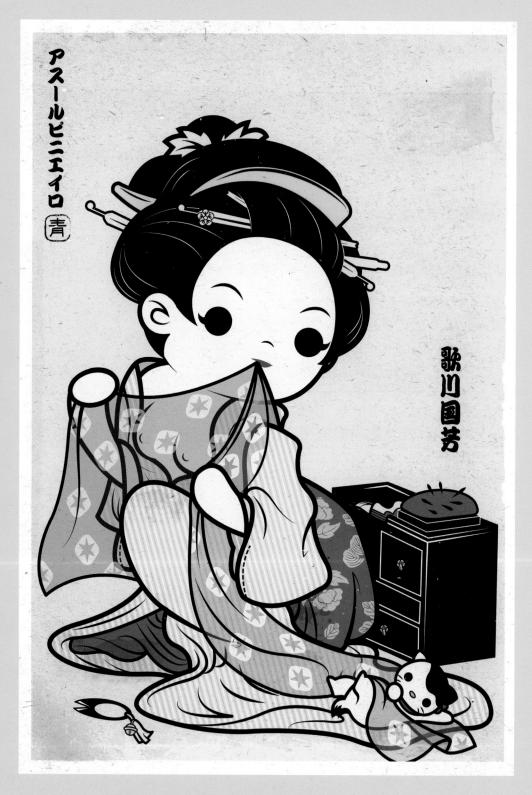

アスールピニエイロ 青

歌川国芳

Azul Piñeiro / *KAWAII E MUJER CON GATO*

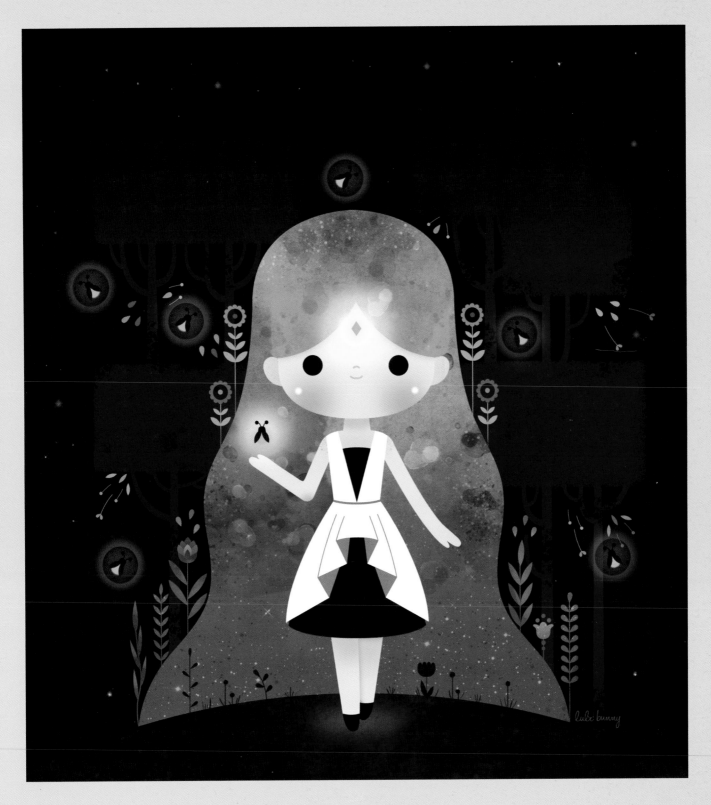

Luli Bunny / *FIREFLY*

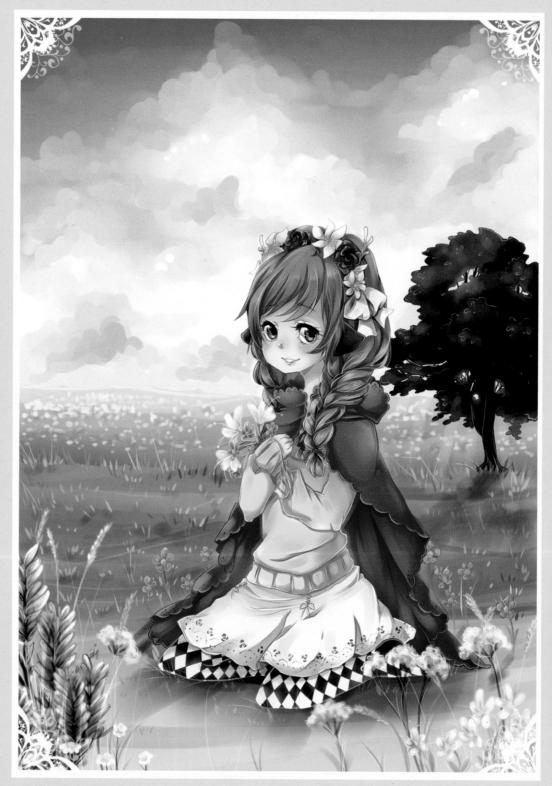

Ame / *SHIORI IN THE MEADOWS*

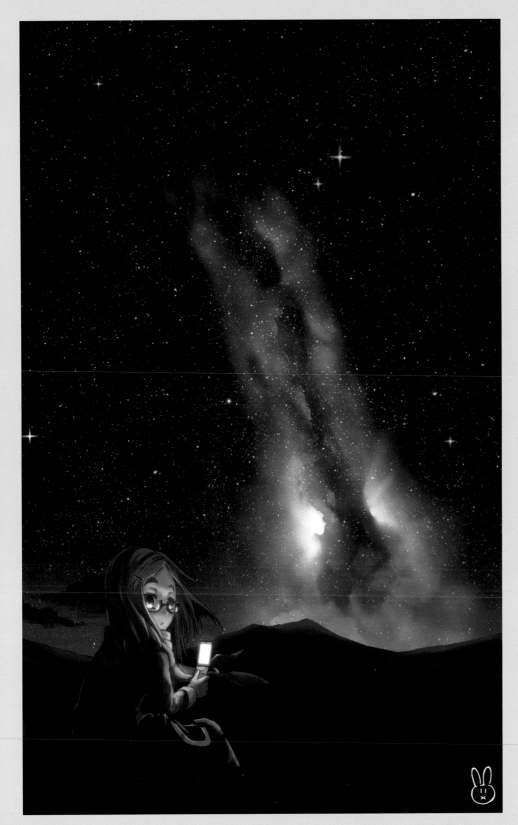

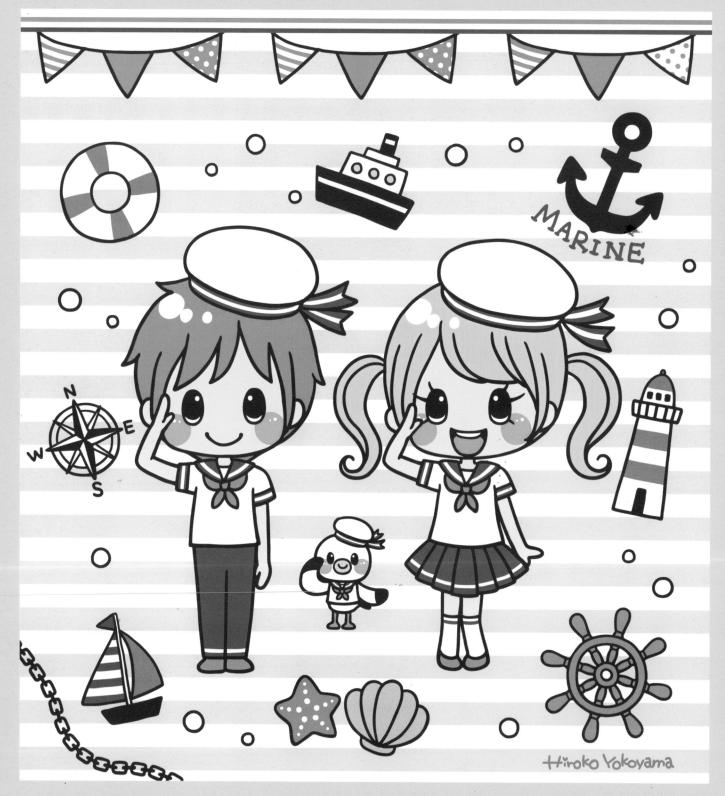

Hiroko Yokoyama / *MARINE*

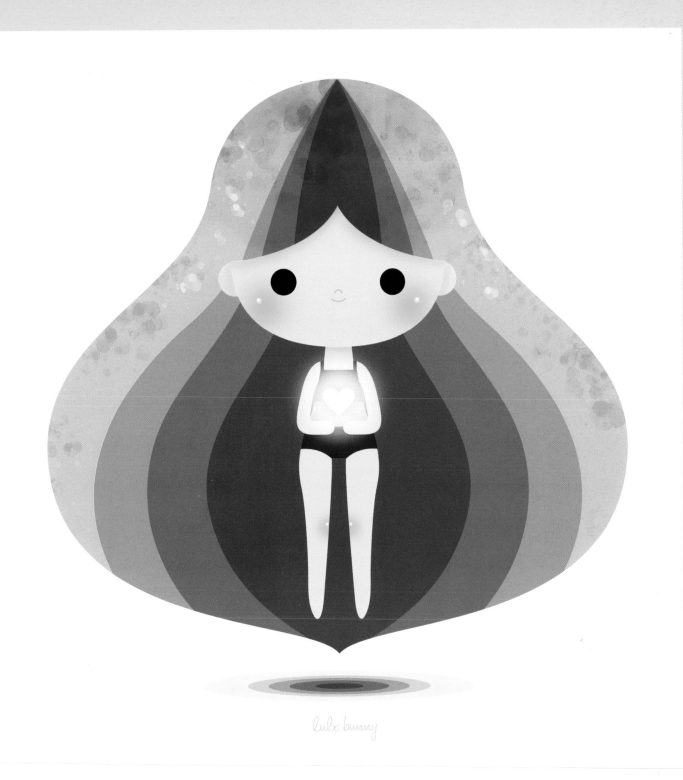

Luli Bunny / *RAIN DROP*

Emperpep / THE FLOWER NARWHALS

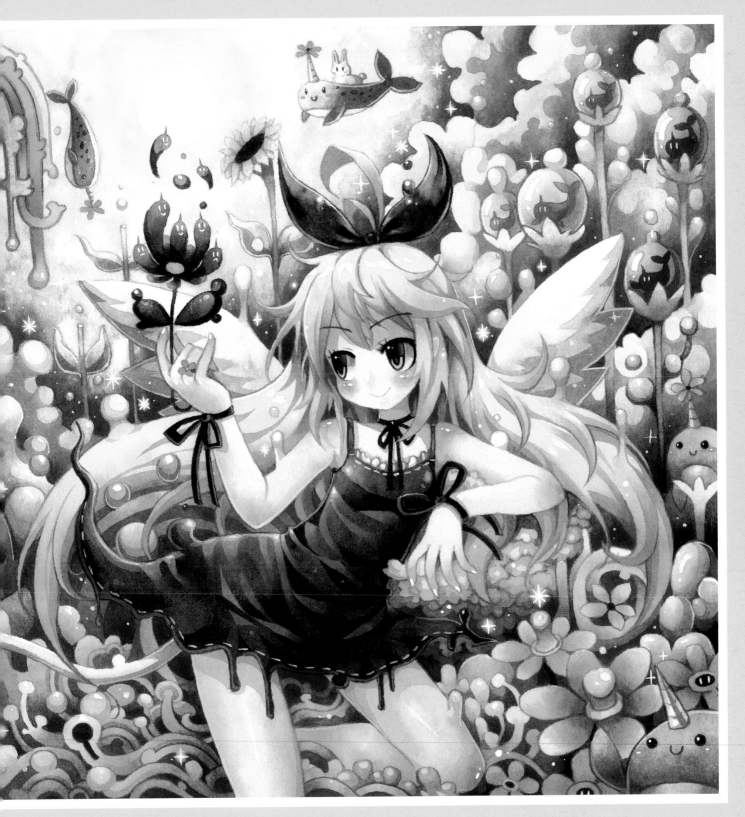

293

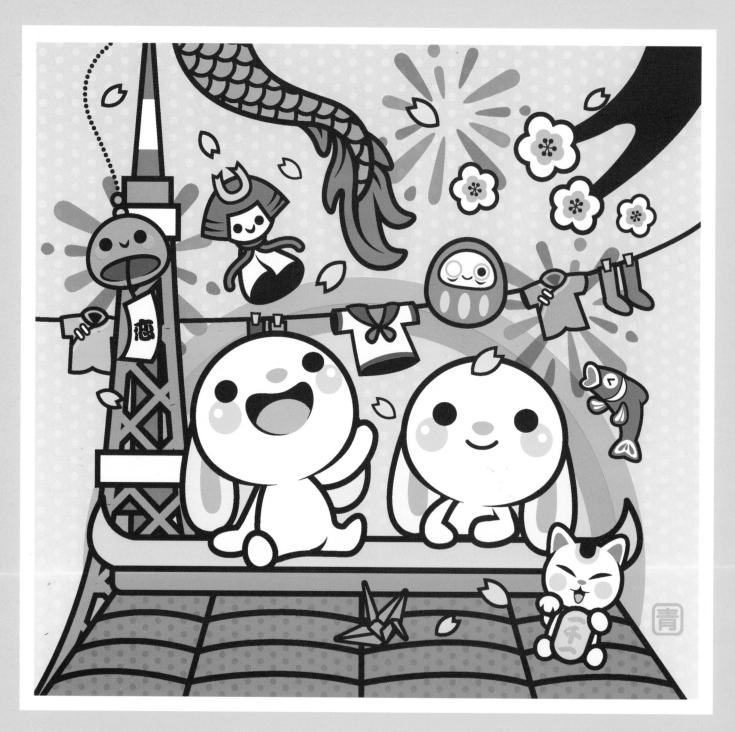

Azul Piñeiro / *CONEJOS EN ASIA*

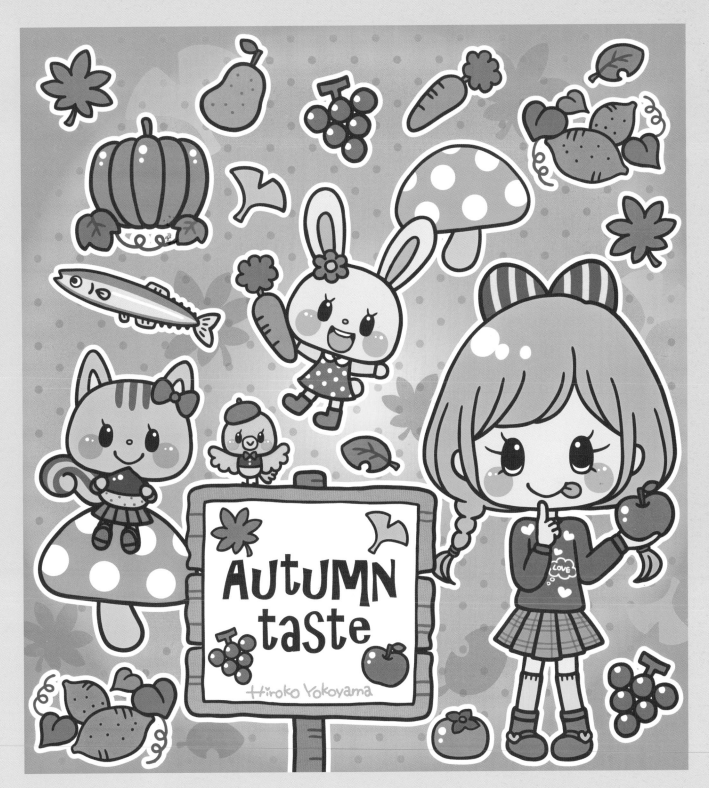

Hiroko Yokoyama / *AUTUMN TASTE*

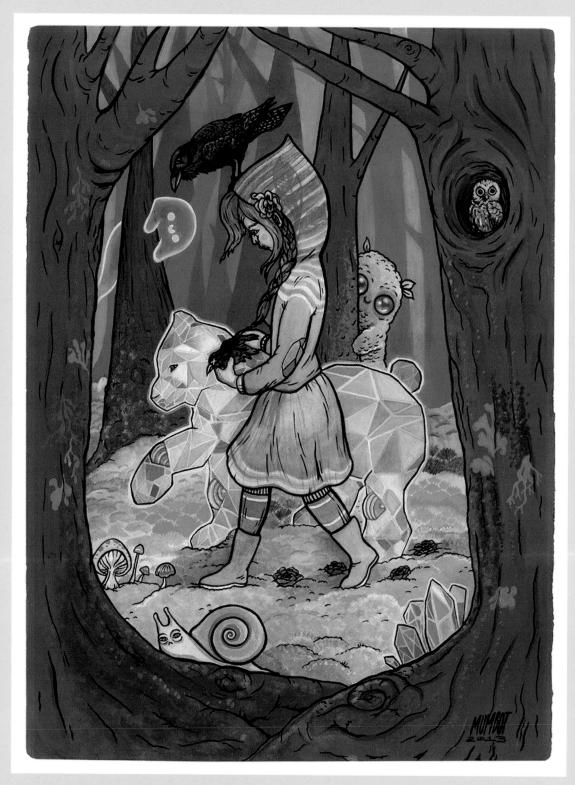

Mumbot / *WALK IN THE WIZARDLY WILD*

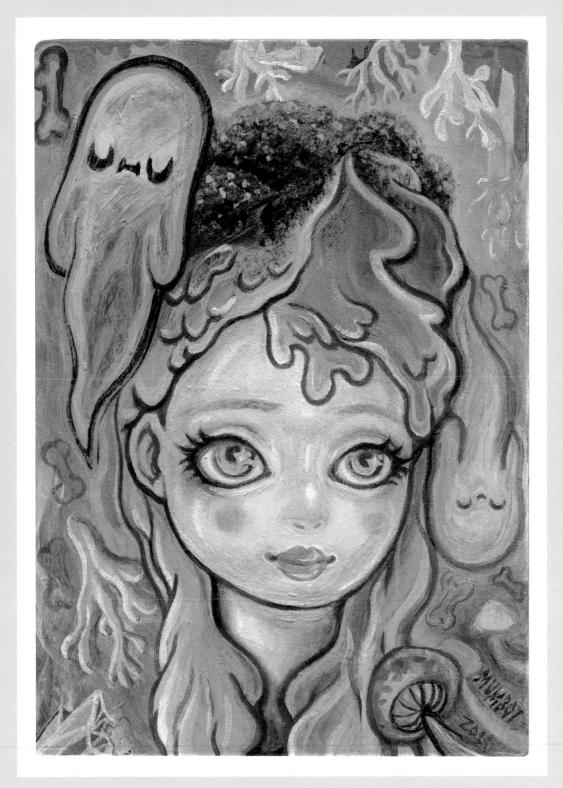

Mumbot / *NATURE NYMPH—FLORA*

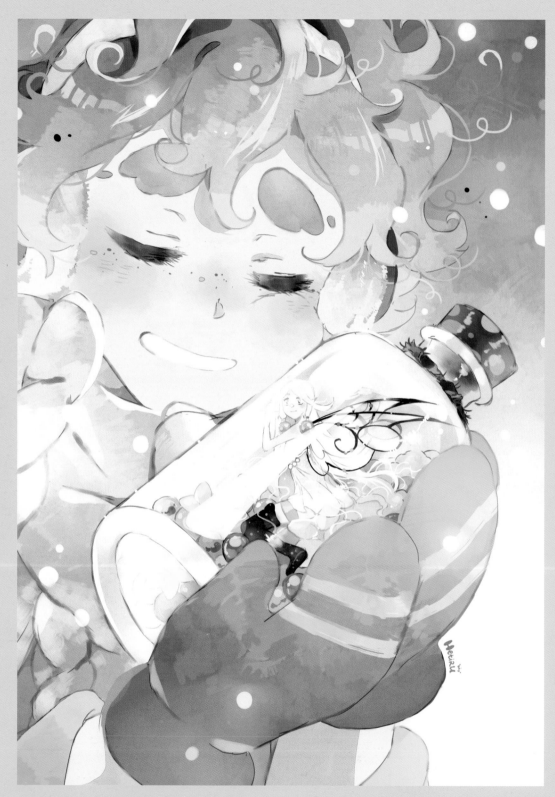

Hetiru / *MY LOVELY FAIRY*

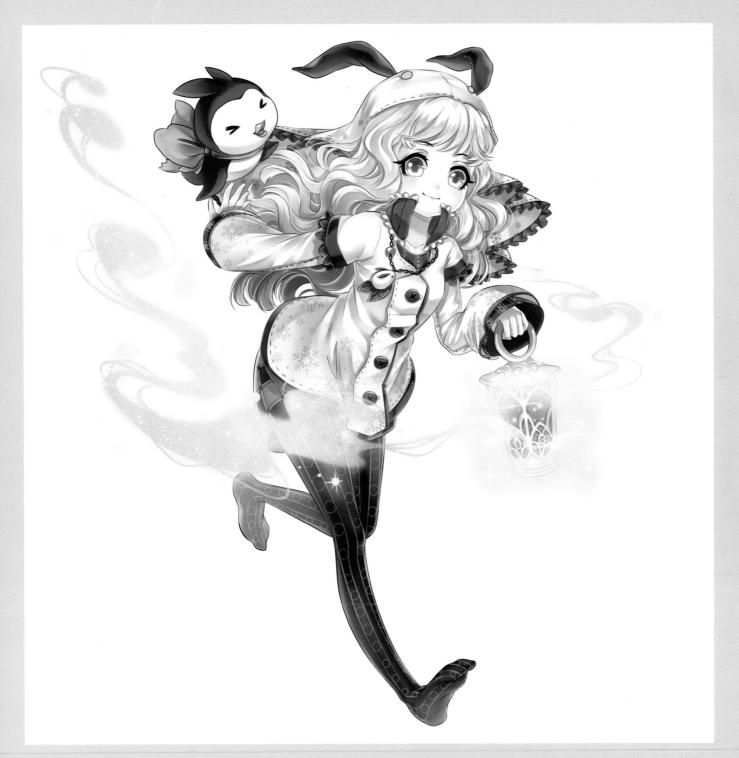

Dat Le / *YUKIKO*

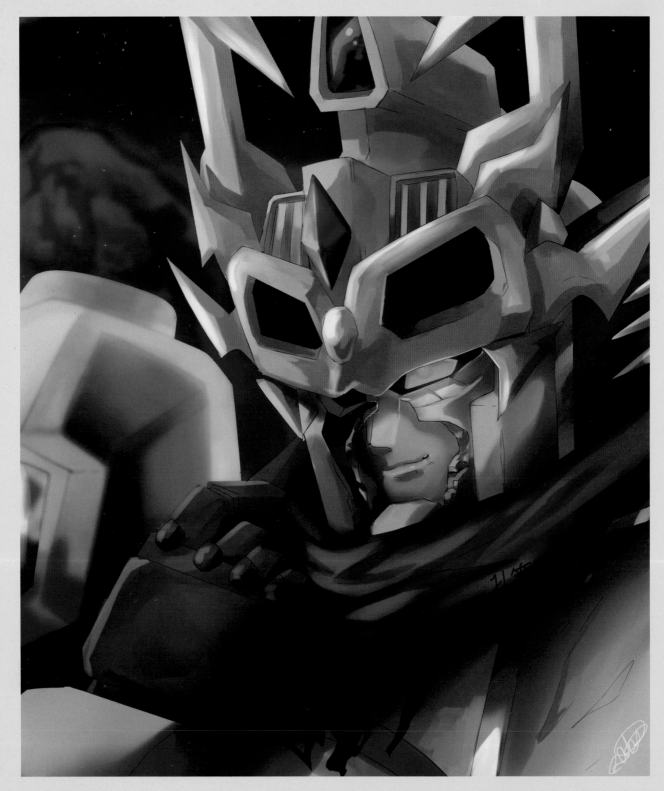

Lillin / *SUN CE*

Lillin / *CIX*

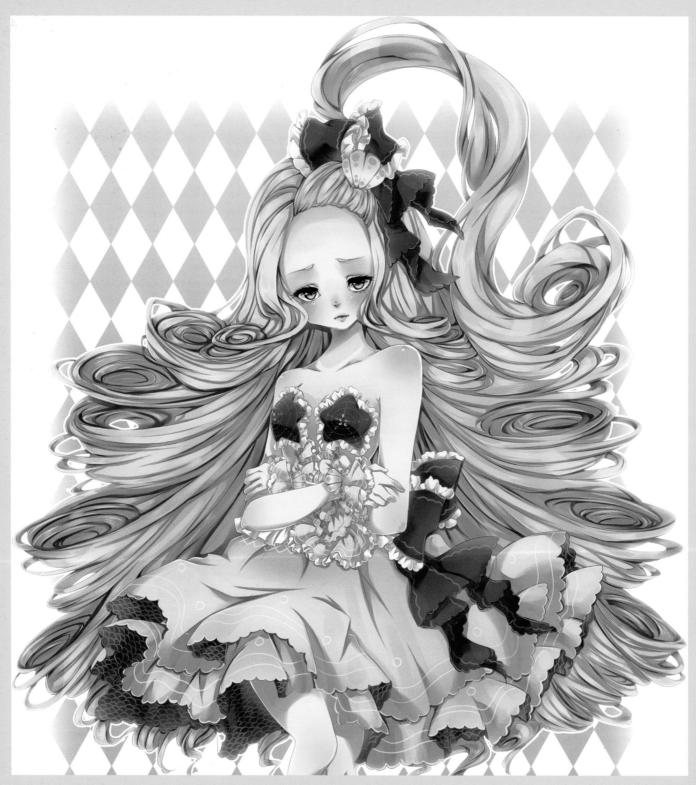

Ame / *LIKE THE SEA*

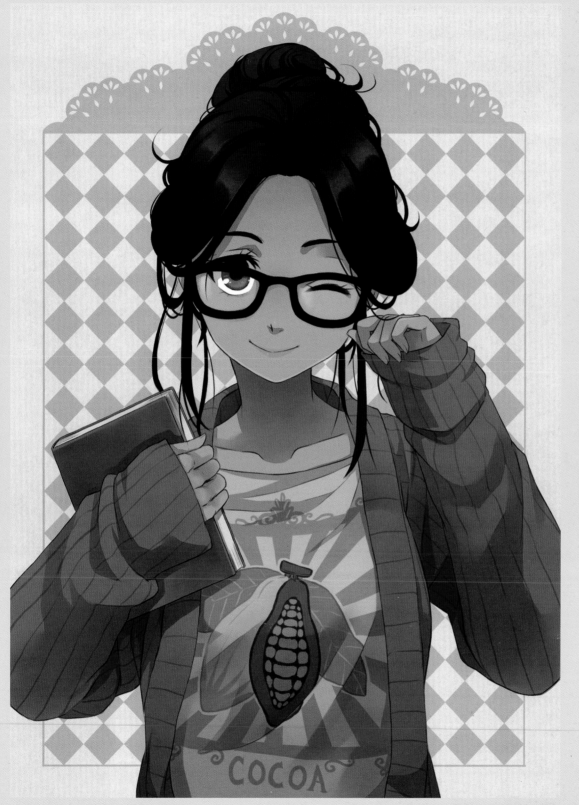

COCOA

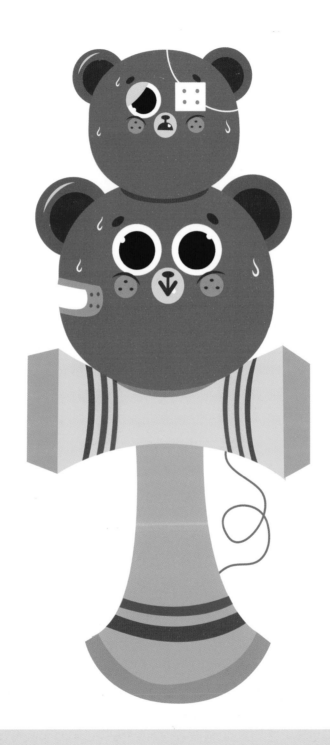

Olla Boku / KENDAMAS

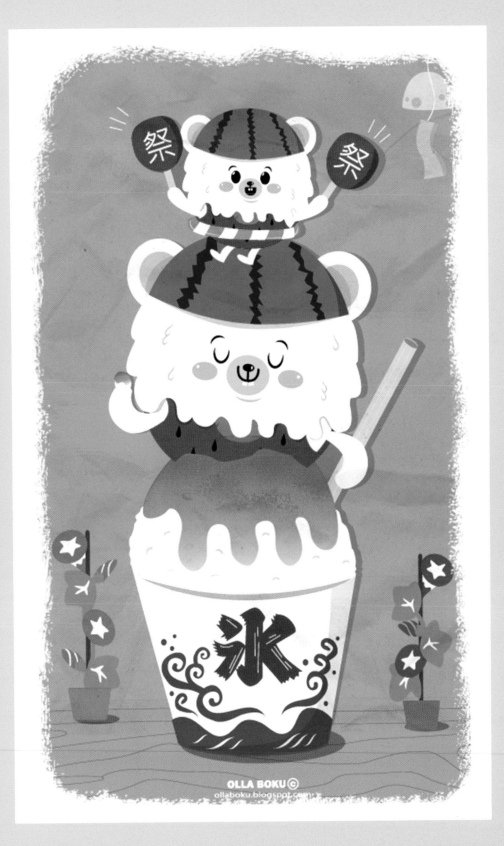

Harousel / FORTRESS TOWN

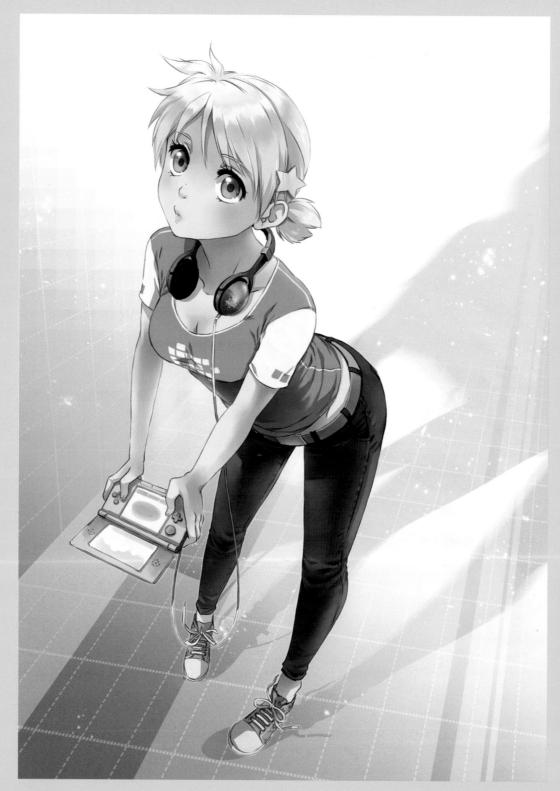

Meago / *GAMER GIRL EMILY*

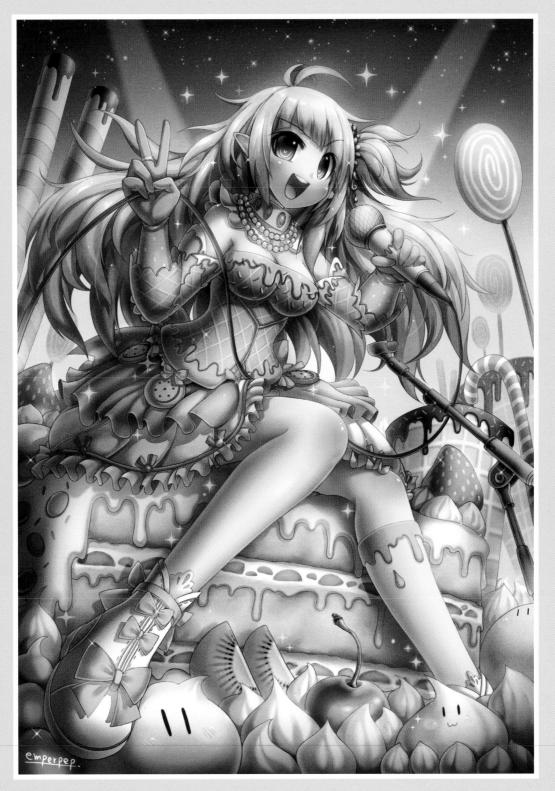

Emperpep / *STRAWBERRY STARLET*

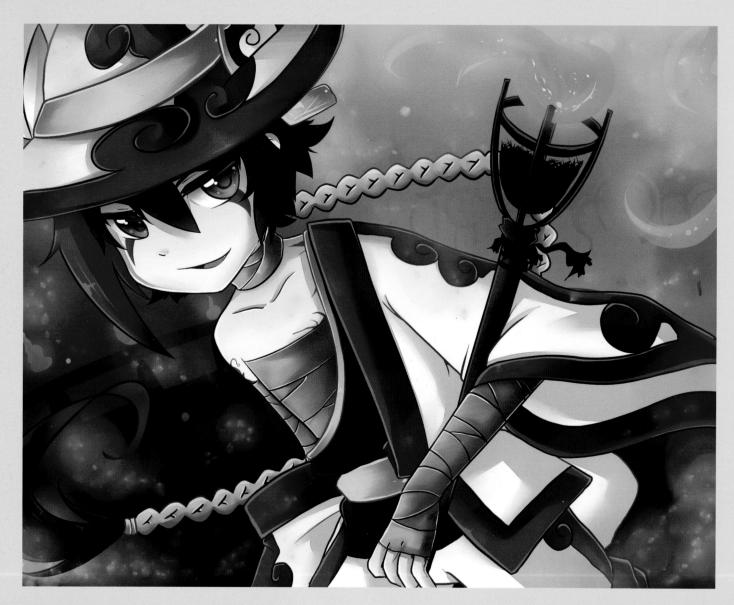

Sandra G.H. / *LANTERN FESTIVAL*

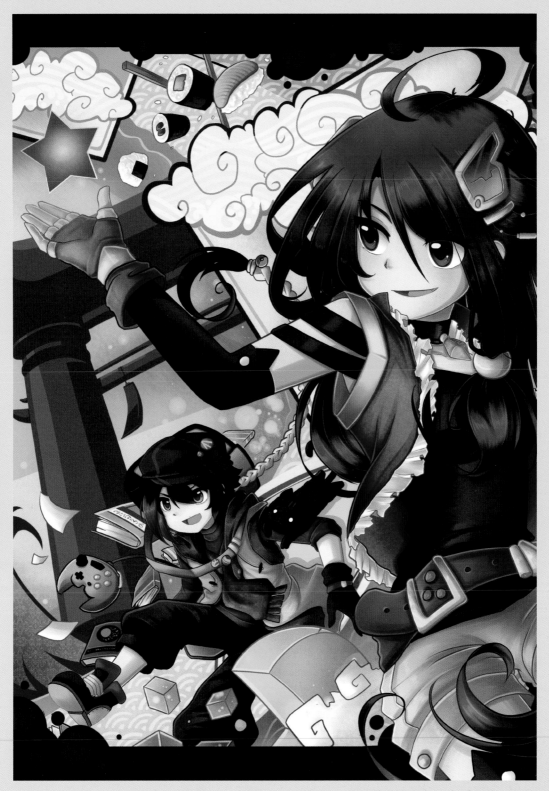

Sandra G.H. / *FANTASY WORLD*

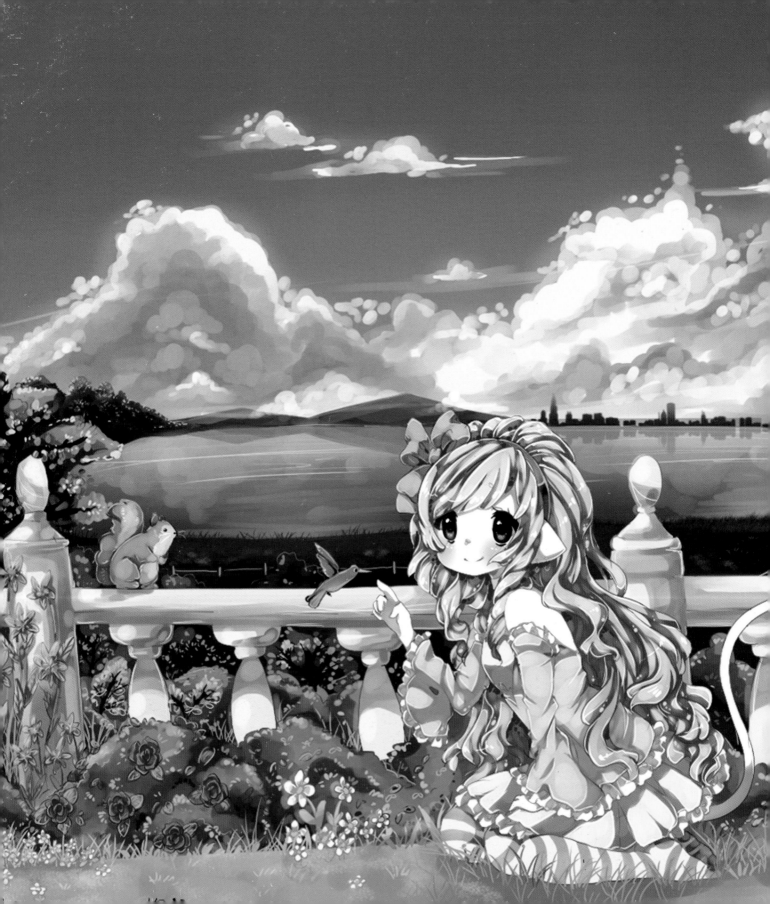

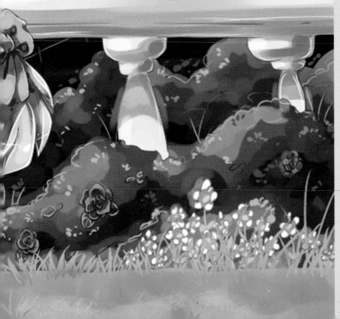

Meago / RAMEN

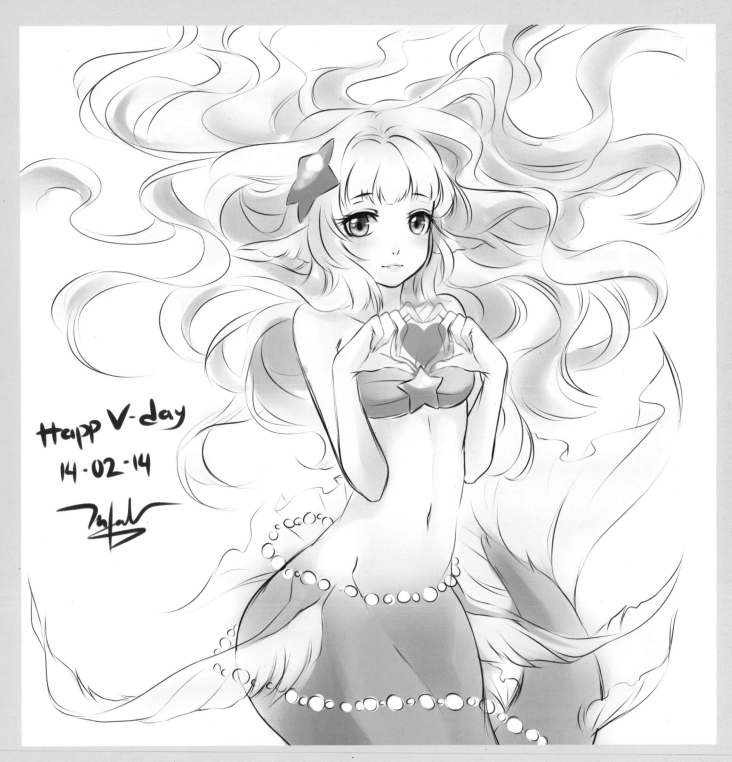

Dat Le / *HAPPY VALENTINE'S DAY*

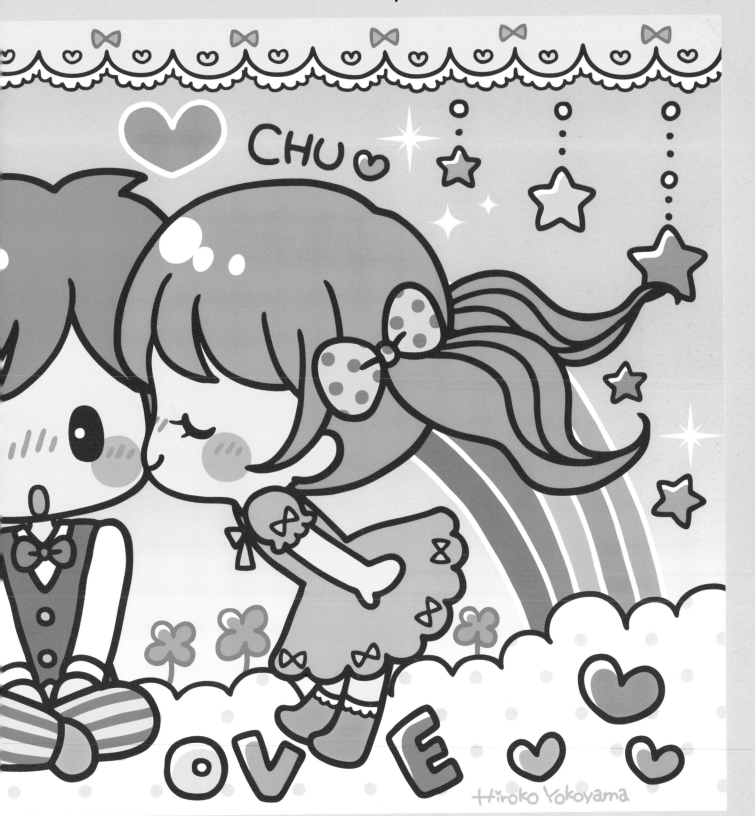

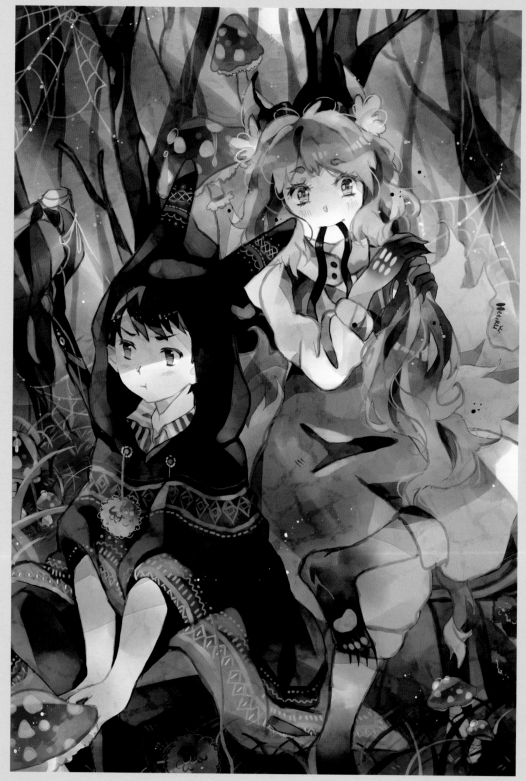

Hetiru / *KITSUNE & KIRKA*

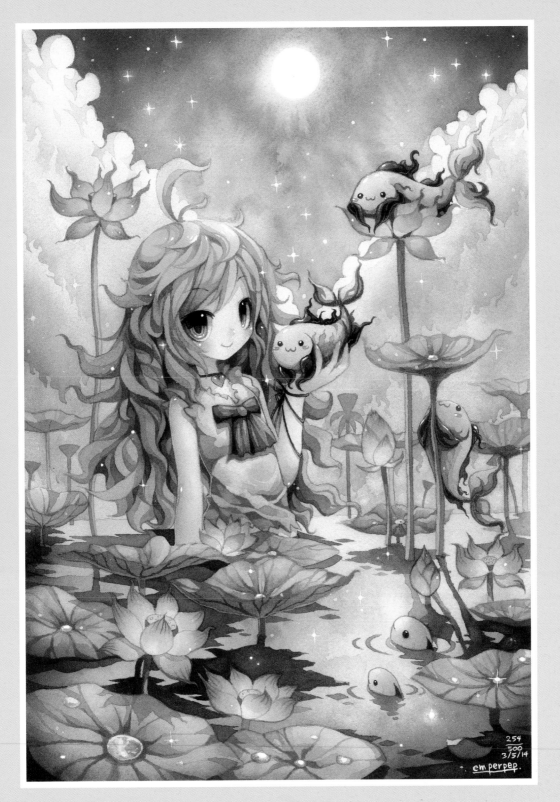

Emperpep / *DIVIDE MARSH*

Legalette / *BEFORE I FREEZE*

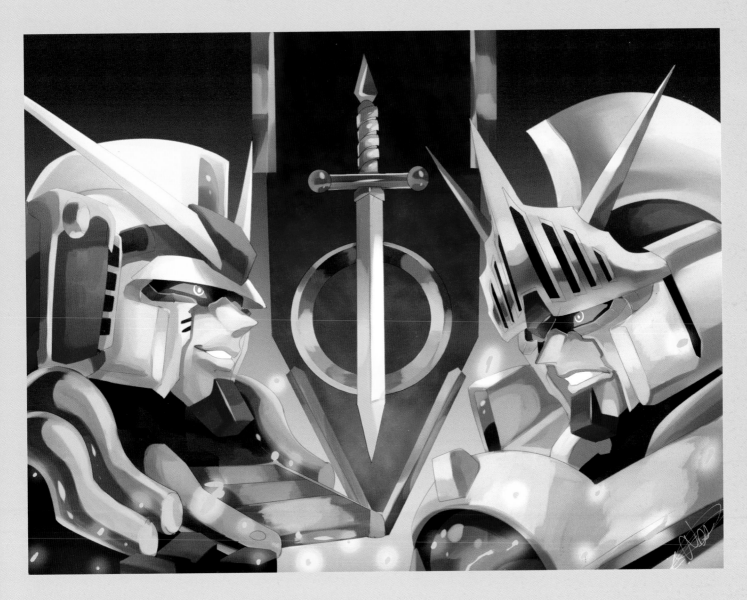

Lillin / *KNIGHT VS. MUSHA*

Azul Piñeiro / *GODZILLA AND MOTHRA SHOPPING IN TOKYO*

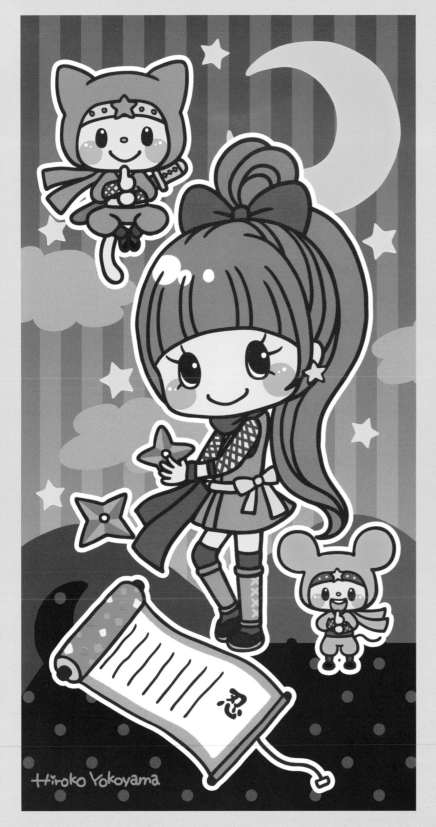

Hiroko Yokoyama / *NINJA*

Hiroko Yokoyama

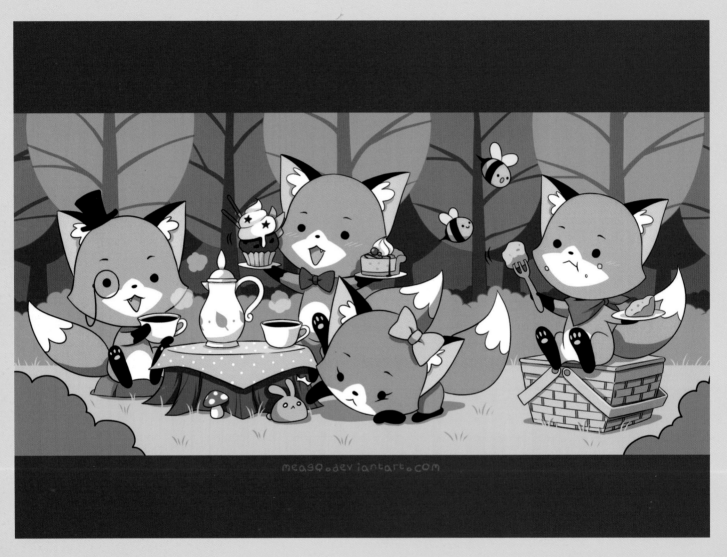

Meago / *TEA TIME*

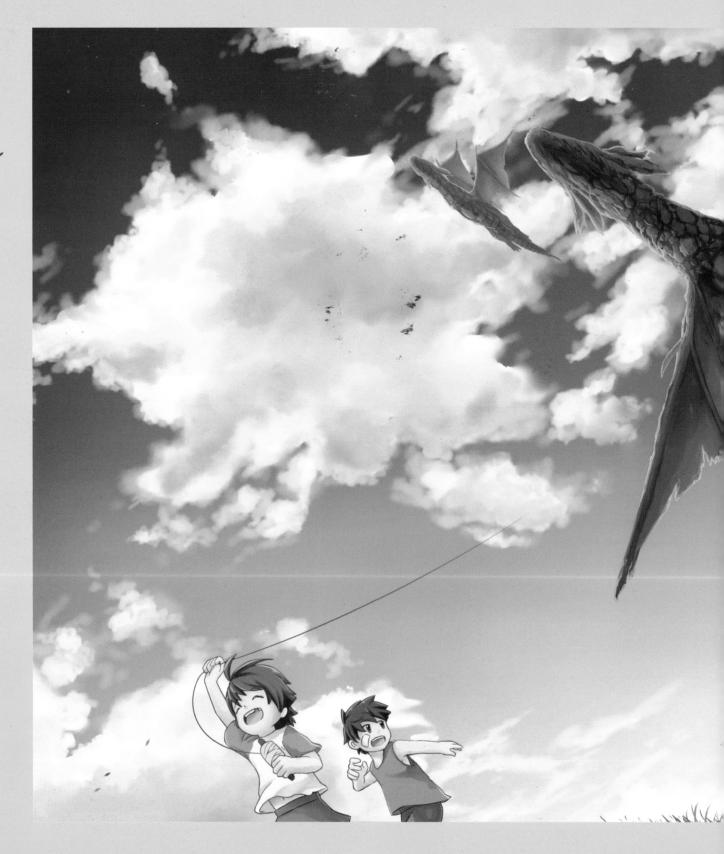

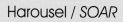
Harousel / *SOAR*

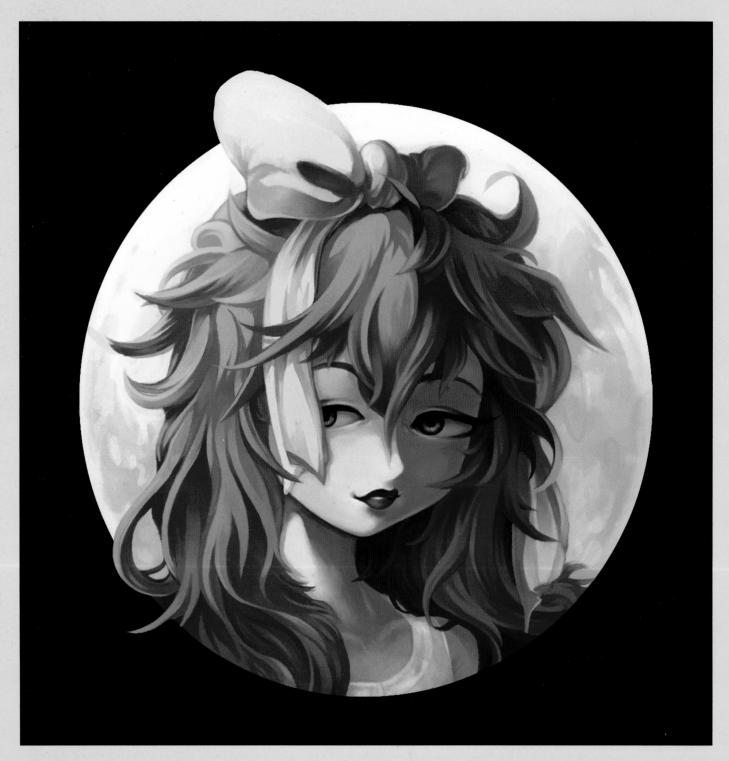

M / MOON

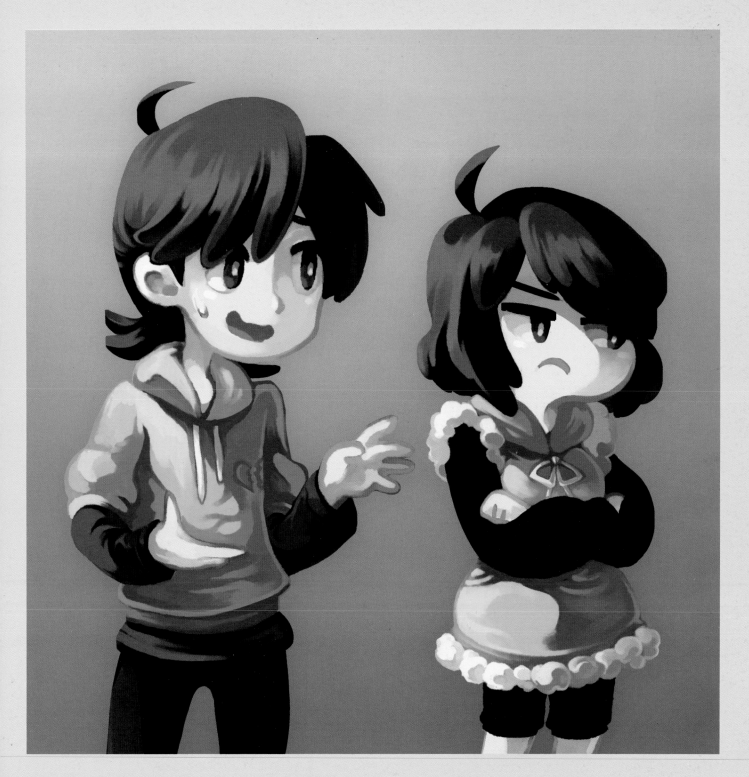

M / HAPPY BIRTHDAY ART FOR G

Meago / *WELCOME TO THE INTERNET*

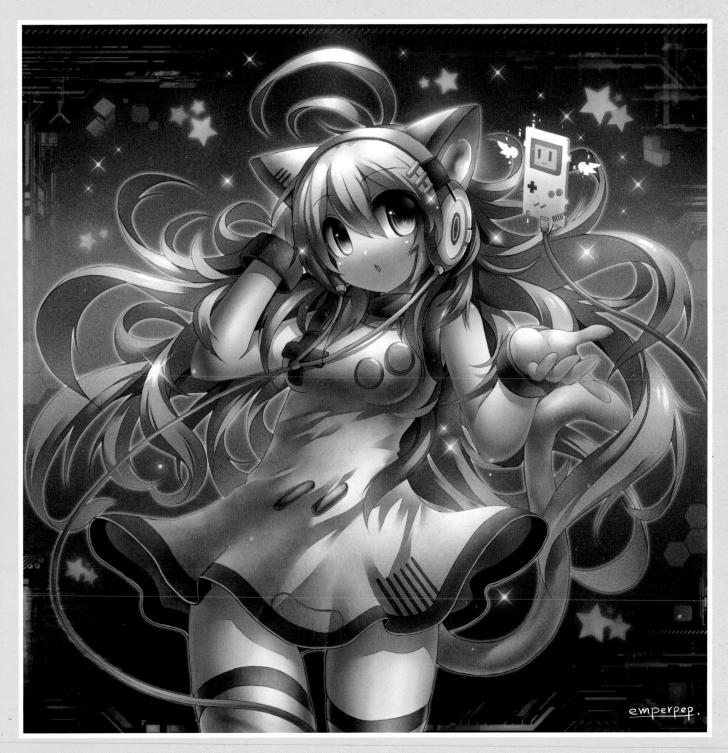

Emperpep / GAMER GIRL

Hiroko Yokoyama / *TEA TIME*

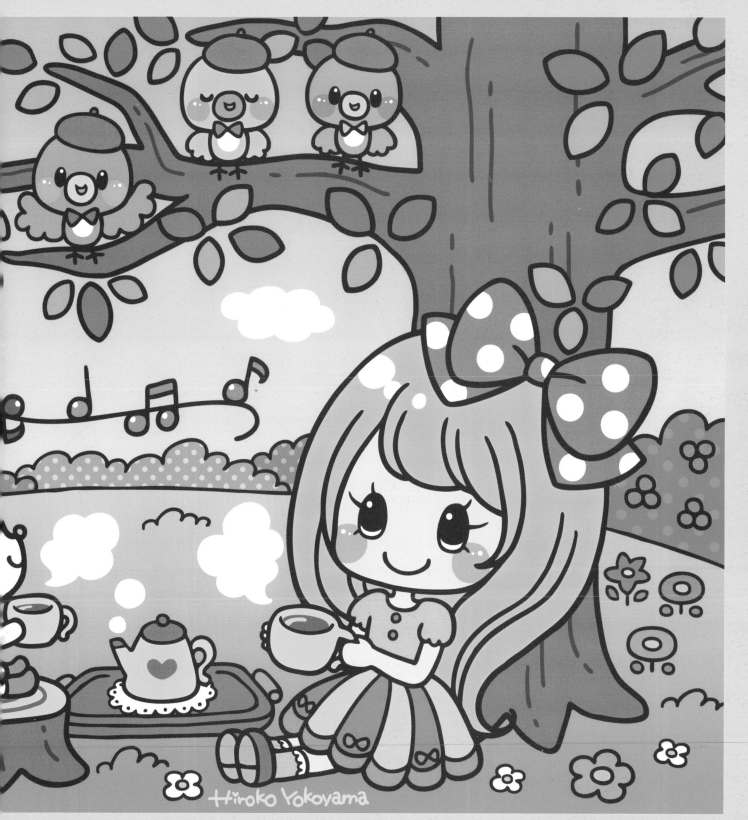

Hiroko Yokoyama

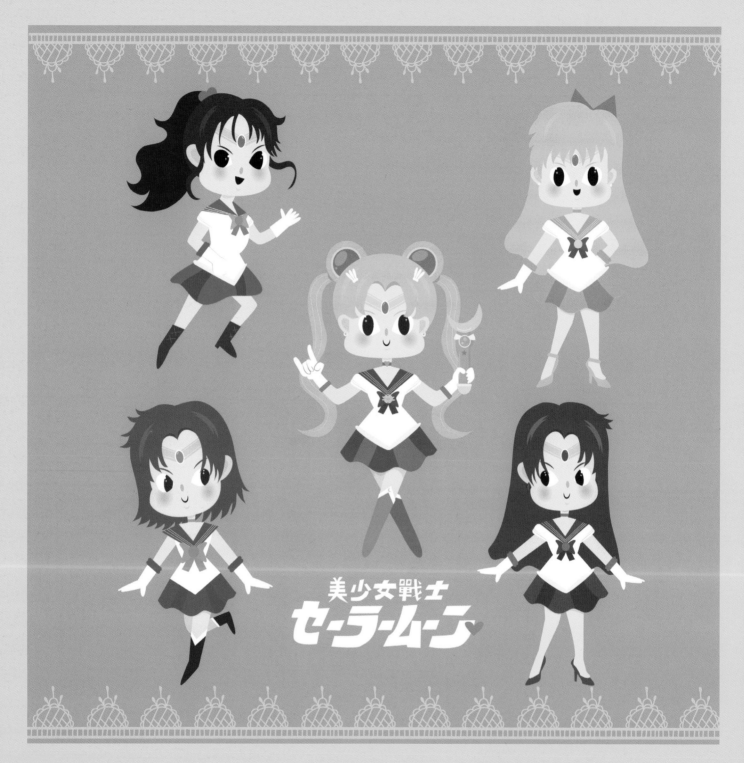

Olla Boku / SAILOR MOON

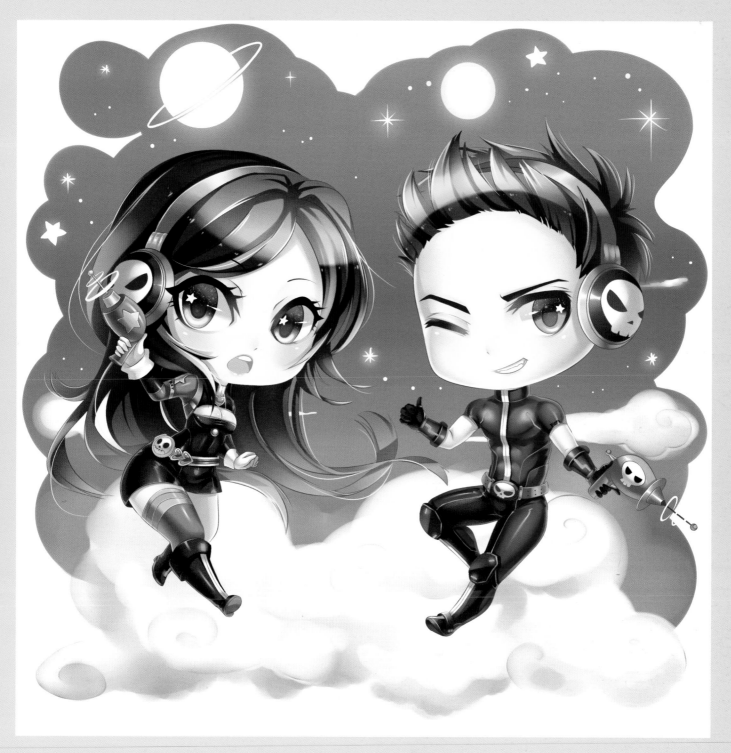

Dat Le / *KIT AND ROFL*

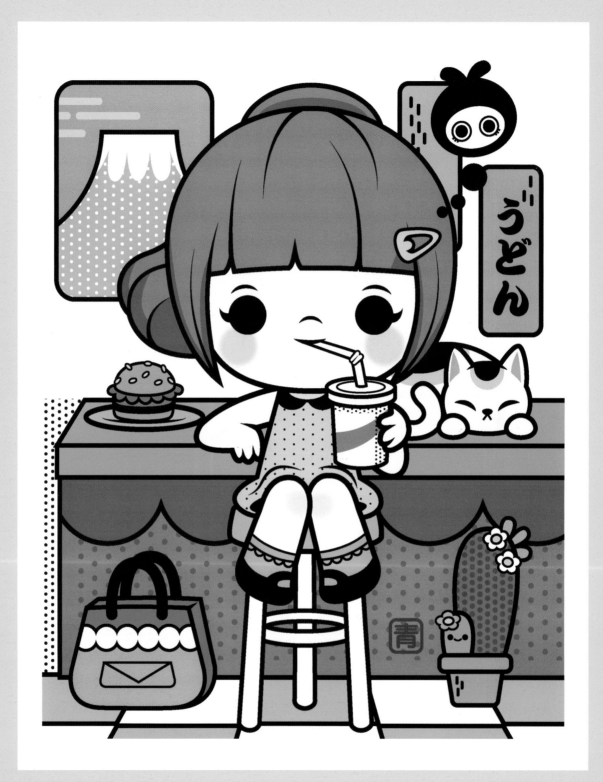

Azul Piñeiro / *NIPPON GIRLS—FUJI GIRL*

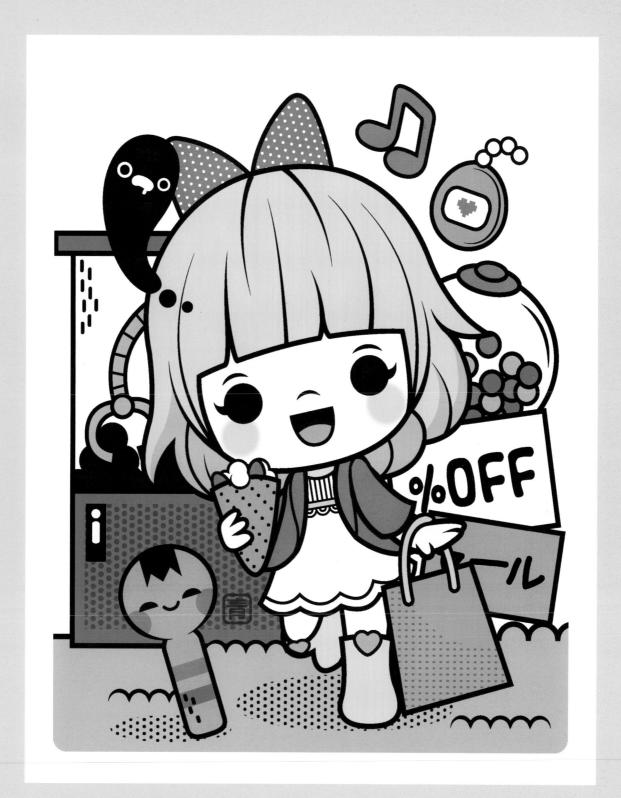

Azul Piñeiro / *NIPPON GIRLS—KOKESHI GIRL*

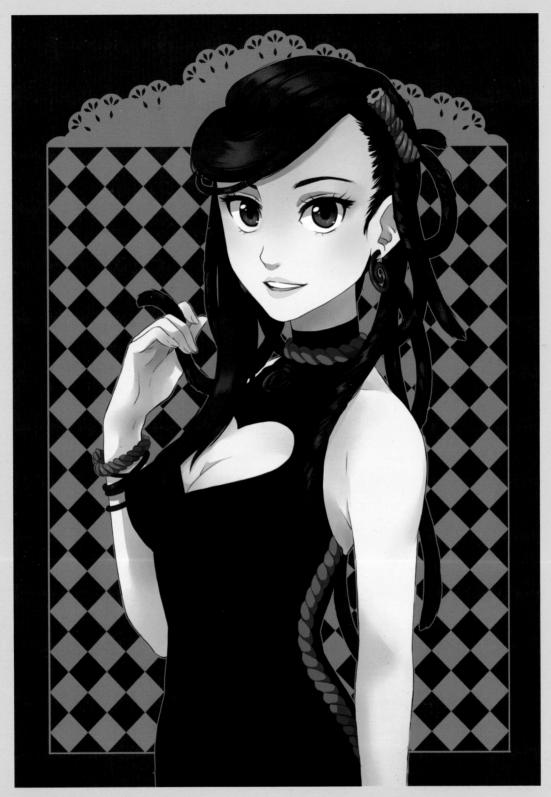

Meago / *LICORICE*

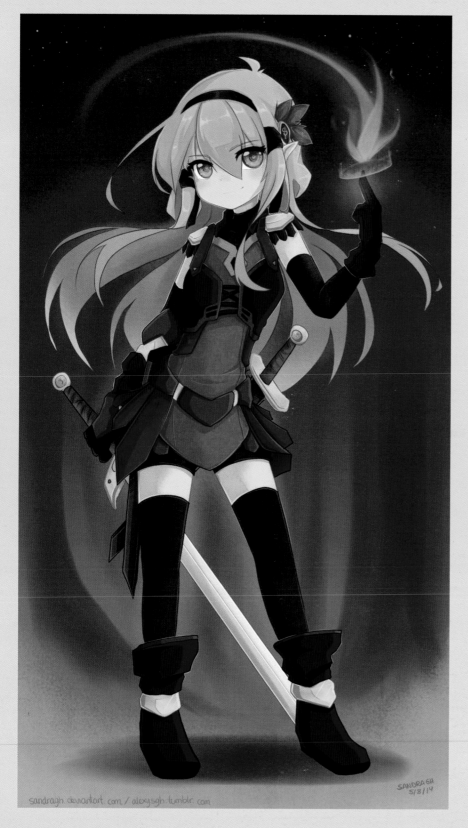

Sandra G.H. / *ELF WIZARD*

SANDRA GH
5/8/14

Hiroko Yokoyama / *CUPCAKE*

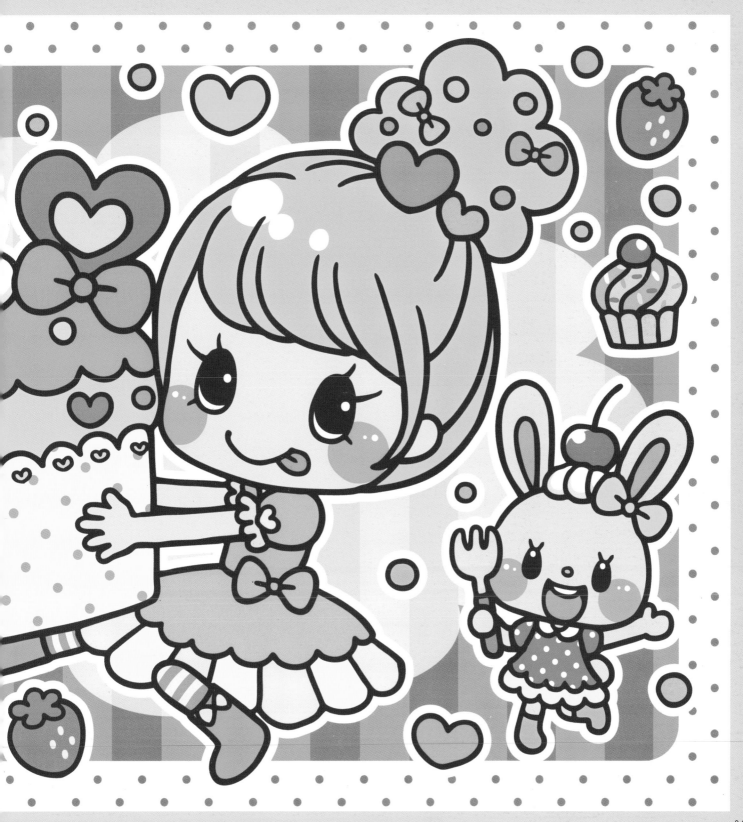

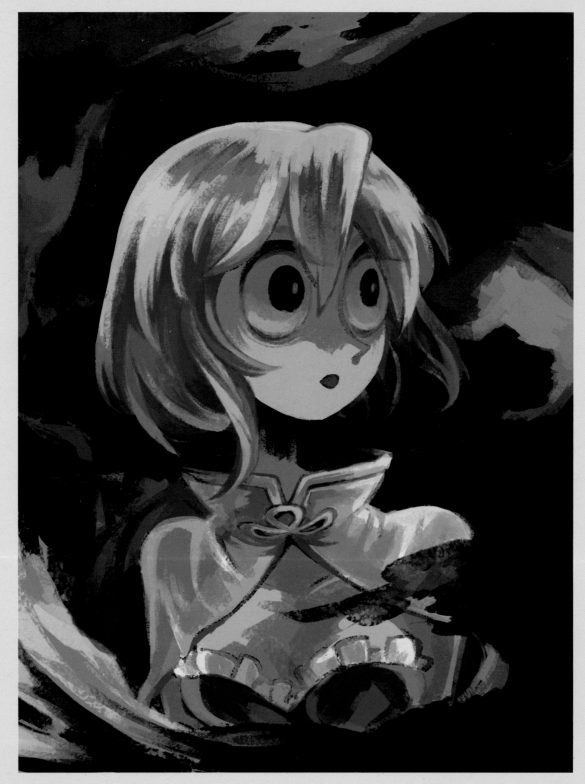

M / SAYAKA

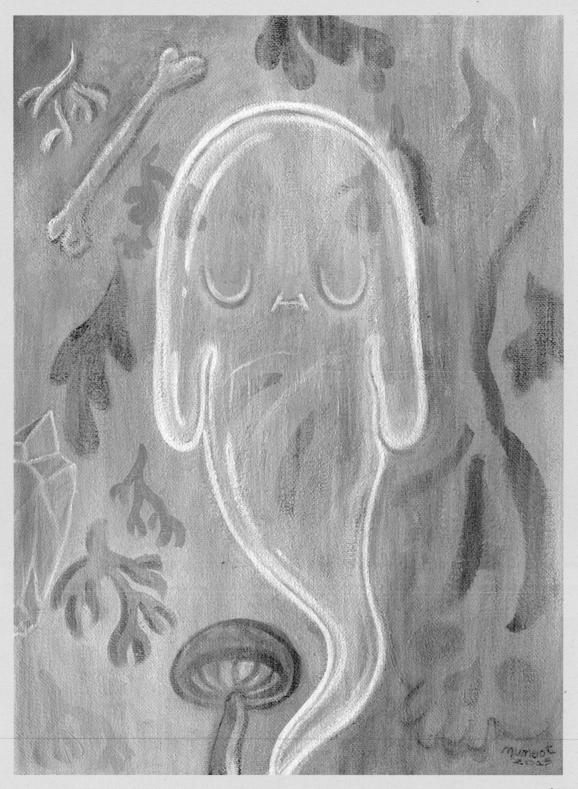

Mumbot / *GHOST & LICHENS*

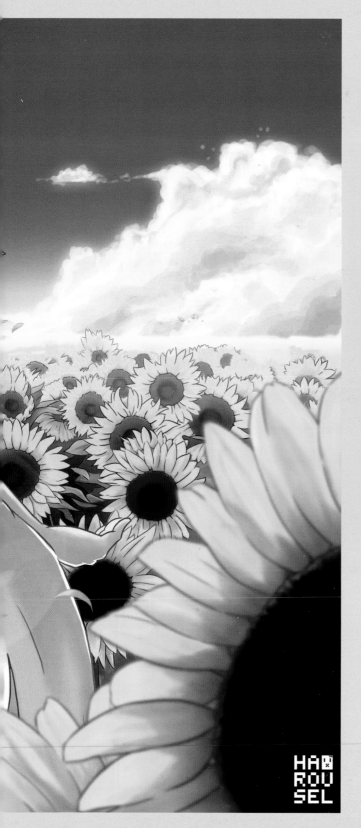

Harousel / *SUMMER*

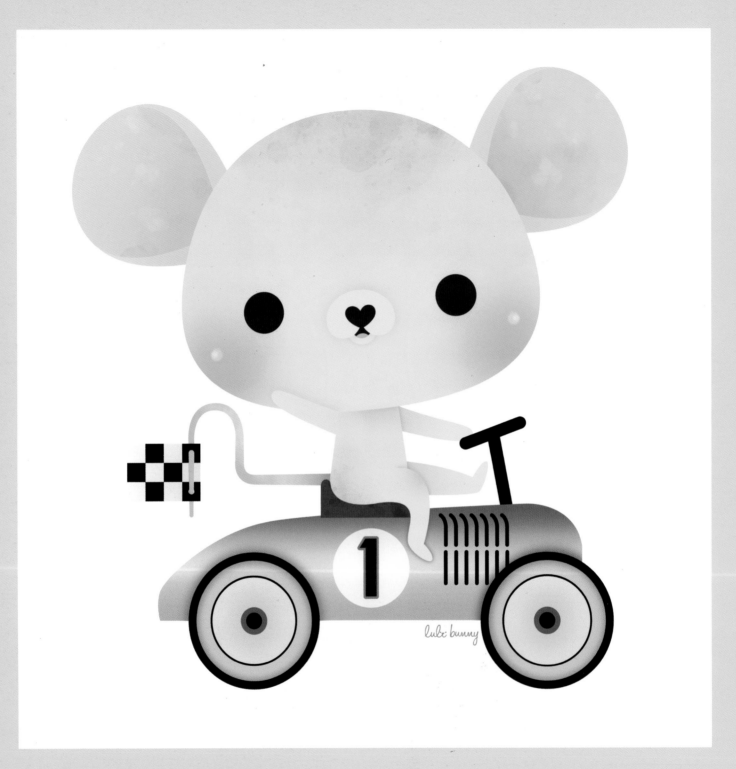

Luli Bunny / *ON YOUR MARK, GET SET, GO!*

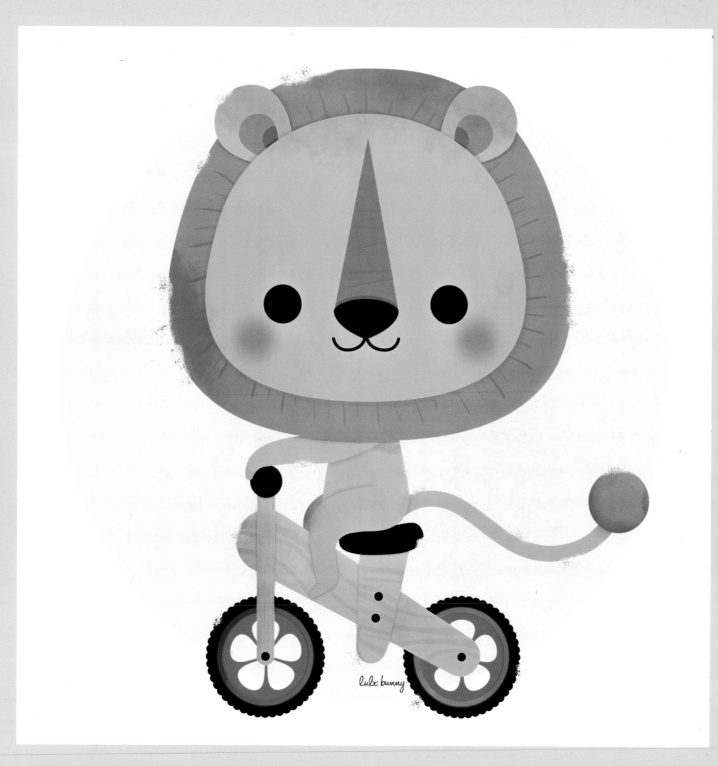

Luli Bunny / *BICI BICI LION*

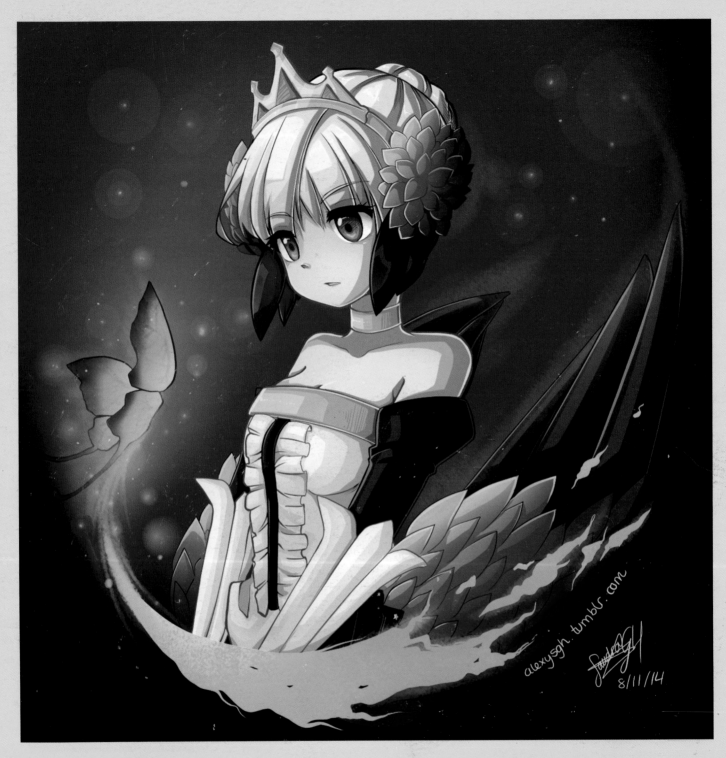

Sandra G.H. / *BLUE BUTTERFLY*